The Lost Carving

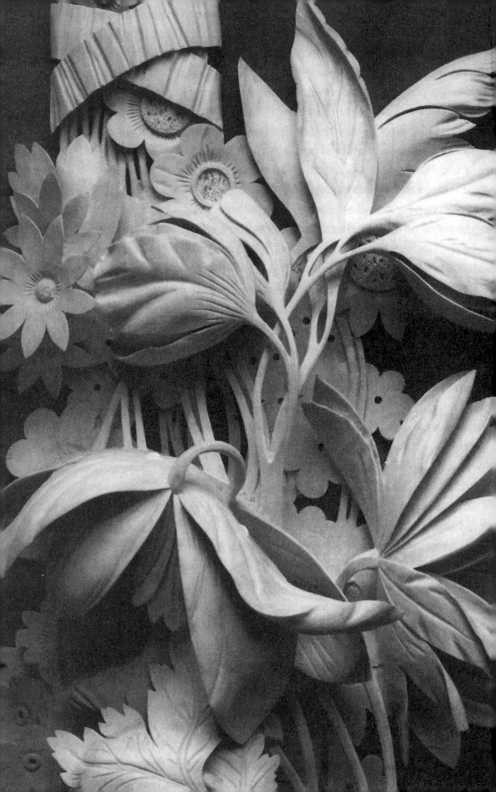

The Lost Carving

A Journey to the Heart of Making

DAVID ESTERLY

Viking

VIKING
Published by the Penguin Group
Penguin Group (USA) Inc., 375 Hudson Street, New York, New York 10014, U.S.A.
Penguin Group (Canada), 90 Eglinton Avenue East, Suite 700,
Toronto, Ontario, Canada M4P 2Y3 (a division of Pearson Penguin Canada Inc.)
Penguin Books Ltd, 80 Strand, London WC2R 0RL, England
Penguin Ireland, 25 St. Stephen's Green, Dublin 2, Ireland (a division of Penguin Books Ltd)
Penguin Group (Australia), 707 Collins Street, Melbourne, Victoria 3008 Australia
(a division of Pearson Australia Group Pty Ltd)
Penguin Books India Pvt Ltd, 11 Community Centre, Panchsheel Park, New Delhi – 110 017, India
Penguin Group (NZ), 67 Apollo Drive, Rosedale, Auckland 0632, New Zealand
(a division of Pearson New Zealand Ltd)
Penguin Books, Rosebank Office Park, 181 Jan Smuts Avenue, Parktown North 2193, South Africa
Penguin China, B7 Jaiming Center, 27 East Third Ring Road North,
Chaoyang District, Beijing 100020, China

Penguin Books Ltd, Registered Offices: 80 Strand, London WC2R 0RL, England

First published in 2012 by Viking Penguin, a member of Penguin Group (USA) Inc.

1 3 5 7 9 10 8 6 4 2

Copyright © David Esterly, 2012 All rights reserved

Parts of this book first appeared in *The Spectator, The Independent Magazine,* and *House and Garden.*

All photographs by David Esterly unless otherwise indicated.

Links to supplementary color images related to this book can be found via www.davidesterly.com.

LIBRARY OF CONGRESS CATALOGING IN PUBLICATION DATA
Esterly, David.
The lost carving : a journey to the heart of making / David Esterly.
pages cm
ISBN 978-0-670-02380-6
1. Esterly, David. 2. Wood-carving. 3. Hampton Court
(Richmond upon Thames, London, England)—Fire, 1986. I. Title.
NK9798.E88A35 2013
730.92—dc23 2012018381

Printed in the United States of America · Set in Bembo Book MY Std · Designed by Amy Hill

ALWAYS LEARNING PEARSON

❧ *Frontispiece: D. E. after Grinling Gibbons's lost carving (detail),
limewood, Hampton Court Palace, 1990.*

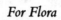

For Flora

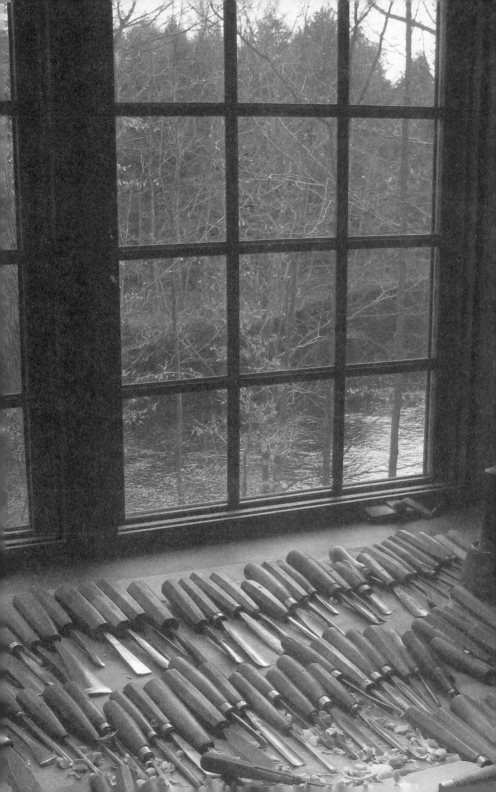

Prologue

L et's see, where was I? At the leaves alongside the peony, I guess, just where they fall over the lilac blossom. Two leaves still to do, and some uncomfortable modeling underneath them. Little lilac florets with obstructed access. Well. A sip from an oversize blue and white teacup. A yawn. Still in my bathrobe. Over to the computer, check e-mails, click on the live feed from the BBC. British voices in this far upstate workroom. Back to the carving bench, under the window. Clouds streaming in from the west. River gray, like the sky. On the trees on the bank a last few brown leaves hang on for dear life. The morning seems to be growing darker rather than brighter. On with the four halogen spotlights over the bench.

Before me, a chaos of half-finished flowers and leaves and stems, clunkily rising out of a sea of pale wood chips. Incomprehensible and unpromising. As appetizing as cold porridge. I know better than to do the things that would improve appearances immediately, at the price of reducing my options in the future. But I wouldn't want the woman who commissioned the piece to see it

❧ *Left: Workbench and river.*

1

now. An ugly duckling with no swan in sight. Never show anyone a job half done, the old adage goes. Especially a patron, I'd say. But she's growing impatient, even to the point of proposing a visit so she can admire progress.

Time for the first stroke of the day. Last night I decided that the lower leaf should have a curl to it. One way to start is by excavating a valley a little inland from the leaf's edge. My eyes stay on the leaf, but out goes my left hand, to land on the gouge I need. There are 130 tools on the workbench. Long ago I memorized the place of each. The hand travels instinctively to its near vicinity, and peripheral vision makes the final course adjustment. You can confirm the identity of the tool the instant you grasp it, by its heft and balance and the feel of its handle and shaft. No need to look.

Like the others, this chisel was lying with the blade toward me. So I give it a little gunslinger's twirl and the handle drops into my palm. Then I grasp the shaft of the blade with my other hand. I'm right-handed, but this stroke will be from the left, in the leaf's own direction. You have to carve ambidextrously, or else waste time by constantly having to turn the wood around. Now the first stroke, long and across the grain. A nice zip as the blade cuts, like the feel and sound you get when you turn the crank of a pencil sharpener, but more delicate. I'm using a fine crisp wood, so there's not much resistance to working across the grain. Nonetheless I give the tool a little twist as I push it. Easing the cut by adding another slicing motion. The whole body propels the blade, arms and shoulders moving with it, torso moving slightly the other way in compensation. The stomach muscles push the blade. A pleasing twist of the whole body. Like kayaking when you do it right.

A faintly nutty aroma from the curled chips as they fall from the blade. Each is different from all the others. Each is the memory of a chisel stroke. It's not like stone or marble carving, where you have

only a few chisels and they model the medium by knocking it away. In woodcarving you slice, and that slice leaves the shape of the blade behind on the wood. So if you're doing undulant complicated forms you need many different chisels. A hundred chisels like a hundred different thoughts, a hundred ideas to propose to the wood.

Soon the valley appears, angling inland from the edge. Now the ridge alongside it needs to be turned into a curled-over leaf edge. Another gouge, this one with a flatter curve, and this one turned over and used upside down. Except that upside down might almost as well be called right side up, since nearly as much modeling is done with the tool turned that way. The edge must gradually curl over the valley as both flow away from the stem. The leaf is like a supplicant's hand, with the arm the stem. It's as if some growth force runs along the stem and then spreads its coiled energy out through the leaf. Leaf and stem need to be part of this same current of energy. I need to mimic its motion with my chisel. Sometimes I think of Dylan Thomas. The force that through the green fuse drives the leaf, should drive my chisel.

Moving deeper into the carving, switching from the BBC to streaming ambient music. No words or thoughts to distract, no melody or rhythm even. Instead a trancelike hum that bleeds away distracting little energies. Later, if I need to concentrate still more, even this will be turned off, so that I can move into the silence, the Empty Quarter, the timeless part.

Late in the afternoon the long exuberant splash of a dozen mergansers landing in the river wakes me back to the world. Happy companionable quacking. It's tempting to get into my kayak and join them, defying the cold wind. Instead I rest my eyes for a few minutes, looking out the window and then glancing around my workplace. It's just off the living room, but the walls are paneled

with rough barn siding. On them hang an eighteenth-century blind cartouche, a plaster cast of a seventeenth-century cherub head, and my old stringless violin, which I used as a model once. To one side there's an etching of a stately palace, and next to it a drawing of the courtyard of a college that's even older than the palace.

Around the workbench an alarming monomania seems to hold sway. There are three framed portraits of the same recognizable man. In the first he's young, handsome, and intense. In the other two he's periwigged and courtly. In one of these he's measuring the cast of a sculpted head, and in the other he reclines with a trophy wife, who's fingering her pearls. A poster from an exhibition in London hangs in a corner, with a picture of some fine carving and yet another portrait of the man.

Back to work, but now daydreaming a little. Clouds lowering. Other times and places come to mind, and the story that ties all these souvenirs together. Now, shaping the uncomfortable florets with a front-bent gouge. Now, more pleasurably, using a larger fishtail gouge to rough out an uncurled leaf. Outside, the contented sound of the ducks telling their stories to one another. Drifting farther off. The workroom begins to fade away. On go the hands. The mind slips its mooring and lets the river take it where it will.

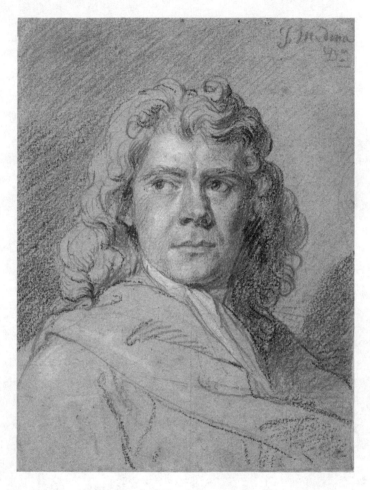

🖎 *Sir John Medina,* Grinling Gibbons, *late 1680s.* © *Trustees of the British Museum*

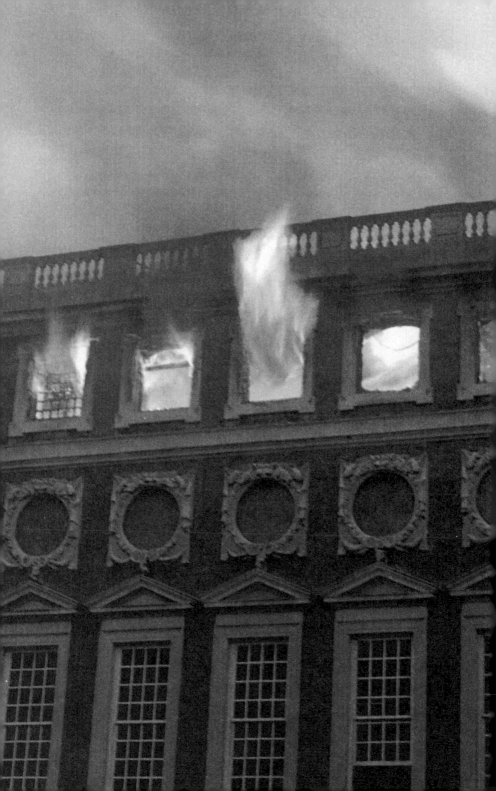

A Metaphor for Everything

I spent a year at Hampton Court Palace, replacing a lost wood-carving by the great Grinling Gibbons. I was apprenticed to a phantom, you could say, and lived among mysteries. When I think of those days now, half a lifetime later and half a world away, it feels more like dreaming than remembering. Down the stone passages, past an echoing fountain, to a workshop in a courtier's chamber, unlocked by a centuries-old silver key. And always in my mind's eye that missing carving, burnt to cinder but holding within it the secrets of a long-dead master.

The day I arrived at the palace somebody told me that I'd come to the most haunted building in Britain. Haunted it was, for me. In that paneled chamber a revenant from another age floated ceaselessly. But it was the same familiar ghost who'd been troubling my life for years—and who, implacable as Hamlet's father, had summoned me there in the first place. Staring into the fire this evening, as the first storm of winter bears down on this remote valley, it occurs to me that I went to Hampton Court to lay to rest the ghost of Grinling Gibbons, or at least sue for peace with him.

◄ *Left: Hampton Court Palace, March 31, 1986.* copyright London Fire Brigade

I arrived empty-handed. When I passed through that towered entrance gate and came face-to-face with Gibbons's work, fifteen years at my workbench melted to nothing. I saw that I'd understood as a child, thought as a child, carved as a child. Then Gibbons did what masters do, even from the grave. He made me put away childish things. He taught me my profession, taught me what it meant to master a profession. When I left there was bounty in my hands. He taught me to carve.

Those months had a paralyzing romance to them. Sometimes, after a day of sinking ever deeper into the seventeenth century, I'd look out at the raking light on fountains and trees and think I was playing a part in some old fable, on an operatic stage set. As a vaccine against unreality I decided to keep a journal, which by dint of ruthless objectivity would prevent me from drifting off into a fairy tale. It might keep a tether on that grand illusionist, the backward gaze. I'd record in excruciating detail all that happened every day, starting with carving procedures and what they were teaching me about Gibbons, moving on to the politics of the project, and including an account of the dignitaries and officials and palace employees who came through the workshop, along with ordinary visitors, family, and friends: an unlaundered record of a year of living anomalously.

It would be found among my effects, I thought, like the daybook of some Victorian engineer at work on the Tay Bridge: discovered among his papers and put away somewhere, to bob to the surface centuries later as quaint flotsam from another age. One of the palace administrators got wind of what I was doing and offered to archive the diary among the other building accounts, ancient and modern. A fine idea, I thought, and at the end of the year I almost handed my three notebooks over to him.

I had in mind, too, a famous diary from Gibbons's own century.

When Gianlorenzo Bernini visited Paris to design the new Louvre Palace for Louis XIV, the courtier Paul Fréart de Chantelou was assigned to be the handler of the great sculptor and architect. Bernini was the last universal artist, a man so famous that villagers lined the roads to catch a glimpse of him as his carriage passed on its way from Rome to Paris. Paris was still provincial to Rome in 1665, but times were changing, and the aging carver of the grand baroque was confronting a new world: a self-confident and nationalistic French court with homegrown architects determined to foil the Italian's proposals.

Chantelou, as sophisticated a courtier as Europe could offer, at once sensed the dramatic significance of Bernini's visit, and recorded it in a diary notable for its detail and its cool objectivity. Bernini is observed carving a masterly portrait bust of his royal patron, creating a series of designs for the new Louvre, and negotiating his way through a refined courtly world that sometimes laughed behind its hand at the Italian's theatrical gestures. In the end Bernini was outflanked by his competitors, and the visit finished in failure. After a sham foundation-laying ceremony he was hurried back to Italy, and the French architects proceeded to build the palace to their own design.

So an obscure woodcarver from upstate New York decided to while away the long train ride home to Hampstead every evening by being the Chantelou to his own Bernini. Forgive me. I told myself that I was also an outlander navigating an unfamiliar court, hired (not without political difficulties) to do what some thought should be a British carver's work.

Grinling Gibbons is Britain's unofficial woodcarver laureate, one of those historical worthies by whom the nation defines its identity. A golden codger, almost of the order of Samuel Johnson or Thomas Chippendale, Charles Dickens or William Morris. With

his memorable name, his breathtaking technique, his easily under-
stood subject matter (flowers, fruits, and foliage, dear to the heart of
a gardening nation), Gibbons long ago took up residence in the folk
memory. An oral tradition of tales about him has passed down the
generations—the most famous of which suggests that he made the
pea pod his signature in a carving. (The pod is open, showing the peas,
so the myth continues, if he'd been paid for the job.) The damage
to Gibbons's carving at Hampton Court elicited universal sorrow,
a prideful determination to restore the palace's full glory—and a
dollop of nationalistic feeling. Before I could be hired, there was
a rampart of protectionism to be scaled.

A nd to tell the truth, there also was the chance that my visit
might end as Bernini's did, in something less than triumph.
I'd been working in a modern version of Gibbons's style for years,
a style so time-consuming that other professional carvers avoid it
like the plague. Carvers are starvers, the old saying goes, and Gib-
bons's style, with its fineness and naturalism, its profusion of detail,
and its arduous undercutting, is regarded by most carvers as a short-
cut to starvation. Apart from British conservators who occasionally
restored Gibbons and Gibbons-style carving, I had the field pretty
much to myself. I'd turned my nose up at repair work and instead
taught myself how to carve naturalistic foliage and flowers from
scratch. I thought that made me better qualified than others to re-
carve a lost Gibbons piece. But it didn't mean that I was certain I
could do it successfully.

I'd never done reproduction work, apart from the simple copy-
ing exercises I'd set myself in early days. My motto had always
been Thomas Young's aphorism from the eighteenth century: he
who imitates the *Iliad* does not imitate Homer. I was trying to

emulate Gibbons's approach, not reproduce his work. I'd discarded the conventionalisms of his day, the lace and ribbons and cherubs, and the ubiquitous acanthus: things that meant nothing to me. I'd made my flowers and leaves battered and insect damaged sometimes. I'd introduced asymmetry into designs in a way that would have been anathema to Gibbons. I'd taken advantage of modern glues and done more separate carving and assembly than you could usually find in his work. I'd tried to reinvent the tradition, make it new.

Nonetheless I was working in the style Gibbons had invented, and so I'd had to draw close to the man. Close enough to regard him with something like trepidation. I'd climbed to the headwall and looked up at those fearsome steeps, the treacherous ice fields and shadowy precipices. When I was in the presence of his work, the wind from those heights chilled me to the bone.

I'd read the best Gibbons scholar's advice to those who would seek to imitate his formidable technique: better to account the secret lost, he said, and devote your time to preserving what is left. I'd seen the sorry attempts at Gibbons revivals in the nineteenth and early twentieth centuries: crude embarrassments, almost all of them. How much did anybody really know about this way of carving? In truth, no one understood how Gibbons proceeded with a project: what his design principles were, how he organized his workshop, how his terrifyingly delicate compositions were constructed, how he used his tools beyond the most obvious ways familiar to any carver.

For that matter, did anyone really know how Gibbons's amazing style developed? Somehow, in England in the 1670s, a breathtakingly naturalistic kind of foliage carving sprouted, and then spread like kudzu through the palaces and churches and great houses of the realm. This new approach, which turned ornament

into something else, wasn't self-inventing. The atmosphere had to be primed before the lightning flashed. But art historians had little to say about the mating of historical and biographical forces that gave birth to Gibbons's kind of carving. I knew some things about Gibbons as only a carver can know them: from the inside. But what I really knew is that I didn't know, didn't even know what I didn't know.

Worse than that. The truth is that after ten years of marinating in Gibbons, I had lost all conviction in my own work. A malaise had come over my professional life. I was weary of being an epiphyte on Gibbons. I felt petrified by that looming presence, turned to stone. Blocked. Blocked as a writer is blocked, blocked as anyone is whose confidence in what they are doing has failed and who cannot see a path forward.

At the Metropolitan Museum of Art in New York there's a painting by Nicolas Poussin (whose great patron was Chantelou, by the way) depicting Orion searching for the rising sun. The giant has raped the daughter of King Oenopion and the king has blinded him in punishment. An oracle has told Orion that if he can find the rising sun his affliction will be cured. He enlists the aid of Cedalion, a worker in Vulcan's smithy. In Poussin's picture, Cedalion is perched on the giant's shoulders, directing him through an Arcadian landscape toward the far-glimmering sea. The image of a man (sometimes a pygmy) on a giant's shoulders has caught the imagination of writers from Lucan to Robert Burton to Hazlitt and Coleridge. The gist of the lesson they draw is that, in the words of Burton, "a dwarf standing on the shoulders of a giant may see farther than the giant himself." Because they ride on the accomplishments of their predecessors, later, lesser figures can outstrip even their greatest forebears.

I'd imagined myself as Cedalion on the shoulder of a giant, and

seeing the farther for it. It's easy to think about ratcheting forward from the past in that way, in happier moments. I could save time and pointless duplication by starting where Gibbons had left off. I could steal what he had so arduously invented, and turn my labors to new tasks in a world beyond his.

I wouldn't have to be a follower of Gibbons. He would turn into a predecessor of me! I could *influence* Gibbons even. His work would alter because it would be seen in the light of mine. Poor man, stuck in history. He would be resurrected and we could move down the path together.

Alas, it wasn't working that way. Late at night, with the inky blackness outside and the moths thumping at the window, Gibbons would glide into my workroom and stand at my back. I could feel his breath on my shoulder. As I carved a flower the voice would say, *I've done that already, I've made just that curl in a petal, and better than yours. Look at me. Here's how it's done.* I wasn't standing on his shoulder, he'd jumped onto mine. He was a monkey on my back. A gibbon! Gibbons on my back.

Only I was the ape, unable to break the spell of imitation even though I never copied the man's work. His shadow moved with me. I tried to strike out in new directions but couldn't escape him. Wherever I went, I met him coming. Am I exaggerating? There's a daunting exceptionalism about Gibbons. Like Shakespeare (in this if nothing else), he invented a new form almost single-handedly and then brought it to unmatchable perfection.

Not even a Christopher Marlowe to prepare the way. Only a tired tradition of inert flowers—"carvers' flowers," they're called, because they resemble no species on earth—in dully conventional swags and drops. Gibbons turned them into blossoms that seem to have the juice of real life in them, seem actually to be made of plant material, and he arranged them in designs of easy fluency.

After that stunning achievement, what's left for a foliage carver to do? You might as well try to write a play in Shakespearean blank verse.

I'd run headlong into an age-old wall: the problem of the great predecessor. The guru-rival, loved and feared. Do you submit? Imitate? Rob? Ignore? Channel? Rebel? All of these? Patrons and friends sometimes told me that I was as good as Gibbons. Maybe even better! I knew this was absurd, remembered the mediocre nineteenth-century carvers of whom the same thing was said by an indulgent public, and rebuffed their praise. I suppose some regarded this as professional modesty, others as the kind of humbleness that masks pride. I know only that I know nothing, said the haughty Bernini to his patrons, when both he and they knew otherwise. In truth I was as far from posing as can be. I loathed the comparison to Gibbons. Ten years into my profession and I was suffering from a scorching case of chronic anxiety: the anxiety of influence.

And I was beginning to have bad dreams. One in particular makes the hair on my neck stand up even now, decades later. Out of the clouds one restless night there swam into view old pale carvings high up on a wall in a great room. I walked about, looking at them with indescribable emotion. Suddenly the scene altered and there were flames, flames enveloping the carvings. I looked on, mired in guilt and dread. Whose carvings they were I knew, and who'd set the fire I also knew.

I awoke clammy with sweat. Gray outside, the first robin commencing. I went downstairs through the half-light. No radiance of dawn, only gray turning paler. I went into the bathroom, stood in front of the toilet, and stared out at the little tipped-up field whose corner climbs the hill to where the forest starts.

I was awake, but the dream seemed to continue. Down the hill, out of the mist, trotted a ghostly coyote, the eastern version, the kind with wolf blood in it. It stopped at the fence, twenty feet away, and sat down. Burning yellow eyes stared at the human face in the window, locking me in an unwavering gaze. A minute or so passed. Then the creature turned, and walked away toward the Swale Pond bounding the field on the north.

I don't believe for a moment in the prophetic power of dreams, and even metaphorically I'm not an arsonist. As for the coyote, well, the feckless farmer had just dumped a cow carcass over the bank by the pond, and the coyote was headed to breakfast. That's all. I shouldn't have mentioned it.

And I wouldn't except for the terrible coincidence that followed a few days later. It was the morning of Easter Monday. I was at my workbench finishing a bunch of grapes when my hands suddenly froze. Over the radio was coming news of a devastating fire at a British royal palace. I put down my chisel to listen. Henry VIII's palace at Hampton Court, on the banks of the Thames ten miles upstream from London. I thought quickly. If they're talking about Henry VIII, it must be the sixteenth-century part of the palace. But it was hard to imagine that brooding pile of stone and brick catching fire.

Then came a mention of Christopher Wren, and I knew the worst had happened. The fire was in the addition Wren had built for William III at the end of the seventeenth century, a building made familiar to me by my acquaintance with Gibbons. I pictured those oak-paneled walls fallen in, the fine apartments a shambles. The news report said no more, but it was impossible not to conclude that what had garnished those rooms—Gibbons's magnificent carvings, the masterpieces of his final period—had been destroyed or grievously damaged. I turned to the window and stared out at

the fields stretching down toward the river. Patches of snow here and there, shining mist. A sickening within me, as if I'd heard of the death of a friend.

This was in olden days. 1986. No Internet, no faxes to speak of, no twenty-four-hour news feeds, nothing but radio and television, which quickly turned to other matters. We didn't have a television anyway. Little to do but wait until tomorrow's newspapers. Soon the telephone began ringing, however, with English friends conveying reports from the British media. They were watching television images of flames shooting through the roof of the Wren building. My worst fears were confirmed. The friends interlarded their descriptions with bereavement counseling.

Subsequent investigations concluded that the fire had started in one of the grace-and-favour apartments on the top floor of the palace. In the days of William III these were courtiers' accommodations, but since the eighteenth century permission to live in them was given at the pleasure of the Crown to those who'd done service to the nation. The fire started in the apartment of the elderly Lady Gale, widow of General Sir Richard Gale (inevitably known, since his school days, as "Windy"). Gale had had a long and distinguished military career, which included the command of an airborne division in the Normandy invasion and, after the war, the position of aide-de-camp to the queen.

The story that made the rounds later at Hampton Court was that Lady Gale had an aversion to electricity and conducted much of her life by candlelight. The rumor may have traduced the unfortunate lady, but in any case the fire was thought to have started around midnight, quite likely by a candle on a bedside table. No Windy to blow it out. The fire smoldered for hours before setting off a security alarm. Two guards were sent along to investigate what was thought might be a break-in, but found nothing. Then,

passing back through the great Cartoon Gallery, one of them looked up and saw a horrifying sight: the paint on the ceiling was bubbling.

The spread of the fire downward was delayed by an odd feature of Christopher Wren's construction. Since a king would not wish to be disturbed by the tread of courtly feet above his grand chambers, Wren had filled the spaces between the floor joists with tens of thousands of small seashells, brought up from the Thames estuary by barge. They served as a retardant even as the fire above was bursting into its fury. A passkey was found to open Lady Gale's door, but flames and smoke beat back the rescuers. Next day her body was found in the rubble on the Cartoon Gallery floor twenty feet below.

Meanwhile the fire, now out of control in the grace-and-favour apartments, had burst through the roof, to spectacular effect. But Wren's shells gave enough time for crews to enter the King's Apartments on the *piano nobile* floor below and rescue virtually every portable work of art and decoration. Out came the paintings, the Monnoyers and Bogdanis. Out came the blue and white porcelain so loved by William's Queen Mary, the tapestries and carpets and chandeliers, the walnut chests and tables.

Out came everything, that is, but the Gibbons carvings, nailed to the walls high above the rescuers' heads. They were abandoned to their fate. By nine in the morning the floor above them had finally collapsed, sending burning timbers crashing down. Firefighters on ladders now directed jets of water through the big windows to drench everything, water under such pressure that it sometimes tore away the stone window casings outside. In the midst of this maelstrom of fire and water hung Gibbons's delicate confections. Marooned, like Andromeda chained to the rock.

An ocean away, the quiet day wore on. I returned to my workbench. My default setting, then as now. The river island where whole days flow by unnoticed, where body hypnotizes mind and vice versa: the Zen of the workbench. It's the default setting of these pages, too, a carver at a workbench. Stick with what you know, says Propertius. The sailor tells of winds, the plowman of oxen; the soldier counts his wounds, the shepherd his sheep.

And the woodcarver tells of his chisels and his wood, and of the act of carving that unites them. There under the window is my workbench, and on it three serried rows of chisels, their blades darkly gleaming in the evening light. An army of 130 cunning specialists, mine to command. Steely veterans that shine in use, preserved from rust by the oil in the sweat of my hands. Like the aged mariners of Tennyson's "Ulysses," they've toiled and wrought with me in a hundred campaigns where victory was never assured. Almost all are older than I am. They've wrought for masters before me, many for masters before those. For bearded men who wore frock coats on Sundays. I'm part of a procession that's already spanned a century. Years of my own sharpening will shorten a few beyond use. The rest will toil for others after I'm gone.

And there, clamped recumbent on the workbench, surrounded by these tools, is the object of their attentions: a piece of limewood. The queen of carving woods, in all its pale glory. This lime has nothing to do with the citrus fruit. That name is a British corruption of "linden," German for the stately tree that's venerated across its north European range; Americans also call it linden. Its mild wood is a carving medium like no other, firm and crisp, regal in its comportment, but for all that, compliant with a shaping chisel.

It's easy to use erotic metaphors to describe the relationship between tool and wood. But it would be wrong, most of the time

anyway, to imagine a conquering soldier having his way with a passive victim. When you are shaping a form, forcing assaults usually meet with furious resistance. The blade must woo the wood. You could just as well think of the wood courting the blade, informing it of the configuration of its grain. The wood instructs the tool in its motions. Who's seducing whom? The chisel may propose, but the wood disposes.

The sailor speaks of wind and sail, and the carver tells of the coming together of chisel and wood. The delectable feel of a sharp edge moving through lime. The zip of the blade cutting across the grain, like the sound of thin canvas tearing. The way a gouge bites into the wood and then exits cleanly, if you handle it right. The gradual and oblique way that the picture in your head takes shape in the wood. The desperate feeling, halfway through a carving, that you've lost your way. Then the growing sense that you. . .

We'll get to that. On the day of the Hampton Court calamity my workbench refused to cast its spell. The hypnotism failed. The hours trudged past. Images of havoc not so far from reality did their dance of death in my mind's eye. Frequently I had to retreat to a chair, where I brooded and brooded. The sun rose higher, the patches of snow resumed their melting.

No more than another story of collateral damage in the sad march of history, I told myself. This is what time does. Yeats's lines kept running through my mind:

> *Many ingenious lovely things are gone*
> *That seemed sheer miracle to the multitude . . .*

Shadows lengthened and the cold descended again, and I decided to seek the age-old recourse for the powerless and the grieving: I went to my desk and composed an obituary. I wrote a little biography of

Gibbons and went on to describe these carvings' place at the climax of his career. All my instincts told me that if the carvings were gone they should not be replaced, so I argued that the authorities ought to think twice before deciding to go down that path of reproduction. Better to let the carvings rest in peaceful memory than replace them with some grisly modern simulation. I ended by quoting the Yeats lines. Before the embers were cold at Hampton Court I'd finished the piece, and next day I sent it off to a popular British weekly.

The morning after it was published the telephone calls began again. This time they were from palace officials, and this time they delivered unexpectedly good news. Michael Fishlock, the government architect with special responsibility for Hampton Court, informed me that most of the damage to the carvings was turning out to be from smoke and water, rather than flames or physical blows. The carvings were thought to be quite restorable. Some were charred in a few places, one or two severely, but their position high up on the walls, under deep cornices, had mostly protected them from the rain of fire and water.

Elated but incredulous, I went over with Fishlock what I knew about the Hampton Court carvings.

"Okay, there are the four big overmantels, one in each room. There are the two smaller overdoor drops above each door, making sixteen in all. There's that beautiful frieze in the King's Bedroom. And the overmantel in the Cartoon Gallery. You're saying that they're all still there?"

"Yes."

"Wonderful. Unbelievable."

"Wait, hold on. Not quite all there. One of the overdoor drops in the King's Drawing Room is gone."

"Gone completely?"

"Reduced to ashes."

"Do you know what it looked like?" The heart of the matter. "Are there any photographs?"

"I think there's an old glass plate somewhere. We're looking for it now."

"If you find it, you'll make a copy immediately?"

"That goes without saying."

The dark wings had swooped low, but passed over. I put down the phone and basked in pleasure at the miraculous survivals. It didn't take long for the pleasure to be alloyed with another kind of feeling. The British were passionately attached to their cultural patrimony. The power of their heritage industry was renowned. It dawned on me that Fishlock's every word was animated by his resolve to repair and restore everything the fire had destroyed. Whatever scruples I might have, the lost carving—that long pendant of flowers and leaves over a door in one of the King's Apartments—was going to be replaced.

The professional beast within me stirred. If a Gibbons piece was going to be replaced, then somebody would have to replace it. Who? Surely not I, who'd always flaunted my abhorrence of anything that smacked of reproduction.

Surely not I? The beast opened its yellow eyes and bared its teeth. Surely nobody but me.

In a twinkling the world had turned upside down, for reasons I didn't comprehend. Some logic of the marrowbone had tossed my scruples through the window. I looked out, half expecting to see them scattered on the grass. The morning sun was rising in the west, over a river flowing upstream.

Thinking back this evening, as I watch the sparks rise in the fireplace and the clouds gather over the fields, it occurs to me that I wasn't so much changing my mind as grasping at the hope

that this calamity would allow me, somehow, to put my relationship with Gibbons on a new footing.

Gibbons had been the air I'd breathed for years, and I'd thought that, if anything, being too close to the man was the source of my problems. But could it be that I wasn't close enough? A heretical idea was stirring. Perhaps what was blocking me wasn't knowing too much about the man, but knowing too little.

Skill is obedience, they thought in the old guild days. Obedience to a master and to the age-old principles of the craft. Craftsmen swam in a religious sea, where freedom was found in service. The journeyman obeyed the master, the master his own long-dead masters. I found that deference to authority distasteful. It made me cringe, like hearing a bride at the altar vowing to obey her husband.

But reproducing a Gibbons piece from scratch had a Mephistophelian charm to it. The ghost beckoned. *Follow me,* it seemed to be saying, *if you want to find the truth.* What if I threw myself over and *became* Gibbons for a while? At least the self-abnegation would be conscious for a change. The sheep would wear the wolf's clothing. I'd put on Gibbons's mantle. Can you break a spell by yielding to it? Maybe I could find the dawn by heading into the night, the dark night of slavish imitation.

This line of reasoning presupposed that I knew less about Gibbons than I thought I did, and sure enough, as I contemplated the difficulties of reproducing a Gibbons piece with holographic accuracy, my feeling of ignorance grew. During the years I'd spent in a Sussex cottage, teaching myself to carve, I'd made pilgrimages to Gibbons's work around southern England. I'd stared at it in wonder. But had I ever seen a Gibbons carving off the wall? Had I ever picked up a piece of his work and examined it from the sides and back?

And what did I know about the man himself, after all, except the bare outlines of his life? There were only two scholarly monographs

on Gibbons. I owned them both and I'd read and reread them, study-ing the photographs obsessively. But their accounts of Gibbons's ca-reer seemed empty at the center, as if some key episodes had been omitted. I had my suspicions about what those missing pieces might be, but I'd never felt compelled to pursue the subject. I couldn't imagine that Gibbons's life might cast a light on mine, rather than just a shadow. It began to dawn on me that if I did go to Hampton Court, chisel in hand, I'd arrive trailing clouds of ignorance.

So I made my reverse Faustian pact. I'd do the devil's work of reproduction for a year in return for . . . for what? Some wholly undetermined reward involving knowledge and liberation, I sup-posed. An uncertain bargain at best, but I was already caught in the project's spell. I wrote more articles. I visited Hampton Court. Fishlock came to interview me in America. I was hired to inven-tory the damage, using photographs taken after the fire, and then to write the detailed specification for the repair. I grew single-minded, and began to feel oddly on edge.

And when the time came, I threw my hat in the ring for the competition to replace the lost carving. With that, the clouds began to thicken and drift over the landscape. More than one public au-thority had responsibility for Hampton Court and its contents. Alongside Mike Fishlock's Property Services Agency, there were English Heritage, Historic Royal Palaces, and the Royal Collec-tion. Probably others, for all I knew. Each of these little duchies had its own sphere of authority. Inevitably there were overlappings and ambiguities, and consequently rich opportunities for border dis-putes and bureaucratic infighting.

At the center of these intersecting circles were Gibbons's carvings, which were not easily categorized. Were they works of fine art, in which case they might fall under the aegis of the Royal Collection? Or were they architectural decoration, part of the fabric of the build-

ing, which would put them under the sway of one of the property agencies? Did they belong in the same category as paintings, or porcelain, or furniture, or paneling? This bureaucratic quandary mirrored the essential ambiguity of Gibbons's work, which has always occupied an intermediate territory between sculpture and ornament. I delighted in this genre-bending quality and had come to see it as the glory as well as the curse of the Gibbons style. The question would never be resolved in art history terms, and neither was it going to be resolved in political terms at Hampton Court.

This hardly would have made any difference, except that the skirmishing authorities conceived of the project in different ways. Fishlock and his allies had supported me from the start. But he'd warned me darkly of departmental infighting. Then one day his voice on the telephone was doom-laden. Another faction, led by someone working in the Historic Royal Palaces agency, had successfully advanced the argument that only a British carver should be hired to replace the missing piece.

"What?"

"Yes. The other side just won the day. It was decided that we ought to be nurturing British carving."

Silence.

"I don't know what to say," he continued. "To be candid, there doesn't seem to be much point in your applying for the job now."

I was speechless, lacerated by a Swiftian saeva indignatio.

In the shaving mirror next morning, yellow eyes and long canines. Yeats again:

> *Even the wisest man grows tense*
> *With some sort of violence*
> *Before he can accomplish fate,*
> *Know his work or choose his mate.*

I'd spent most of my adult life in England. I was educated there, learned to carve there. Met my wife there, fathered my child there. England had made me! I'd learned all my bad habits there. I was as tame an American as you could find, you'd think. But that wasn't good enough for some Little Englander. Would they have all the British architects in New York deported? The British editors, the British designers, the British business executives, each denying a job to a perfectly qualified American?

Art was global before practically anything else was. For centuries a tide of painters and sculptors had ebbed and flowed back and forth between Europe and its offshore island. By the standards now being suggested, Grinling Gibbons himself probably would be denied the job. After all, he was born in the Low Countries and never set foot in Britain until he was an adult. He spoke English with a heavy Dutch accent. Wren had called him a German! Don't get me started.

Part of the lure of woodcarving had been the prospect of a simpler life, straightforward in its goals, concrete in its products, removed from the exasperations of office work. I was prepared for the vagaries of the marketplace, but not for intrusions of bureaucracy and policy. I had imagined Gibbons quietly creating his masterpieces, untroubled by distractions like these. I hadn't yet discovered that the politics of the great world had nearly ruined Gibbons's career. And then reshaped it, as surely as a chisel shapes wood.

I had nothing to lose. No civil service career to jeopardize, no superiors to offend, not a bridge to burn. What happened next can be told briefly. I telephoned an acquaintance, a member of Parliament with a position in the government. Was what I'd been told, I asked him, consistent with government policy?

"Certainly not. We'd want a fair competition open to all comers. I'll take up the matter with my colleagues."

A week or two passed, and then came another telephone call. A letter from the ministerial level had gone down the chain of command. The faction led by the Historic Royal Palaces person was forced to concede. I was offered the job, and a few months later I arrived in London, en famille, for my year at Hampton Court.

The other night I met someone at a party who asked what I did for a living. I told her, and the generic cocktail party expression was replaced by a look I'd seen before: a sudden brightening of curiosity, tinged with skepticism. She wasn't sure what to ask next, but she wanted to ask something. The creature in front of her had wandered in from some distant time or place. A pearl diver. An ambergris collector. A denizen of a cultural Fourth World. She looked at me with an expression I can't describe, but it was something like nostalgia.

There's a deep vein of atavism to woodcarving. You take a sharp edge and dig it into a piece of tree. Was art born when a hominid picked up a clamshell and scratched a piece of driftwood? Carving operates near the bedrock of cultural activity. It's a primal manipulation of the world, and this archetypal quality means that it resonates in other, later-evolved human actions. Just as you strike off chips when you're wasting away wood with a mallet—big chips and small, falling at your feet or flying across the room—so woodcarving strikes off metaphors.

I became aware of this the first time I picked up a chisel and looked down at the board clamped on the table before me. It struck me that this was like being a writer, staring down at a blank piece of paper, pen in hand. In front of you the same smooth vacant surface waits, and within you the same nervous mustering of resolve, the same sense that the first stroke is important and a bad start

might be ruinous. (Update the paper to a blank screen if you like, and the pen to a keyboard. The analogy holds even with this step further away from physicality.)

It goes the other way, too. Knowing about carving, you find its echoes in the other activities of life. When I stared at the blank first page of my Hampton Court notebook, my mind jumped immediately to woodcarving; this was like staring down at an untouched board on a workbench. I remember gathering my courage and thinking, I'll take a stab at it, then realizing that with those words I still hadn't left the world of carving. "Stabbing out" is a technical term in the profession. It happens at the start of modeling, especially with relief carving. You hold a chisel or gouge vertically, as you might a knife, and stab down around the outlines drawn on the wood.

Language was built out of metaphors taken from the world of handiwork, of bodily activity. Some expressions, like "against the grain," come down unmodified and flaunt their origin. But this was more than a matter of linguistic relics. When you write about carving, you enter a landscape haunted by symbols, where meanings flow together. You write about one thing only to find that you're writing about something else.

I cannot break the habit of seeing woodcarving as emblematic of a thousand human endeavors. Nor, conversely, can I reflect on experiences in life without workbench analogies flooding in. Carving is a metaphor for everything. What is abstract elsewhere is concrete here at the workbench. Even the course of a carver's career—the happenstance of taking it up, the making of a style, the unearthing of patrons, and all the rest—seems to echo other kinds of lives. This anachronism, this most discardable of professions, this repository of everything scorned by contemporary art, of beauty, skill, nature, feeling, tradition, sincerity, this throwback,

this lost cause so hopelessly at odds with the present age, nonetheless seems to me a glinting fountain of symbols. Thinking about wood-carving, you think about the world. Well, I do anyway.

When my year at Hampton Court ended, I took a cord and tied my three notebooks together in preparation for donating them to the palace archives. Then I didn't do it. I brought them back, still warm to the touch, and put them out of sight in a drawer next to my workbench. For a while, whenever I opened it I caught a whiff of smoke, as if they were still smoldering a little. Then the years went by and other strata were deposited above them. They remained untouched, an igneous layer.

Until this afternoon, when in the middle of carving a leaf I stopped to glance at some mementos on the walls of my workroom, and my thoughts floated off. The story came back to me as if it were a tale told in some old manuscript. Where did I put those notebooks? I rummaged through drawers, digging deep in one after another until they appeared, under a yellowing file, lying still and cold like stones at the bottom of a river. I closed the drawer, walked to the window, and stared over the bare fields, about to fill up with snow. Darkness coming on. Horizon still alight, burning red and orange like the fireplace embers. Light in the room turning pearly. Time to put another log on the fire and let the wind in the chimney suck it to life. Then I'll go back and open the drawer, put my hand into the stream, and lift out those days.

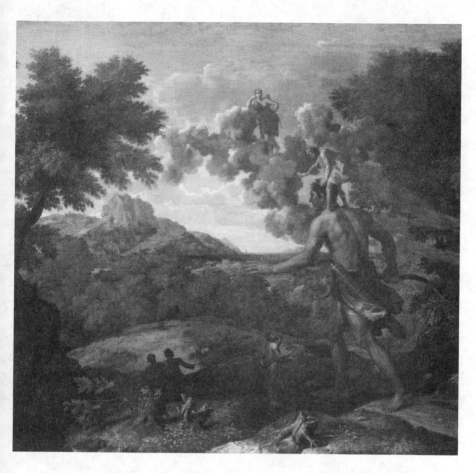

Nicolas Poussin, *Blind Orion Searching for the Rising Sun* (detail), *1658.*

The Use of Time Is Fate

F ate and chance, two words for the same thing: the sudden swerve of events that sends life spinning onto a new trajectory. Every life is shaped by unforeseen incidents and chance encounters. But the extravagant and unstable lives of artists seem especially in thrall to fortune. Restless postmedieval artists, anyway. Searching after a style, beset by competitors living and dead, dependent on capricious patronage, their lives are a galliard of luck and will. A simple twist of fate could change everything!

Gibbons, on the other hand, seemed to gaze down from a citadel of serenity, like an imperturbable Dalai Lama. The books about the carver depicted his career as a triumphal progress, as inevitable seeming as his graceful tulips or burgeoning foliage. Something in me recoiled from this story of an unruffled ascent, so unlike my own life and the unruly lives I saw around me.

In the months before leaving for Hampton Court, I decided to take a closer look at the man whose identity I was about to snatch. I pored over the source documents again, and this time they began

❧ *Left: Grinling Gibbons, reredos carving (detail). St. James's Church, Piccadilly, London, 1684.* Photograph: David Luard

to yield to scrutiny. The curtains parted. A new figure stepped forth, one whose story was replete with indirections and false starts, strokes of luck and seasons of perdition. The stately music faded, the royal progress melted into air, and there was Gibbons, down in the base court with all the others, dancing his own tarantella of chance and ambition.

Falling to earth, he became more serviceable. Gibbons the carver seemed a flawless taskmaster; Gibbons the man was molded by failure as well as triumph. Failure more than triumph. Through the bright lens of his career I could see my own life in vivid form, as if heightened by an artist's white chalk. Not only my life, but the life of anyone buffeted by chance and trying to respond to it.

S
ummer over, bags packed, chisels wrapped in tool rolls, fare-wells said, and the long-awaited year began. On the flight to London my wife, Marietta, and our seven-year-old daughter, Flora, slumbered quietly. Thoughts of Gibbons wound and wound in my mind, keeping me awake, until I finally dozed off and they morphed into fitful dreams out of my own life. The night wore on. Our destination drew near, the island where lightning had flashed for me, years before, and where it had flashed for Gibbons, too: both of us new arrivals in a newfound land, where anything could happen and the future was malleable.

The plane broke below the clouds. Winds had forced us farther south than usual, and there, in the watery dawn, was a West Country landscape of tiny irregular fields and hedgerows running down to the Channel. Little lines of sportive wood run wild, as Wordsworth wrote. Portland Bill, like a teardrop falling off the chin of Dorset. The Isle of Wight. Now the Sussex coast. Seaford Head. Then the seven white cliffs, with their skirt of downland bright green even in

September. And there, a few miles inland, a familiar place, glimpsed from an unfamiliar angle as if conjured up in memory.

When I'd first seen it, fifteen years earlier, I thought I'd stumbled into the *valle incantata*. On a bright July afternoon in 1974, weary from months caged in London, I'd stepped off a green country bus at a little church by a dew pond, walked along a country road until a white wooden gate appeared on the left, and then turned down a long steep drive ("STRICTLY PRIVATE").

An old hollow way, the high bank on each side topped with a flint wall. Behind the walls sheep grazed peacefully in pastures bordered by woodlands of ash and beech. Ahead, on the other side of the valley, a grassy swath of downland, then forest, then downs again, stretching on endlessly. Not a house in sight. With every step London sloughed off. Blue sky, sweet air. Senses awakening, mind quietening.

Silence but for the baaing of lambs and my own footsteps. Down and down went the body, up and up rose the spirits. Time slowed, stopped, ran backward. Disappeared altogether.

Near the bottom, another sign: DEAD CHILDREN AND SLOW ANIMALS. What? I'd left behind world of the quick if not the dead, apparently. I looked again. The placement of the words was ambiguous. DEAD SLOW CHILDREN AND ANIMALS, this time. Still odd. Not a creature in sight anyway. Nothing moving but the trees, stirred by a wind that smelled of grass and felt of the cool sea beyond.

On the left reared up a grand Elizabethan facade, all gables and half-timbering, soft brick and leaded glass. To the right, a medieval flint building with three cottage doors, its steeply sloping peasant roof like something out of Breughel. A feeling in the hollow of my stomach as if I were returning to a familiar scene. I'd inhabited this place before, but not with my body. As if I were walking into a painting. Or a Shakespeare play. *Twelfth Night*, perhaps.

Beyond the Breughel cottages, at the very floor of the valley, a high stone wall with carriage lamps atop Georgian entrance pillars. Through it went the drive, to end in a loop around a circle of elms. On the left, a flint barn, its yard now a walled garden. Facing it on the right, the end of my journey, a pale washed cottage from the eighteenth century, embowered in blossoms. Birds sang, roses climbed, sun shone. At the end of a Hollywood romance, with orchestra swelling, this would be where the lovers go to live happily ever after.

Marietta and I had been living together in London, young graduates looking for a way to move to the country. The idea was that Marietta would cook for the lord of the manor on weekends, in lieu of rent. At our interview later, the children turned out to

❧ *The cottage in the South Downs.*

be quite alive and in their mid-twenties, like us. Instant rapport, probably sensed by their father, the redoubtable Lord Shawcross. It seemed that the family was looking to inject youth and life into the place.

Another point in our favor: I asked Shawcross if he was related to John Shawcross, who in 1907 had produced an edition of Coleridge's *Biographia Literaria* that was still in print, and continually at my side while I wrote my dissertation. "My father," he answered. Glacial melting, in the handsome seventy-two-year-old face. The interview with Marietta ended in a brief exchange.

"I hate American cooking. Can you do jugged hare or forcemeat balls or brandy snaps?"

"I've never heard of any of them."

Pause.

"Well . . . can you start two weeks from Friday?"

Then he turned to me. "And you can have your nine bean rows." Yeats's "The Lake Isle of Innisfree," and behind that, Thoreau's *Walden.* Two classics of sylvan escape. The old man's smile was skeptical but indulgent.

So, to the beautiful dower house in a valley in the South Downs the real lovers went, out of the storm, to live for eight years in happy poverty. One restored fine porcelain, to bring in a little money. The other, still scorched from a thunderbolt moment in London a few months before, set out to teach himself to carve limewood.

N ow the plane heeled away from the Channel, crossed Kent to the Thames estuary, then banked left again for the descent over London. Upstream along the Thames we glided. I stared out the window and realized that Gibbons place-names were scrolling past, almost in curriculum vitae order.

First Deptford, on the biggest meander in the river, hard by Greenwich and long since melted into it. In the seventeenth century the site of a great royal dockyard, where craftsmen turned out warships and pleasure barges alike. And someplace down there, buried under that sprawling nineteenth-century streetscape, was the field where a fateful cottage once stood.

Hardly a cottage; more a tumbledown thatched hut, forlorn and solitary. One winter's day near the beginning of 1671 you might have seen a figure approach it, a gentleman out from his fine house on a constitutional. As he walked past the cottage he happened to glance in the window. It was by mere accident, he wrote later.

What he saw there caused him to stop short, stare for a while, then knock on the door and ask if he might be admitted. On a workbench under the window, taking advantage of the natural light, was a nearly completed relief sculpture after Tintoretto's *Crucifixion*. The young carver who opened the door had been bent over it when interrupted.

The carver was the twenty-two-year-old Gibbons. The strolling aristocrat was John Evelyn: courtier, connoisseur, dendrologist, gardener, diarist, and—though not a profound thinker—polymath. Evelyn was dazzled by the Tintoretto relief, claiming never to have seen its like in all his travels. And he was charmed by Gibbons, who was modest in demeanor and handsome in a young Nick Nolte sort of way. At once Evelyn offered to introduce the budding prodigy to great men who might patronize his work.

Of all the persons in England who might have knocked on Gibbons's door that winter day, hardly a better advocate for his work could have been found. Evelyn counted among his friends not only the king but many from the noble families of the realm. The patron class. No less important, he was also acquainted with architects and

surveyors of works, the clever operatives who actually carried out the grand projects of the day.

Within the month, true to his word, Evelyn had brought to the dilapidated cottage two luminaries of the age, Christopher Wren and Samuel Pepys. And to crown it all, shortly afterward he presented Gibbons and his Tintoretto relief to Charles II at Whitehall Palace.

A discovery out of a fairy tale. Consider for a moment how perfectly the stars had lined up, on both sides of that cottage door. Gibbons's day job was decorative shipcarving for the Deptford dockyard, conventional work that never would have stilled Evelyn's footsteps.

But on this day Gibbons was working on his own time and to his own agenda, which was to pitch his career up to a higher rung on the ladder of the arts. Gibbons had been born in Rotterdam of British parents, his father a draper, his mother the daughter of a tobacco merchant. He'd served a long European apprenticeship, and acquired skills in drawing and carving technique that gave him a decided advantage over his British colleagues. Wren complained bitterly that although *disegno* was the foundation of everything, young English artists weren't taught to draw. What Evelyn singled out for praise, as it happened, was precisely the skillfulness of the drawing embodied in Gibbons's sculpture.

And from his early years in Europe Gibbons also gained two advantages that would cause any carver's ears to prick up: he'd acquired a finer set of chisels than any in England, and learned to use a potent European medium, limewood. His British colleagues' bread and butter—and main course, and pudding, too—was conventional decorative work in oak or pine. For Gibbons during his Deptford years, that kind of carving was paying the bills. But he was on a different trajectory. His ambition was to become in Britain

what he'd trained in Europe to be: a maker of small tour-de-force figure sculptures, usually on religious themes.

The earliest works recorded from Gibbons are just such "objects of virtu." All of them date from shortly after his arrival on British shores. There is a boxwood relief sculpture of King David playing the harp, which he may actually have brought from Europe as a sampler, and a miniature (six-inch-high) "History of Elijah under the Juniper Tree," which survives only in that description. These exotic European works would have dropped down onto a sleepy British sculpture scene as if from Mars. But Evelyn was one of the cognoscenti, who'd done his grand tour and prided himself on his connoisseurship. He knew about limewood and its special connection with sculpture. The first edition of his masterpiece, *Sylva, or a Discourse of Forest-Trees* (1664), notes limewood's tractability and its use as a medium for small figures.

Evelyn was also enough of a savant to recognize the model for the carving he'd happened upon in the cottage. Gibbons was copying this *Crucifixion* directly from an Agostino Carracci engraving after a huge Tintoretto canvas in the Scuola di San Rocco in Venice. Evelyn had seen the painting itself, and he had brought back from Venice the very same Carracci engraving. More than that, he'd particularly praised this work in a treatise he'd written in 1662 on the art of engraving.

A Europeanist sculptor on the make, a Europhile connoisseur on the prowl. The two backstories converge. Artist and discoverer were preconfigured to each another. The poles were charged, the spark jumped. Within a few years Gibbons was at work at Windsor Castle, strongly in royal favor and on his way to becoming one of Britain's famous men.

But there's a problem with this fast-forward and its smooth crescendo: it masks the reality of what actually happened. It leaves out

a disaster, the debacle that shaped the rest of Gibbons's career and generated the style that made him famous.

A bright morning, bitter cold flooding down from Canada. Snow painted on field and tree: winter's primer coat, first of many. The remnants of summer steam out of the river, in tall plumes of vapor that mark its course like a battle line at the bottom of the field. The plumes condense to ice on the trees lining the bank, so that the river's long reach coming toward the house is a smoky hall, with walls of crystal.

Sitting here in a sunny window, I recall the exhilaration I felt when I finally pieced together the origins of Gibbons's style. It hadn't come with his mother's milk. The muses hadn't paid a midnight visit to a genius in his studio. There was no annunciation. It was forged in bitter failure, made up out of rejected parts, probably in humiliation and confusion, by a man groping for a way forward. Gibbons had been pushed off the ladder he was climbing toward the high art of sculpture, and found himself where Yeats says all ladders start, in the foul rag-and-bone shop of an unsatisfied heart.

You can read the warning signs between Evelyn's lines. Normally voluble, he's silent about Pepys's and Wren's reaction to the young prodigy. (Alas, Pepys had stopped keeping his own famous diary by then, so we lack what might have been a colorful and candid description of that visit to Gibbons's cottage.) Wren's subsequent inaction speaks volumes, however. The architect was in a unique position to influence patronage during these years of reconstruction after the Great Fire. When he met Gibbons he had the construction of fully twenty churches in hand. Gibbons's carving can be found in none of them. More than a decade would pass before Gibbons worked in a Wren building: a church on Piccadilly that was to loom

large in my own life. By then Gibbons was the leading woodcarver in the land, strongly in royal favor, and could not be ignored.

But the worst was yet to come. As promised, Evelyn brought Gibbons and his sculpture to Whitehall Palace, where the king praised it—and then declined to buy it. Gibbons's *Crucifixion* foundered on the rocks of anti-Catholicism, that enduring seventeenth-century English sentiment. Yet wasn't Charles II himself a closet Catholic? Less than a year earlier he had signed the secret Treaty of Dover with Louis XIV, in which he embraced Catholicism and promised, as soon as feasible, to publicly declare his faith and bring his country back into the Roman fold. A few months before his meeting with Gibbons, Charles had had his "Cabal"—his senior ministers—secretly sign an expurgated version of the treaty. The Catholic clause was omitted, too radioactive even for his most trusted allies.

However, unlike his brother and successor, James II (who flaunted his Catholicism and lost his crown), Charles understood the delicacy of his position. He studiously avoided any show of Catholicism or its trappings. These would include depictions of the Crucifixion, even those carved after great Renaissance paintings.

Charles ordered Gibbons's panel carried to the bedchamber of his (openly Catholic) queen for her to see, and then he conveniently withdrew to a council meeting. To Evelyn this meant Charles thought the queen might buy the piece, "it being a Crucifix." But the queen was ruled by one of her ladies in waiting, who pointed out faults in the carving. The woman knew no more than an ass or a monkey, fumed Evelyn. (Actually, the lady in question was a French aristocrat who might have been well familiar with sculpture of this kind.) In a fury, Evelyn ordered the panel carried away.

Gibbons had the long boat ride back to Deptford to contemplate his failure, and his future. The fairy tale discovery that seemed to

validate his career had done just the opposite. It revealed that he'd been in a blind alley from the moment he'd set foot on British shores.

The problem went beyond the Catholic contagion carried by certain kinds of sculpture, to a more general limitation of taste and patronage. London wasn't Rome or Paris or Amsterdam. In Britain there were too few connoisseurs like Evelyn to sustain a market for small tour-de-force figure work or pictorial relief sculptures in wood. Years of training had prepared Gibbons for a doomed career. After Deptford he carved only one more such sculpture, a large relief showing the stoning of St. Stephen. It didn't leave his house.

Our plane continued its descent along the Thames, past St. Paul's Cathedral, Wren's masterpiece and repository of Gibbons's largest commission. Gibbons carved in wood and stone there in the 1690s, when his workshop was at its apogee and he and Wren were working closely together on a number of important projects. In 1671, however, what Gibbons would have seen was "Old" St. Paul's, the huge medieval cathedral that had been gutted by the Great Fire of London five years earlier. And he would have seen it every day. A few months after his disaster at court, Gibbons had abandoned Deptford, married, and moved into new quarters in a coaching inn on Ludgate Hill, the short street running up to the cathedral.

Gibbons's rooms on Ludgate Hill may have been a step up from a tumbledown cottage, but he was still in the very ordinary world of anonymous and ill-paid decorative carvers. The dream of becoming a great European wood sculptor, a Donatello or a Riemenschneider, had dimmed. He remained on a low rung of his profession. A maker of ornament, marginal texture for the eye.

What happened next represents the real turning point in Gibbons's career: his gritty and pragmatic decision to take what he had—skill in drawing and modeling, an understanding of limewood, and a set of fine tools—and deploy these powerful sculptural weapons in the low craft of decorative carving. He decided to sweep incendiary religious themes off the table and turn to subject matter that was politically inert: flowers and fruits and foliage.

But those flowers would be modeled with all the attention a high European sculptor might give to the face of a saint. Surfaces would be given an undulant subtlety as if modeled in clay. Detail would be exquisitely crisp. Leaves and petals would be radically undercut, to paperlike thinness. Limewood would be pushed to its physical limit. Gibbons had emerged out of a Dutch culture where naturalistic flower painting was prized, and it's hard not to think that his own sensibility also drove this transformation. It would take years before he achieved the full glory of his decorative style, but its revolutionary qualities were there from the start.

And they did not go unnoticed. Before 1671, his year of humiliation, had ended, another bolt from the heavens struck. Astonishingly, Gibbons was discovered again, this time as a decorative carver. He'd been hired by the actor and impresario Thomas Betterton to carve ornamentation in the new Dorset Gardens Theatre, under construction on the banks of the Thames several hundred yards to the southwest of Gibbons's rooms on Ludgate Hill.

This was journeyman architectural enrichment work on cornices and capitals, with some eagles thrown in (all long since lost), but Gibbons seems to have turned it into something more striking. His discoverer, no less distinguished than Evelyn and rather more useful to Gibbons's career, was Sir Peter Lely, the principal painter to the king. Lely's closest friend was the courtier and architect

Hugh May, and it was to be May, not Evelyn, who presided over the rise of Gibbons's career as a decorative carver.

May quickly secured Gibbons commissions at two important country houses. Then, in the mid-1670s, Lely and May arranged a reprise of Gibbons's introduction to the king. At stake was carving for the largest construction project of Charles's reign: May's rebuilding of the royal apartments at Windsor Castle. This time Gibbons showed Charles not a European religious figure sculpture, but a decorative extravaganza: a large overmantel with a festoon of fish, shells, and other ornaments. No scruples of taste or politics could deter Charles this time. Gibbons was hired, and with this royal imprimatur and its exposure at Windsor Castle, Gibbons's became the blue-chip carving style of the age.

He'd invented a new form. An embarrassment was turned into a source of pride. In the window of his Ludgate Hill workshop he placed flowers carved so thinly that they trembled when carriages passed. An Evelyn strolling by in the crowded street now would be halted by the sight of a decorative craft transformed into something that might answer to the name of sculpture. Even in the seventeenth century, when the distinction between ornament and sculpture was less strongly drawn, this was lead turned into gold. Before Gibbons, nobody had given to wood the loose and airy lightness of flowers, Horace Walpole famously wrote, or chained them together with a free disorder natural to each species.

A minute or two later and the plane was slowing quickly. On the right, Piccadilly, and just discernable halfway along it, St. James's Church, where Gibbons did his first carving for a Wren building.

And where, one day in the 1970s, I swerved into my present life.

It was a few months before we left London for the South Downs. Marietta and I were on our way to have tea at Fortnum & Mason with my parents. She was meeting them for the first time. Instead of being nervous, she was nonchalant and playful. We were passing the stately Wren church when she stopped and impulsively said, "Let's go see Grinling Gibbons!"

I looked at her blankly. She had encountered Gibbons's work in her Cambridge days. But she was with another man then and the carvings were in his college's library, which I'd never visited. I must have seen Gibbons's carvings elsewhere, though, at St. Paul's Cathedral and Windsor Castle and other tourist pilgrimage sites. At Hampton Court itself, even, during a year when my parents lived nearby. But not even the man's quirky name had lodged in my memory.

Would we be late to tea? I didn't care. What interested Marietta interested me. She grabbed my arm and veered me into the church. Have I made all this up? Marietta says not. We walked toward the altar. Floating on the reredos, the wall behind the altar, was a shadowy tangle of vegetation, carved to airy thinness. Organic forms, in an organic medium. My steps slowed, and stopped. I stared. The sickness came over me. It seemed one of the wonders of the world. The traffic noise on Piccadilly went silent, and I was at the still center of the universe.

A tingling in the palms of the hands, a loosening in the solar plexus. I looked and my tongue seemed to be moving over carved ivory, cool and smooth. Don't ask. I haven't a clue. It's what I still feel in the presence of great limewood carving.

Somehow I was taking in the thing with body and mind at once. In an early essay, Yeats writes about seeing the *Winged Victory of Samothrace* and sensing it in the soles of his feet, or reading the *Odyssey* and feeling the salt wind blowing. He entitles this little

chapter "The Thinking of the Body," using that phrase to describe our reaction to all good art. For me the meaning of those words has broadened and deepened over the years, to encompass the making of art as well as the perceiving of it. Something like this was in the air even in those moments in St. James's. I was only an observer, but somehow it felt as if I were creating the object I was observing, creating it in the act of seeing it.

After a while we were out on the street again. A wind had begun to blow.

W hat brings us to these moments? Chance and desire hashing it out together in a back room somewhere? The chance part of it is what haunts the memory, my memory anyway. I wouldn't have been in England at all that afternoon, still less walking arm in arm with Marietta, had it not been for an idle choice made years before.

It was at the very end of my first visit to Europe, during the summer before my last year as an undergraduate. My petit tour, done on a shoestring, a rite of passage for countless American students. I was in London and decided to fill the vacant day before my plane left for home by making a sightseeing visit to Cambridge.

I'd been to Heidelberg a few weeks before, and it had confirmed my earlier resolution to try to get a postgraduate fellowship to study there. I had a passion for nineteenth-century German poetry and philosophy, and the romance of the town had sealed my decision. But those plans were washed away by a rainy afternoon in Cambridge, with its solemn architecture, its neat courtyards with their perfect lawns, its flower gardens along the miniature river. And at the end of that day, King's College Chapel, clouds caught on the spires, lashings of rain against the stained glass, the ceiling tracery vanishing into the gloom.

Tourist sights, all, the kind that Cambridge undergraduates love to turn up their noses at, even as they luxuriate in them. The place sent an arrow to my heart. Out went Hölderlin and Schlegel, in rushed Shakespeare and Coleridge and Yeats. The capriciousness of youth, when an impulse is embraced, and in the blink of an eye a life wheels on its axis. I resolved to find a way to spend a year as a student in this Arcadian town.

I did; then the one year stretched into six. Every morning I awoke happy to be where I was. I gulped the place down. My fellow Arcadians seemed to live a life of continual jeux d'esprit. They lived by their wits. They lolled on the grass like shepherds in a Poussin painting and turned their pleasures into droll observations.

Life was richer than before. In the afternoons I'd row in a college shell on the river, with its fierce swans and flowering banks, all the oarsmen straining for that elusive moment when eight men move as one, and effortlessly. One or two evenings a week I'd climb to a paneled seventeenth-century chamber for a session with my academic supervisor, a distinguished Yeats scholar, an Anglo-Irish aristocrat who in his youth had been a friend of the poet. Whiskey would be poured and the talk would move easily from rowing to painting and sculpture, war and salmon fishing, Yeats and Shakespeare. The old song was being sung, the fading song of European civilization. Shadows grew, cows mooed on the river meadows. Can I be blamed for not wanting to leave?

So after the Tripos examination, I stayed on to write a dissertation on Yeats and the third-century philosopher Plotinus (ca. 205–270 C.E.), the father of Neoplatonism. You'd be forgiven for never having heard of him, though he is the third great ancient philosopher, after Plato and Aristotle. I stopped rowing, stopped being an undergraduate, and started thinking hard for the first time in my life. The years went on and I noticed that I seemed to be drawing

myself ever further up into my mind. I'd embarked on a long frenzy of hard thinking. I defined myself by what I thought, not by anything my body did. There were physical pleasures enough, but they seemed beside the point.

Some friends and I rented a large old farmhouse in the wet forgotten lands north of Cambridge. One rare sunny June day some friends were swanning around the lawn, next to a field of young wheat. Marietta was one of them. I wandered over to the old iron rail fence with her. She climbed it and walked a few steps into the field, then turned and struck a pose with a green wheat ear. Ceres lording over her domain, her golden hair promising a rich harvest. Strange words from the seventeenth-century mystic Thomas Traherne floated into my head: "The Corn was Orient and Immortal Wheat." I said nothing, I did nothing, for years. Unbeknownst to me, the guide who would lead me to my profession had slipped into my life.

The farmhouse stood on the last rise before the Fens. You looked out on a level Dutch-like expanse to see little villages poking themselves out of the fields and hedgerows, one after the other, flattened by distance so that they looked like stage sets, or the silhouettes of battleships plowing the sea. Longstanton, Swavesey, Over, Fen Drayton, and others beyond, fading off into an endless expanse.

Exhausted with intellectual effort, I would look out over the fenland as over the wide world. It seemed to be receding from me just as my body was receding from me. I was retreating like a mollusk deep into its whorled shell. I grew tired even of beauty, almost. It was beginning to seem like little more than anything else that might enter your mind. Little more than another thought. I remembered Coleridge in his dejection, writing about seeing, not feeling, beauty.

I began to think that I was being stained by the subjects of my

studies: the ferociously antimaterialist Plotinus, who professed himself ashamed to be living in his body. And Yeats, who claimed that the whole world is a kind of dream that we create out of our bitter soul. I had swum far into a profound sea, out of sight of land. By the time I finished my dissertation I was desperate to swim back to shore, to clamber out of the mind and into the body again.

I went back to America, reading Kerouac on the plane. My parents thought I'd be starting the academic career I'd been so expensively trained for. But I thought of myself as John Synge heading for the Aran Islands, looking for as different a life as could be imagined. I'd been a Teamsters union member in my undergraduate days, when I took a summer job in a truck tire warehouse in South Central Los Angeles. I still had my honorable withdrawal card. This time I got jobs out of the Teamsters hiring hall in Akron, Ohio. Local 348, down on West Market Street.

I worked on beer trucks and boxcars and moving vans, in machine shops and warehouses. Pay was good and the days were agreeably free of intellectual content. I tasted the pleasure of going to bed physically tired every night. Some of my fellow workers were family men, some boxcar poets, many former high school football players. They drew me into a rollicking world, with its own wit that usually took physical form.

This is the life, I thought at the start. Then, after a while, this isn't the life. One day I found myself standing in a muddy parking lot outside a broken-down roadhouse, the sleet pouring down. It was eight thirty in the morning. I was drunk and so was my beer truck driver. The bars of northern Ohio were full of roistering workers just off the night shift. After we delivered our barrels and cases the barman would stand us a drink, and after the third or

fourth delivery . . . I looked out on the desolation as cold water dripped off my cap and under my collar. The driver was loading empty beer kegs, whistling a happy tune.

Marietta had come back to America and was working in Boston. I moved there so I could be near her, though to this day I've never told her that. I got a job making earplugs in the basement of a half-abandoned factory in Cambridge. The earplug-making machine was so loud that you had to wear earplugs while operating it. One day I was driving out to a job with another worker. Sunlight was mixing with showers, so that a rainbow formed over the bleak industrial scene before us. It vanished as we were crossing a bridge. "Where's the rainbow gone?" I asked. He looked at the oil-slicked water below. "It's floating facedown in the Merrimack River."

I went back to London. Marietta came with me. I took a job in an office, not as a quest for anything except an income. Workdays were spent thinking of days off, days off were haunted by workdays; both were empty, as if each longed for the other, for something the other could give. All the while I pondered the foolishness of pendulum swings from all brain to all body. I should have known better. There is no chariot to take you from yourself, says Plotinus.

The exquisite irony of what I'd become at Cambridge hit me. The whole point of my dissertation was to strike down the idea that my subjects were unworldly dualists. To bring them back to the world. But I myself had receded entirely into the intellectual life. I'd turned into what I was arguing they weren't. I was studying their message, but it never occurred to me that I could heed it in my own life. What business does an academic have heeding messages anyway? The critic's job is to analyze and interpret, for heaven's sake, not to act out the implications of the text. Keep your private

life to yourself! I'd locked myself away in the academic guild and hardly thought to question its rules of objectivity.

Yeats would have shaken his head at this and told me to start thinking in the marrowbone. And even Plotinus, as I conceived of him, might have been on Yeats's side. Plotinus, with his notorious contempt for the body. I'd forgotten that what drew me to him in the first place wasn't, at heart, the lure of his philosophy. I was attracted to him for the same reason that many of the poets and artists I admired had been. Michelangelo, Milton, Poussin, Coleridge, Yeats, Pound: all were moved by the beauty of Plotinus's expressions, his sudden flashes of vision—the sense of great doors suddenly flung open, as someone put it. And by his metaphors. Trying to describe the intensity of his intellectual experience, Plotinus turned to vivid analogies from the realm of the senses. The world of the Platonic Forms isn't a marmoreal Greek sculpture gallery; it's boiling with life, he says, an overflowing fountain of beauty. Or: soul isn't in body; body is in soul, like a net in the sea, stretching out but unable to contain it.

The poets' and artists' Plotinus is a man who doesn't want to escape from the senses so much as plunge more deeply into them, to an unimaginably rich world within. Artists like the plunging part. Yeats wrote a magnificent little poem about Plotinus swimming through the tumultuous sea of life, the salt blood blocking his eyes. The artists' Plotinus seems to telescope together sensory and intellectual experience, and reveal a world of transparent luminousness. In the years after I picked up a woodcarving chisel, I would come to find an even more fundamental reason for artists' attraction to the philosophy of Plotinus. I'd grow to think of him as—how can I say this?—the lord of the workbench.

As for Yeats, what made me dream that he was any kind of immaterialist? He may have tried to sail to Byzantium in old age,

away from his tattered body to a realm of ageless intellect. But he could never leave behind the sensual music of the physical world: the young in one another's arms, Crazy Jane with her carnal wisdom, Holy Joe the beggar man singing his penance on the roads of Ireland.

In the end Yeats rejected the dualism of mind and body, in favor of what he called Unity of Being. Why hadn't I understood the full meaning of this? It's all in a beautiful passage from Yeats's prose that I've had tacked up above my desk ever since my earliest days in Cambridge. In it Yeats invents another Byzantium, an idealized version of the sixth-century city where, for a moment in history, just such a unity of being is possible. In this dream place, Yeats conceives of going into a little wineshop and finding "some philosophical worker in mosaic" who can answer all his questions, because the supernatural descends nearer to someone who works with his hands than it does to Plotinus even. The delicate skill of this anonymous craftsman allows him to turn a vision or an idea into "a lovely flexible presence like that of a perfect human body." Into art, that is to say. For Yeats such skill embodies the unity of mind and matter—embodies it in the work of art, and embodies it in the very process of making the art.

There it is above my desk still, a little yellowed now, that sheet of paper with Yeats's words. They figured strongly in my dissertation, but at the time I was too timid to let them speak directly to my own life. On the other hand, can you marinate for years in ideas about unifying the head and the hand, without it having an effect? Somewhere Coleridge uses the analogy of a caterpillar feeding on a leaf until it turns green. Despite myself, I'd been primed for what happened that afternoon in St. James's, when I stood before a Gibbons carving and saw it in a way that I'd never seen anything before.

But old habits aren't easily cast off. I assumed my interest in Gibbons was an academic one. The idea of becoming any kind of artist or craftsman myself never sullied my thoughts. Long ago I'd been shown my station in life. I was ten, and my school art teacher, no doubt thinking to inspire her students' creativity, put on a phonograph record—Grieg's Peer Gynt Suite, as I recall—and asked us to draw whatever came to mind. To my mind came a vision of a waterfall half hidden in a jungle. I drew it with rare verisimilitude, my pencil flying over the paper. I took my work up to the teacher's desk. Astonishment silenced her for a moment. Then she brightened. "I see what you've done. You haven't really drawn a picture *of* anything, have you? You've let yourself dream and put down lines that express that. I can almost see the music here. You've done something very important. It's what we call abstract art. Class, look at this!" The door of the palace of art slammed shut. I was in the dry land outside, among the critics.

No, I'd thought that at St. James's the gods had been kind enough to give me a new subject, and that I should do what I'd been trained to do: write a scholarly book about Gibbons. I went to libraries and began my research, taking notes like the good student I had once been. Three-by-five cards were filled and arranged. I formulated hypotheses, worked out a narrative, thought up some vivid turns of phrase. I was back in my room at Cambridge.

One day it occurred to me that you couldn't fully understand how Gibbons developed his style unless you understood something about his tools and his medium. I made a note to try to find an art historical study on woodcarving techniques. In the meanwhile, just to divert myself, I thought I might as well get some chisels and wood and see what carving felt like.

Just to divert myself. No sooner do I write that phrase than I know it's false. I was being borne toward carving by a tide stronger than I could control, a tide made up of all that I'd thought and read and experienced in the years before. Writing a book wasn't going to answer to it. More than the mind needed to be deployed. And this was the turning point, for me: not the epiphany in the church, but the decision to try the tools of the trade.

Fate is in the before and after. Before the bolt strikes, something charges the atmosphere, some long foreground of decisions and actions. And the sudden flash doesn't always light up a clear path forward. But if you read the portents right and set your trajectory accordingly, fate and desire seem to come together, life swerves, and what happens after looks like what was always meant to happen.

In one of his poems, George Chapman, Shakespeare's contemporary, compares time to a pollinating honeybee and the world to a flower garden, declaring strangely that "time's golden thigh upholds the flowery body of the earth." He explains that when we use time correctly it brings harmony and legitimacy to life. The verse ends with an aphorism: *"The use of time is fate."* The phrase is inscribed on my workroom door. It's in front of me now, in the flickering sunlight glancing off the river. The Use of Time Is Fate.

In the verse I quoted in the last chapter Yeats says that you have to accomplish fate. *Accomplish* fate? Isn't fate, by definition, exactly what's beyond human accomplishing? The mind tells us that Yeats's words are an oxymoron. Another part of us feels otherwise, feels that if you use time correctly then somehow you're harnessing the forces of destiny. What fate proposes, you can bring to pass.

As if you were fate's deputy. The idea gleams with danger. In politics and religion it can be viciously delusional. An instrument of power to princes and clerics, a murderous madness in the mob,

says Yeats, in his passage about Byzantium. But today, as I sit in the wintry sunlight and let my mind stray, it occurs to me that the sense of being fate's agent might be part of the making of every piece of art. The making of anything, maybe. Idea in mind, brush or pen or chisel in hand, you begin to fancy that you're creating something that was meant to exist, that exists before you make it. Perhaps in the end you feel that way about the life you make for yourself, too.

I bought a dozen presharpened woodcarving chisels. They're still on my workbench, simple laborers amidst the older and more sophisticated brethren that joined them as the years went on. The first chisel I ever held in my hand I still use every day, a no. 6 Henry Taylor gouge with a slightly uncomfortable round handle. I remember taking it out of the box and picking it up for the first time, rotating it back and forth, looking at it front and side, and admiring its utter simplicity of form. Essence of tool, it seemed. Only two parts to it: a wood handle and a steel blade. It came to me for the first time that "handle" must derive from "hand." The part of a thing that's made to be grasped by a hand. A carving chisel's handle is made of wood, organic like the hand itself, warm to the touch, and often constructed with facets that make it pleasant to grip.

Then there's the other end of the tool, made of sterner stuff and designed to impose its will on the world. A shank of steel. The nearer end is a tang, embedded in the handle. Just where the steel enters the wood, it has a shoulder, to stop the tang from digging in deeper during use. Often, too, there's a ferrule around the wood here to keep the handle from splitting. The other end of the steel shaft turns into the blade, the business end, the menacing purpose-

ful edge that does the work. Only a few woodcarving tools have flat blades like carpenters' chisels. All the rest are curved, with shapes that run the spectrum from wide flat valleys to narrow U-shaped defiles. Properly they are called "gouges."

Odd, I thought, that the handle is only large enough to accommodate one hand. Maybe woodcarving chisels were originally designed to be used with a mallet, and have retained this one-handed form. But I was pretty sure that woodcarvers—especially those who work with softer woods like lime—spend most of their time without a mallet, plying the tool with their hands alone. And because the wood is clamped to the bench, this isn't like whittling, where one hand holds a knife and the other the material.

But if you're going to hold the chisel in both hands, then where does the second hand go? Why hadn't they made the handle long enough for two hands? I tried putting one hand on top of the other. That way both would be on the handle, in some sense, and they could exert their strength together. But this was like driving a car from the backseat. There was plenty of power, but the blade kept skittering off the wood. It didn't work, pointing the tool from the rear and using the power of both hands not only to propel the blade but guide it, too.

Instinctively, I shifted the top hand forward, grasping the steel shaft itself, in front of the other hand and close to the blade edge. Instantly I gained control over the chisel. Again and again I dug shallow experimental valleys in the wood. Other revelations came. That front hand on the blade now had ceased to provide propulsive force for the chisel. Quite the opposite. The rear hand was providing all the power, and the front hand was actually *resisting* that momentum. In fact this was exactly how I was controlling the blade: one hand pushing against the other. When the muscles were pitted against one another in this way, the chisel edge moved with preci-

sion and power. The greater the tension, the more delicate the command over the blade.

What kind of principle was this? That only when the body is at war with itself can it control the chisel? Out of the quarrel with ourselves, says Yeats, we make poetry. Out of a muscular quarrel with ourselves, then, we make a carving? It reminded me of Hamlet, bitterly divided within. One part propels him toward revenge, and another part restrains him from action. Nonetheless, whenever he appears he is the most commanding presence on the stage. Others have to adjust their trajectory when they encounter the internal tectonic pressures that impel Hamlet. He's the lord of the action. Though it may destroy Hamlet physically, the world is no match for his coiled power. The edge of his character cuts through every circumstance.

I'd discovered the principle of dynamic tension that's at the heart of the act of woodcarving. Dionysus grapples with Apollo. Why stop there? The propulsive hand: id, body, will. The restraining hand: superego, mind, judgment. The propulsive hand always wins, or there is no carving. The chisel moves forward to do its work. But not before its primal energy has been reined in by the constraining hand, chastened and given a tincture of purposeful intelligence.

There's a third player, too. As beginners often do, I started by holding the chisel above the wood so that only the blade touched it. As if it were a house painter's brush. Or maybe a gardener's shears. But muscles alone, even tightly arrayed against one another, cannot control a carving tool when the hands are floating in the air. The blade continued to either dig in too deep or skitter over the wood. Often, when the chisel slid out of control, my forward hand and wrist would cuff the edge of the wood violently. After a while trails of blood appeared on the carving.

I'd discovered that woodcarvers are like Antaeus, the mythological giant whose strength comes from his mother, the earth, and who is defeated when Hercules breaks that contact by holding him aloft. The heel of the carver's restraining hand must rest on a ground. A stable surface. Sometimes this is the workbench, often it's the work itself—wherever a firm anchor can be found. Faced with the power of the propelling hand, as strong and unruly as desire, the restraining hand finds its ally in what is stable and unmoving.

It's a beginner's error, the idea that you can operate while floating above the world, in some ether of strength and desire and inspiration. Years later, after Hampton Court, Marietta and I rebuilt a blue wooden barn here on the banks of a river winding out from the Adirondacks, and made it our house. It's where I carve and where I'm writing this now. The bedrooms are in the milking parlor, on ground level. Above is the hayloft, which on the inspiration of Hampton Court we turned into the *piano nobile*, the main floor. As at Hampton Court, there's an enfilade passage from one end to the other, alongside a bank of floor-to-ceiling windows. Here a rustic William III might walk, floating contemplatively above the earth, surveying his demesne from a height.

The analogy is laughable, and of the thousand dissimilarities between this place and a palace, the most important for me is this: there's a barn ramp that slopes up to the main floor. Our *piano nobile* hasn't lost its connection to the earth. You enter it up a hay wagon ramp. There's no grand staircase. Never mind climbing away from the world on the ladder of art, never mind Yeats's ladder out of the rag-and-bone shop of life. You can walk up to my workroom with mud on your boots.

A world that might allow such a life beckoned me, that first afternoon I held a chisel, like a half-glimpsed land of endless prom-

ise. The muscular motion of carving seemed athletic and deeply pleasurable. I'd intended to carve while sitting, as if this were like writing or reading or some other intellectual endeavor. But I was forced to my feet, and I found that as the blade moved through the wood my whole body moved, too, with it and against it at the same time. A wave of pleasure passed through me. The genie was out of the bottle, never to return. The windows blew open and a wind scattered my three-by-five cards to the four corners. The book on Gibbons was written eventually, but that was years later and in another world.

The plane on its final approach to Heathrow now. I moved across to a window on the left, to try to catch a glimpse of Hampton Court, off to the south. I could see a smudge of parkland on a turn in the river, but before I could pick out buildings I was scolded back to my seat by a flight attendant.

Never mind. I could picture Wren's palace standing there, empty and scaffolded. And within it, amidst his broken and singed carving, the specter of Gibbons. The other Gibbons. Not the man but the carver, the daunting technician. The wraith who guards his work, clinging close to it like an emanation. In a day or two I'd be walking into a sanctum of his carving. He'd take up one of his viciously sharp gouges, and turn to face me.

❧ *Leonard Knyff*, Hampton Court from the East, *circa 1712.*

If the Fool Would Persist in His Folly He Would Become Wise

G ibbons in his lair, drawing a blade on me. I was a little overwrought, that morning of our arrival in England. In the three years since the fire, I'd made two preliminary visits to Hampton Court. Each left me perplexed. Enigma after enigma, in those ruined chambers, one resolved only to be replaced by another. I'd opened a book onto a text that sometimes seemed corrupt, sometimes written in a dialect I couldn't quite comprehend.

My first visit had been on a chilly October afternoon, six months after the fire. I took a train southwest from Waterloo through ever leafier neighborhoods. After a while we jutted north toward the Thames, and suddenly Wren's palace rose up across the river, like a leviathan riding the tide offshore. An orangey red factory for the production of kingly pleasure and the extolling of royal power. The mirage vanished behind trees and suburban houses, but in a minute or two the train halted at the end of the line, Hampton

Left: Grinling Gibbons, overmantel (detail), King's Drawing Room, circa 1699. After the fire but before conservation. © *Crown Copyright. NMR*

Court Station. I walked over the bridge and made my way through the great sixteenth-century gatehouse into Henry VIII's part of the palace. A bluff guard showed me on to the elegant little Banqueting House built for William III at the very edge of the Thames.

The ground floor had been transformed into a temporary architectural office. Drafting boards, drawings pinned up on the walls, pieces of burnt timber lying on shelves. A huddle of people in a corner. Out from it came a smiling man of about sixty, handsome in a comfortable sort of way.

"David? A face to go with the voice! For both of us. Mike Fishlock."

Alert icy blue eyes. Maybe not so comfortable after all. It occurred to me that this was a man whose life had been transformed overnight. He'd gone from a sleepy maintenance architecture job, at the end of a career, to overseeing the biggest restoration project in the country. I wondered if he'd had his own bureaucratic battles along the way.

Introductions and pleasantries, then he and I walked through a still exquisite fountained garden to the ravaged shell of Wren's South Wing. A door opened and I found myself in a Piranesi-like scene of scaffolding and catwalks and dizzying vistas up through charred timbers and missing ceilings. Soon we stood high on a teetering platform, and for the first time in my life I found myself inches away from a Gibbons carving.

I'd been commissioned to survey the damage to the surviving work, write a catalog of needed repairs, and suggest a guiding philosophy for the carving restoration project. Should prefire damage, of which there was plenty, be repaired along with the fire damage itself? Should gaps in the work be filled where there was nothing to indicate what had been there originally?

In the past such scruples never ruffled the glassy pond of Gibbons

restorers' minds. Something missing? Carve a nice flower and glue it in. Never done that sort of thing before? Now's your chance. Since damage most often occurs in forward elements, the consequence of this approach was that grotesquely inferior later work now occupied pride of place in many Gibbons carvings.

I'd already decided to argue for a simple principle: no speculative carving. Unless a missing element was either documented by prefire photographs or clearly indicated by the surviving carving around it, it shouldn't be replaced. This would hold for that lost drop, too. Nothing should be invented to fill in voids that appeared in the prefire photograph.

Standing there on the scaffolding with Fishlock, I wasn't thinking about conservation philosophy. I was hardly thinking at all. In front of me, in the flesh, close enough to touch, was a passage with arching tulips and crocuses I'd particularly admired in photographs. A giddy air of unreality gripped me, as if I'd been ushered into the presence of a famous person and was still seeing through the glass of a familiar image. "Amazing to be so close. Really something. Actually seeing these things." Tongue-tied.

I reached out. Touched. Held a stem between my fingers. *Nice to meet you. It's such an honor.*

These stems, I was thinking, are much more solid than they seem. It's all part of Gibbons's illusionism. I'd never really believed that old story about the flowers in his window trembling when carriages passed. A little wiggle will reveal in a trice that a stem like this is nowhere near as delicate as it appears.

At first pressure, a quiet snap. Gibbons's twig came away in my fingers.

Aghast. Suddenly glazed with sweat. A cold trickle down my back, as if a sponge had been squeezed. Fishlock swiveled his head away from the carving and fixed me with a steady look. "Yes, the

work is very delicate." He reached out himself and touched a neighboring stem. It, too, broke away.

Wordlessly we laid our twigs back in the thicket of vegetation, for a conservator to glue back in place in the coming months.

What had I been thinking? There was no earthly reason for me to touch the carving. First *do* harm—was that my oath? I'd broken a Gibbons carving and every rule in the conservator's book. True, I wasn't there as a conservator. It wasn't in my brief to restore the old work. No decision had been made yet about replacing the missing drop, so I wasn't even there as a carver. But I was someone who was meant to understand seventeenth-century foliage carving.

Not a day but something is recalled, says Yeats, that conscience or vanity appalled. Conscience and vanity both, in this case. For years the memory of that quiet snap could put me into a sweat. Sometimes I saw my little sally as an affectionate gesture gone wrong. Other times I imagined it an act of repressed aggression (*Who's boss here now, Gibbons?*). Now I look back on that broken twig as the casualty of a greedy desire to make the carving yield up its secrets as quickly as possible. It was my first sight of the terrain I was intending to occupy. I couldn't forbear to send out a quick probing sortie to test whether its physical reality corresponded to my ideas about it. Gibbons's retort was swift and short.

What consolation was there? I remembered the lesson I'd learned from my own work, long ago. Breakages are powerful pedagogical devices. If you penetrate the bitter rind of these disasters, you can relish them for the instruction they provide. That sickening snap is a cry from the wood: *Don't do this! Do you think you can get away with it? You don't understand me.* The wood is teaching you about itself, configuring your mind and muscles to the tasks required of them. To carve is to be shaped by the wood even as you're shaping it.

It was one of the elementary lessons I'd begun to learn in the first months after Marietta and I had fled London. That rose-embowered house in the Downs had only one room with a permanent heat source. Perforce, with its little coal stove, it became our workroom. The thick stone walls made for deep-set windows with large sills, which we extended and turned into work surfaces. Marietta restored Derby and Delft and Staffordshire ware in one window. Like Gibbons in his cottage in Deptford, I carved in the other. We looked out past the circle of elms to the old flint barn and the walled garden in front of it. A sentinel pair of old trees, a sycamore and a horse chestnut, stood beside its iron entrance gate.

We had nothing. No car, no television, no money. We had everything. I grew vegetables and brewed beer. Blackbirds and thrushes sang, and nightingales, too, on umbrageous June evenings, their songs sometimes mixing with the faint foghorn boom of the Channel lighthouse off Beachy Head. And always, the sense that we were living at the edge of a great solitude, an empty world of forest and downs that rolled on for miles beyond our valley.

Marietta had apprenticed with a Dickensian china repair firm in London and later taken a job with them. She knew what she was doing, but for me the workroom was a classroom. I couldn't find anyone to teach me to carve in the style of Gibbons, not even in London. There was no community of carvers, no guild. Only a few scattered conservators, a few makers of reproduction Chippendale mirrors. But new work in high-relief limewood? The tradition was dead as a doornail. I was on my own.

So my instructor was trial and error, an exacting master whose teaching methods involved the cracking of wood and sometimes the spilling of blood. I learned that long grain was strong, short grain weak, end grain tough, and that the attack of the blade had to

be adjusted to the configuration of the grain it was cutting. I learned these things the way a carver has to learn them, in the muscles and nerves. There was plenty of feedback from the wood. The air was filled with its reports.

To transgress limits is to define them. Blake says that you never know what's enough until you know what's more than enough, and so if the fool persists in his folly he will become wise. A dangerous strategy for airline pilots or surgeons, perhaps, but a method of learning for all that. Usually an inadvertent one, adopted by children and beginners.

On the Hampton Court scaffolding I was a beginner again. This time the crack of wood taught me about the special frailty of Gibbons's carving that comes with its age. Summer had turned to winter and back again three hundred times, ceaselessly expanding and contracting the wood. A witches' brew of fungal or microbial or beetle infestation had laid siege to it. Sometimes, to "feed" the wood, destructive coatings had been applied by deluded caretakers. All these abuses had conspired to produce a stem far more brittle than a stem I'd made in my workshop a month or a year before.

There's more than that. Even in the vigor of their youth Gibbons's carvings flirted with danger. When I scrutinized closely the sprays of flowers and foliage before me, I could see that they were more radically undercut than I dared to venture in my own carving. They danced at the edge of a precipice. In Badminton House I found a Gibbons overmantel that has what seems to be insect damage to two leaves. He's beaten me even to this, I thought, when I first saw it. (I'd been incorporating insect holes in my leaves for years.) But closer examination revealed that those perforations were unintentional. The leaves had been undercut from behind so zealously that in several places the gouge had broken through the front surface. Always on cliff's edge, even the mature Gibbons.

At my own workbench I slowly graduated to different kinds of mistakes. The quality of my errors improved. I learned how to move toward the danger point, then stop short. And pitch my tent there, because that was the territory where I, too, wanted to operate. The edgy place Gibbons inhabited, where the medium is understood and respected but pushed to its limits.

Now when I break something the wood is usually sending a different message: the problem here, it's saying, isn't your technique but your design. The composition you've drawn asks too much of wood, no matter how adept you may be with a chisel. You've persuaded yourself that a spray of leaves has to arch across the grain just so, because it answers to that other spray over there, or because it adds richness to effect, or simply because it's beautiful; but an aesthetic triumph can't change the temperament of wood. When writers use similar arguments to justify an unneeded beautiful sentence, editors famously tell them to "kill their darlings." If you're a carver, the wood sometimes kills your darlings for you.

Breakages that come from the folly of bad design can also lead to their own kind of redemption. Not just by inspiring improvement over the long term, but even in the minutes immediately after the damage is done, when economic forces are bearing down and there's no question of abandoning the work. (If you carve for a living, you can't afford to start over again.) You can take out the glue and hope for the best, or you can exploit the new dispensation that your error has created. Disaster allows nature to take control, to create its own order. Disaster can be a fine designer. Better than pencil sometimes. It can lead you to safety.

So instead of gluing a broken petal back on, it's often better to discard it altogether. Just leave that beautiful sentence out. (Sometimes you have no choice in the matter: maddeningly, the petal or twig has flown off and disappeared forever into the chaos of wood

chips at your feet.) You simply leave the gap, which suddenly turns into a welcome breath of air. An injection of realism, the kind of damage that might happen to a living plant in the real world. Or you can carve a new petal out of the wood that's left. Since what's left is often little more than a nub, the petal usually has to be twisted back, or set on an angle, or otherwise contorted. What results is almost always livelier than the petal you'd had in mind. A breakage is a little thunderbolt that upends the intended order of a design. Form that follows failure incorporates the random mishaps of life, to the carving's advantage.

Another thought occurred to me as the prospect of carving at Hampton Court loomed closer. If bad design is associated with structural weakness, then good design should consort with structural soundness (at least until the wood grows aged and frail). Gibbons's compositions could show me how to exploit the qualities of limewood, to their limit, in my own designs. The flame flared up again, on that first visit, the yearning to be the carver who replaced the lost drop.

Fishlock climbed down the scaffolding, leaving me alone in the echoing room. I kept my hands off the carvings, but my eyes wouldn't leave them. An hour sped by. How exotic these forms were, seen from here rather than from fifteen feet below and away. The modeling was minimalist in some places, exaggerated in others. Flowers and fruits seemed overscaled and strangely oversimplified in places. Tulip petals could be six or seven inches long. But how decisive the carving, how fine the edges, how vast the airy gaps between elements, how scrupulous the excavation even in places that seemed impossibly narrow and difficult of access, how strong the surface veining, how simple the accenting gouge cuts,

how subtle the undulating reverse curves. I wandered through a strange land, puzzled and exhilarated at once. The carving was cunning in ways I didn't understand. I couldn't quite read the text.

And what was this heavy coating on the wood? The comments of his contemporaries make it clear that Gibbons left his work plain, without any applied finish. But the Hampton Court carvings were slathered with something that looked like colored wax. What was it? How long ago had it been applied? What was the wood like underneath? On the principle that the work should be restored to its prefire appearance, should this charmless yellowy brown coating be reapplied after the conservation?

After a while Fishlock reappeared and I clambered off the scaffolding. We made our way down to a morguelike chamber on the ground floor that held carvings too damaged to be left on the wall. These were mostly pieces from the King's Drawing Room, where the destruction had been the worst. Where the missing drop had once hung.

As we walked down the stairs, I went over in my mind what I knew about the carvings' arrangement in the palace. The Royal Apartments follow one upon another in a crescendo along the south front, the carved decoration growing in sumptuousness with each successive room: First Presence Chamber, Second Presence Chamber, Audience Chamber, King's Drawing Room, and King's Bedroom, as they were then called. The centerpiece of each room is an impressive overmantel carving above the fireplace. Each of the rooms has two doors, and over each door is a painting flanked on each side by a carved pendant. I got in the habit of calling these by their less formal name, "drop." Thus there are four overdoor drops in each room. Each of them is fully seven feet long, but in the architectural scheme of things they are subsidiary carvings.

So, the coordinates of the lost carving: south front, King's

Drawing Room, west door, left-hand drop. Fishlock had found the fifty-year-old glass plate, which owed its existence to a momentous crisis. In 1939, when German bombers were about to wreak havoc on London, there was every reason to think that well-loved historic buildings would be among the targets. At Hampton Court a saga-

☛ *The lost carving. Left-hand drop, west door, King's Drawing Room. Glass plate photograph, 1939.* Reproduced by permission of English Heritage. NMR

cious civil servant, his name now lost to history, ordered a photographer to mount ladders and hurriedly take pictures of the carvings, to preserve some record of these masterpieces of Gibbons's final phase. The palace survived unscathed, but it was now serendipitously endowed with a precious set of archival images.

The glass plate image was the salvation of the lost carving, but it was also underlit, blurry, and in places difficult to decipher. The small print I'd been sent a few weeks before revealed little about the projection of the piece, the heights of its hills and depths of its valleys. But I was about to see the companions of the lost drop, which I hoped would flesh out the photograph with more information. I needed to know more about the meticulousness of its modeling, the fineness of its detail, the scrupulousness of its undercutting. If these overdoor drops were only handmaids to the room's kingly overmantel, to what degree of refinement had Gibbons taken their carving?

Through the low door I followed Fishlock, into an unprepossessing little storeroom next to another that was being used as a cement-mixing site. Amidst the dust and ever growing gloom— for the clouds were lowering and a premature sunset seemed to be imminent—six or seven plywood coffins could be seen. Some were twelve or more feet long. The coffins of titans. A workman began to unscrew their tops, one by one. Within lay the poor scorched and besmirched forms, some merely smoke- and grime- stained, others partly charred to cinder, others missing large sections altogether, with only a kind of lighter shadow on the oak backboard to show where carving had once been affixed.

Of the three surviving overdoor drops from the King's Drawing Room, the most important would be the right-hand one over this same west door—the surviving companion of the missing left-hand drop. Unlike the pair over the east door opposite, which were relatively unscathed and so remained mounted on the wall, this

survivor had sustained severe damage to its top section, and so had been taken down and laid to rest in its coffin.

Off came the top. I stood back for a moment as it was taken away, then walked over, crouched down, and peered in. There was a chance I would see something like the relatively low-relief over-doors of the First Presence Chamber, but it took only a glance to know this wasn't the case. Some of the deeper-level carving seemed a little flat, to my untrained eye. But the prominent elements, the elegant blossoms and fruits and curling leaves of the forward layers, were modeled with extraordinary fluency and decisiveness. They showed a breathtaking delicacy of undercutting, and an almost sur-real three-dimensionality. I hardly knew where or even how to look.

That didn't stop me from wandering into realms of speculation. Did Gibbons himself do this fine forward modeling, leaving to his assistants the less obvious parts? Even so, it would have meant weeks of work for him. Did he have undercutting specialists? Maybe there were tulip specialists, or peach specialists, or flower-rope specialists. How could he set them to work independently but still fit everything together at the end? How many separately carved pieces were there in this drop, anyway?

A tidal wave of fine carving was breaking over me. Wherever I looked, man-years of carving stretched away into the gloom. Like everyone else, I was accustomed to using the name Gibbons as shorthand for the man and his assistants together. Now the reality was flooding my consciousness: this really was a workshop opera-tion on a grand scale. And the workshop's role in producing subsid-iary pieces—the missing drop, for example—would be particularly important to understand. How did Gibbons manage to imbue his assistants with his intentions, and with skills nearly equal to his own? Could he do the same for me, from the grave?

Hypotheses about Gibbons's carving techniques and workshop

methods raced through my mind. I wiggled every twig of explanation, formulating theories even before I'd taken in what was in front of me. The fool launched onto his follies, trying to pluck the heart out of Gibbons's mystery all at once. On the other hand, didn't Charles Darwin, who confronted many an unexplored world, claim that there's no good observation without speculation? On that principle, the wise man is the fool who persisted in his speculations until one of them clarified what he saw before him.

I was right, anyway, to be excited by the virtuosity of the carving. Subsidiary though they may have been, these were fully realized pieces of sculpture executed by formidably skilled carvers. And yes, the forward blossoms were the equal of anything in the great overmantels. They bore the prints of a masterly hand.

At the end of the afternoon, lost in thought, I walked back out through Henry VIII's gate. The sun had dropped below the clouds and rested on the horizon, casting an alpenglow on a long ridge of clouds that had reared up over the river. The eastern scarp of the Sierra Nevada, forming and reforming, drifting off toward Twickenham. Magnificent, but if there was a pathetic fallacy on offer here, and my spirits were meant to rise, then they weren't obliging. A malaise had come over me. It wasn't chagrin at the broken twig. Rather it was a sense that something was amiss in this treasure house of carving. Out of place. I couldn't put my finger on it. *Just as well*, the ghost of Gibbons might have whispered.

The day after that first visit to Hampton Court, I flew back to New York, then took the train north into the teeth of the advancing cold. Autumn had burned down to a few embers in the red oaks above the Bass Pond. Fishermen gone, dirt road empty, hills lonely. Geese honking, bucks scraping. Fading goldenrod and

aster and ragweed, ferns turning brown, sumac staghorns red. Waste meadows the color of old tapestry, the dusty mustard that sets the hearts of hunters alight.

Hampton Court was fresh in my mind when I went back to my workbench next morning. Before picking up a chisel, I stood with my hands on my hips, looking at the nearly finished carving in front of me. My eyes had been washed clean, and what they saw made my spirit sink. No bravado, no haughty boldness of projection, no death-defying undercutting. Tastefully subdued surface modeling, rather than stormy swells and hollows. Bernini once boasted that he could handle marble as if it were dough. Gibbons seemed to be modeling his leaves out of a similarly pliable substance, shaping it with his fingers. But my leaves? Clearly carved out of something hard, with a chisel. And there were other differences. Thick single stalks, rather than Gibbons's fine thin stems arranged in pairs and triplets. (Of course! Those duplications of stems reinforce one another, not only structurally but visually.) Before me were timid lonely passages instead of a large fluent design. The carving lacked confidence in its style. Let's just say it: it lacked style. It shrank back in embarrassment as the flâneur Gibbons strolled by.

I stared out my workshop window. Garden, field, meadow, an orchard in the distance. I'd wanted to bring everything out there into here. I put flowers on my workbench as models. I copied nature more literally than Gibbons. But my carving didn't have the life of nature in it. His unrealistic flourishes somehow made for realism. I'd sensed this phenomenon before, but never had it so vividly demonstrated to me: even naturalistic limewood foliage carving doesn't reproduce nature but translates it. It's as artificial as any other style.

How could I imagine that literal reproduction could be my goal anyway? After all, limewood is a monochrome medium. There are no colors. You could never deceive anyone into thinking they're

looking at something from the real world. Trompe l'oeil? Not at all. The eye isn't deceived. It knows perfectly well it isn't looking at a real leaf. Eye and brain understand the rules instinctively, and they throw themselves into the game. Watching a black-and-white film, you don't spend time wondering what color Humphrey Bogart's shirt is.

As artificial as any other style. These days I tell anyone who'll listen that if you carve a leaf with holographic accuracy it looks like a wooden leaf. You need to introduce a series of selective exaggerations, which acknowledge the wood medium and render the leaf in that new language. At this point, if someone were to show me a leaf like one of those I saw on my workbench that day, I'd give them blunt physical advice. I'd take a U-shaped gouge and cut brutal arbitrary transverse gullies in it. I'd tell them to smooth those out and see how the leaf looked then.

Gibbons's con brio flourishes aren't embellishments, they're necessities of his style. With color drained away, form takes center stage, and to succeed in its role it must don a theatrical costume and aim for heightened effects. Don't actors have to work up the mannerisms that make them seem as though they're not acting? Isn't Shakespeare's language about as far from ordinary speech as can be, and doesn't that high talk somehow establish a deeper connection to human experience? Hyperbole in the service of naturalism. I began to hope that I was starting to break Gibbons's code, and penetrate the visual idiom I'd found so perplexing.

As I stood there, looking over my timorous carving, any last hesitation about that Faustian bargain fell away. I longed to turn myself into Gibbons for a while. Perhaps the old academies were right after all: don't learn by copying nature, copy art. It's not that nature gets it wrong, it's that good artists show you how to get nature right. They know what changes you have to make to a thing

to make it look like itself, but in another medium. What a chisel has to do to make marble flowers look like flowers, what a paintbrush has to do to bring a face to life in two dimensions. No matter what direction you take later, imitating the best work of your betters makes a good beginning. Maybe my eighteenth-century motto got it backward. Don't imitate Homer, imitate the *Iliad*.

A few days passed. Autumn was decaying into winter. The sun, tardier every morning, fought retreating skirmishes with the frost. Cold had light by the throat. I started carving again, to the gratitude of my long-neglected muscles. My carving style didn't change. I still didn't understand Gibbons well enough to steal from him.

On the last evening of that October, the niggling dissatisfaction I'd felt at Hampton Court finally got the better of me. What was it exactly? I downed my tools and spread out on my drawing table the recent photos I'd brought back from London. I took out the glass plate image of the missing drop and placed it next to the picture of its surviving companion. A startling discovery was at hand.

The outlines of these two drops were probably sawn out at the same time. It's a decorative carver's trick. You draw the outline of the design onto a board and saw it out. Then you flip that sawn-out piece over and place it facedown onto another board. You trace out this (now reversed) piece onto that second board, and you saw out that second outline. The profile of each drop is then the mirror reverse of the other. (Or you can fasten two boards face-to-face, draw an outline of the design on one, saw out the shape through both boards simultaneously, and then turn one board over.) The ploy works even if the content of the pair of carvings is different, as it always is in Gibbons's designs. The bulge in outline that is to be a peach in one of the carvings can become, say, a peony in the other.

This is a version of the age-old "counterproof" method of design, where the left half of a composition is drawn with greasy chalk and the paper then folded over and pressed down, transferring the design with perfect symmetry. The fact that Gibbons used such a method would make the replacement carving somewhat easier to design. One would need only to trace the outline of the surviving drop and make a counterproof reverse for the new piece.

But something was wrong with what I saw on the table in front of me. There was no reversal of design. The two photographs showed carvings with the same outline. Both the shape and the internal flow of the carvings duplicated rather than mirrored one another. The foliage on the left side of the surviving right-hand drop configured itself quite closely to the straight edge of the picture frame it flanked; on the other side it arched out irregularly away from the picture. But the missing left-hand drop had the same shape exactly, with the foliage now arching *toward* the frame rather than away from it. It was another right-hand drop, but placed on the left side of the picture.

Now I understood the malaise I'd felt earlier in the month. I'd obsessively studied the archive photograph of the missing drop. I'd practically memorized the carving. When I looked at its partner in the flesh, there welled up a deeply unpleasant feeling of duplication. Now that I'd put the two photos side by side, it was like seeing double. Or looking down and discovering you were wearing two right shoes.

There was something spine-tingling about this revelation, that dark All Hallows' Eve. One day three centuries ago, while Iroquois and cougars walked the riverbank outside, a carver in a busy London workshop forgot to turn over a board. What other explanation could there be? And now the real question: should Gibbons's error

be corrected? Yes, I thought. Yes. The fiery hand of fate had snatched up Gibbons's only mistake. A lightning strike if ever there was one, and it could be turned into a felix culpa. The missing piece could be carved in reverse and the error rectified.

Suddenly a knocking on the door. A troop of rural goblins and spooks. *Trick or treat!* After they left, I stared out into the darkness, conjuring up a ghostly outline and then mentally reversing it, again and again. By Christmas I'd written another article, describing this surprising turn of events. We should look beyond the principle of returning things to their immediately prefire state, I argued. Gibbons's usually steady hand had slipped this one time, and a serious visual flaw had resulted. If we mustered our courage and allowed ourselves to be guided by the artist's intention, then we could rescue Gibbons from his error.

It made for a good story. But have you heard? The illumination from a lightning flash isn't to be trusted. Before spinning out this tale, I should have looked harder at the Hampton Court carvings. All of them, in the full light of day.

The puzzle of the backward carving didn't finally resolve itself for several years. We need to leap forward again, to the day we arrived in London to take up residence as the carving project was beginning. The flyover of Gibbons sites had ended. We'd landed at Heathrow. In the bright morning sun Marietta and Flora and I made our way to Hampstead and the furnished flat on Christchurch Hill we'd rented for the year. Hampstead, London's hill town. Bohemia in heaven. Bohemia with money. Thoroughly gentrified except for a few redoubts, one of which we were inhabiting. Asked for a description of the flat's kitchen, the previous resident said it was the kind of room where you don't have to get up from the table

to take the milk out of the refrigerator. But there was a grand piano in the front room and views over leafy gardens.

Across the street was a Georgian pub, and around the corner from it, the house where John Keats once roomed with his brothers. Several doors down, Constable's house. A few minutes farther were the bosky paths of London's wilderness, Hampstead Heath. The same distance in the other direction and you were on the High Street with its shops and tourists. The back lanes were quietly urbane. As we strolled about that first morning, they echoed with the sound of amateur chamber music groups practicing. Hampstead's garage bands. Even the street trees sent me into a reverie. A great bough of limewood leaves filled our front windows. *Tilia europaea.* I was in Gibbons's haunts, and the very shape of the narrow lanes called him up. He might have walked up Christchurch Hill to take the waters of Hampstead's mineral springs.

Sunny warm days, one after another, as if we'd carried the American summer with us. I lay low, making no contact with anyone at Hampton Court. We found a school for Flora at the top of the hill, an amiable progressive place filled with the children of academics and BBC employees. During their lunch break the students were encouraged to climb trees on Hampstead Heath. Flora's natty uniform, carefully fitted in a West End specialist shop, soon grew battered.

At Hampton Court, meanwhile, the campaign was beginning in earnest, according to reports that had reached me over the summer. All the remaining carvings had been taken off the walls now, not least to prevent their being damaged during the rebuilding work. A conservation firm had begun cleaning these relatively unscathed drops and overmantels. Afterward they'd be boxed up and shipped to several different carving workshops around the country for repair.

The seriously damaged carvings would remain at Hampton Court. Two woodcarvers had been chosen to restore these charred and broken forms. Missing leaves or flowers or stems or fruits, sometimes whole sections of carvings, would be replaced wherever these were documented in the prefire photographs. A daunting task, which carried an added challenge I was happy to escape: the replacement carving would have to be fitted seamlessly into surviving work. Often only a few frail attachment points would be available to glue onto: nubs of stems, broken-off leaves, inconveniently thin petals.

I didn't realize it at the time, but one of these carvers, Richard Hartley, whom I'd never met, had already nearly finished replacing the badly burnt top of the surviving mate to my carving—the drop I'd examined in its coffin that gray October afternoon two and a half years before. Who was overseeing his work, I wondered? Who, for that matter, was going to oversee mine? There was no immediate supervisor and apparently no plan to install one.

So the decisions would be left to the carvers. We'd be working without interference, doing what we thought best. The idea made me nervous. Who of us knew what was best? Did Hartley realize that the top of his piece was missing an entire arching spray of foliage, broken off long before the fire? Was he replacing it? Was he guessing at its content, contrary to the specification I had written?

But that was nothing compared to the more fundamental questions. We didn't know how Gibbons modeled the surface of his wood, for example, to bring it to its final state. I'd always been convinced that he'd left it just as it came from the chisel. But who knew what kind of surface we'd find under that layer of wax now covering the carving? Other disquieting thoughts arose. What kind of limewood was available for us to use? Was it good enough for the demands that would be made on it?

Lime is a wood like no other. Gibbons couldn't have invented his style without it. Crisp and firm, soft enough to be carved quickly but strong enough to be radically undercut, with a remarkable grain structure that can (with a little effort) be worked in any direction. Limewood is amenable to the fine detail, the soft reversing curves, the thin edges that are trademarks of Gibbons's style.

It's a charismatic medium, and adding to its magnetism is its pale creamy color, without obvious grain to distract the eye. Even before he'd met Gibbons, John Evelyn was writing of limewood's "extraordinary *candour* and *lightness,*" which "dignifi'd it above all the *Woods* of our *Forest.*" Evelyn was using "candor" in its original Latin sense, to mean dazzling whiteness, but the word was already carrying implications of purity of character, fairness, openness, and impartiality. And so does limewood, metaphorically speaking. Mild, strong, open, impartial, kindly, it has the strength of character to be self-effacing. It rarely impedes the effort to shape it to a desired form. It has something of what Keats famously called negative capability: it can adapt itself to the forms of things. The candor of limewood. It's like a gentleman from another age, deferential, courteous, indulgent, an age when even a lord might close a letter with "Your obedient servant." That may have been no more than a conventional epistolary formula. But limewood is a patrician medium that, treated correctly, really will be an obedient servant.

Not all limewood displays these admirable qualities, however. The *Tilia* family is unusually sensitive to growing conditions, with the result that its carving quality can vary from the sublime to the unusable. In the wrong soil, lime can grow up corky, grabby, and grainy. Tough and weak at the same time, like a schoolyard bully. And sometimes a pinkish tone and a too-strong annual ring presence spoils limewood's fashionable pallor.

At Hampton Court there had already been a disappointment.

The second carver at the palace, who would do the lion's share of the repair and replacement work, was a very skilled and somewhat headstrong man named Trevor Ellis. A few weeks before I arrived in London, he'd telephoned to say that the stock of limewood set aside for us by the Property Services Agency was "rubbish." It was rubbish, however, with a remarkable pedigree. Not long before the fire, a decision had been made to fell the rows of ancient limes next to the east front of the palace. They were in an advanced state of decay, and interplanting with new trees had proved unsuccessful, so it was judged best to start anew with saplings.

The thought came to all of us that this felling might allow a romantic reuse of the palace's own trees in the carving restoration work—trees that dated back to the very days when Gibbons himself carved at Hampton Court. Actually, to even before then. In 1662 the newly enthroned Charles II, fresh from his exile in Europe and with memories of its lime tree allées, ordered 758 lime saplings to be brought from Holland to Hampton Court. That year Evelyn reported seeing "sweete rows of lime-trees" on the palace grounds.

More were planted later, in radiating avenues, and by the time he wrote *Sylva* Evelyn could single out the limes at Hampton Court as a model for the way these trees should be grown. The young saplings were carefully fenced and therefore, Evelyn waspishly remarks, "defended from the injuries of Beasts, and sometimes more *unreasonable* creatures, till they are able to protect themselves." Gibbons and lime trees, the man and his medium: both from Holland, both promoted by Evelyn.

Because it seemed likely that most of the wood from these trees would be unsound, I'd written Fishlock suggesting that an excessive number of boards be sawn. (Besides, if there happened to be any left over, I thought I could buy them for my own work. Imagine, carving from a stock of Hampton Court limewood!) But Ellis

and Hartley had found that the entire sample sent from the sawmill was unusable. They'd decided to resort to their and my usual source for limewood, a commercial timber yard in Sussex. Ellis and Hartley were skilled carvers, and I supposed that the unromantic wood they had ordered would be good enough. Still, I thought selfishly, they were doing the selecting, and I'd never yet had to carve wood I hadn't chosen myself.

What Trevor told me next aroused other selfish thoughts. He painted a dire picture of the carving facilities on offer at Hampton Court: a small room with just one window, through which the public could peer. No shades and no heat. Did I really want to share a room with other carvers anyway? I'd always worked alone, or with just Marietta in the room, and I could imagine only annoyances and distractions. For example, I happened to know that Trevor had a habit of honing his tools by means of a special attachment on an electric drill, which consequently shrieked into life every few minutes, nerve-janglingly.

But these concerns melted away in a fire that was burning in my mind, set alight when I realized that the restoration project would require a number of carvers. Why couldn't Hampton Court become the incubator for a new school of contemporary limewood carving? For years I'd tilled the field alone, wishing there were other carvers who could assist me, or collaborate with me. Or compete with me. It might be unsettling to share a room at Hampton Court, but what could better reawaken Gibbons's style than a workshop, with its collegiality and its edge of competition?

The carvers might be persuaded to see their work at Hampton Court as more than an exercise in repair and reproduction. I could tell them how I'd found it possible to earn a living making new work in a style that they (like everybody else) had pronounced dead, hopelessly time-consuming. We'd be gaining an adroitness

of technique undreamt of in modern carving. And skill stimulates creativity. In the usual way of thinking, you have ideas, and then you learn technical skill so you can express them. In reality it's often the reverse: skill gives you ideas. The hand guides the brain nearly as much as the brain guides the hand. A workshop where we learned to mimic something old could become a seminary for creating something new.

That wasn't the only idea roiling my mind as I arrived in London. I'd decided that there should be a Grinling Gibbons exhibition at Hampton Court. It was the opportunity of a lifetime, of a century. Of three centuries! The carvings would be off the walls and in some cases disassembled into their constituent layers. They could be displayed close at hand. The whole world could see what I had seen on the scaffolding and learn what I was about to learn at the workbench. Carvings could be shown back to front. With their layers exploded. Chisels and gouges could be displayed and their uses demonstrated. The origins of Gibbons's style explained. Off would come the moss that covered Gibbons's back. He'd step forth into the world.

A seminal workshop and an illuminating exhibition. The two ideas converged. Wordsworth says that you have to create the taste by which you are to be enjoyed. A Gibbons show could prepare the way for a new school of limewood carving. Admirers who'd learned to see the style with fresh eyes might sustain a market for innovative work born out of that tradition.

For months my thoughts had been circling these twin idées fixes. Over the summer I'd canvassed acquaintances in the art world in New York and London. The idea of a Gibbons show at Hampton Court aroused enthusiasm everywhere. Emboldened, I'd gone so far as to broach the idea with the acting palace administrator. However, two days before we left America, what should arrive but a bleakly formal letter telling me that because of limitations in

"resource availability" it had been decided not to proceed with a Gibbons exhibition at the palace.

A little setback. I hit on a risky strategy. I'd arrange a meeting with the administrator soon after I arrived at Hampton Court, advance the arguments again, and ask him to postpone a final decision. In the meanwhile I'd go public. I'd been planning to write another article about Gibbons at Hampton Court, and I could use it to make the case for an exhibition. This would bring no delight to the palace authorities. But they'd already turned my idea down, so what was there to lose?

What was spurring me to take up my pen again was something else altogether. New evidence had come to light that solved the puzzle of the backward carving. I needed to correct my account and proffer an apology. Embarrassingly, the engaging story I'd concocted about a workshop error had been proven wrong. In its place was an even stranger tale to tell.

The truth was that even as I was propounding that theory about the workshop error I couldn't quite get the story to ring true. So gross a mistake—carving two right-hand drops for the same door—would almost certainly have been caught early on. And even if it hadn't been, would Gibbons really so compromise his standards as to put the carvings in place and hope nobody noticed? My judgment had been clouded by the bewitching idea that the fire, like a deus ex machina, had snatched away Gibbons's error.

I discovered my mistake on my second visit to the fire scene, some months after the first but before the remainder of the carvings had been removed from the walls. This time I penetrated as far as the King's Drawing Room itself, the scene of the worst damage. I wanted to see for myself the charred west doorway where the lost

carving and its surviving companion had hung. After staring at the devastation for a while, I turned around, idly, to look at the unscathed doorway opposite, where the carvings still hung. To my amazement, the same kind of formal error stared me in the face, only this time there were two *left*-hand drops above the door.

With that glance Gibbons's workshop was exonerated. The error was not in the carving but the positioning of the four drops. Two complementary pairs had been made, but they'd been misarranged into two pairs of twins. Could the mistake have gone back to the original mounting? Unlikely. It would have been recognized and corrected at once. No, the carvings must have been taken off the wall at least once during the last three centuries, then incorrectly remounted by careless workmen. So my carving really *was* meant to be a right-hand drop. To resolve the problem it needed only to be remounted on the other side of the picture, and the other drops in the room rearranged accordingly to make two mirroring pairs.

But there was one more twist to the story. Later that day, clambering through those burnt-out rooms, I noticed another anomaly. In three of the four Royal Apartments the overdoor drops form a quartet, with all the carvings closely similar in form. As you'd expect. But in the Second Presence Chamber I suddenly noticed that the carvings divided into two very distinct pairs, with the outlines of the east door drops decidedly unlike those above the west door.

How could this be? Why would Gibbons suddenly adopt a different design principle in this one room? But two sets of carvings stared out at me now, and so did they, I now noticed, in the archive photographs from 1939. A new puzzle had replaced the old. Once again I walked out through the great gatehouse into the evening light, troubled by an unresolved mystery.

Until one steamy summer day a few months later. I was at my drawing table at home, hoping that distant growls from the west meant that a cooling thundershower was on its way. I was examining the recently taken photographs of the carvings inch by inch, comparing them to the archive images and preparing specifications for the carving repairs. I'd come as far as the east door drops here in the Second Presence Chamber, making notes on damage to a wonderfully fluent spray of nodding oak leaves that appeared two-thirds of the way down in both carvings.

But wait—hadn't I just seen a similar grouping of oak leaves in the two *west* door drops? Only, there, weren't they pointing upward? And weren't they more like *one*-third of the way down? Then, a little farther along, I came upon a device I'd also noticed in the west door carvings: a carved spike of the sort that purports to suspend a floral drop. In those west door carvings the spikes were at the top, where they ought to be. But here, in the east door drops, senselessly, they were near the bottom. And even more absurdly, they appeared to be driven in at the wrong angle, upward rather than downward.

Suddenly it became laughably clear. The east door carvings, all but the bottom grouping in one of them, were mounted upside down. And in left-right reversal, to boot. If they were turned right way up, then their outline would harmonize perfectly with the west door drops. The four drops in this room would form a suite, as they did in the other apartments.

Upside-down carvings unnoticed by numberless casual visitors. Not to mention palace curators and scholars of Gibbons. These weren't exactly abstract expressionist paintings. Bunches of berries were thrusting upward in defiance of gravity. Sometimes the obliviousness was breathtaking. Not long before, some replacement carving (of singular coarseness) had been added to a gap at the bot-

tom of one of the upside-down drops. The restorer himself managed not to notice that the carving he was ministering to was the wrong way up.

The clinching evidence that these drops (like the backward ones in the King's Drawing Room) had been removed and improperly remounted would be the presence of extraneous nail holes in the oak panels behind the carvings. That would prove there had been an earlier mounting arrangement. Sure enough, when the carvings were lifted from their backboards, just before I arrived for my year at Hampton Court, there it was: a scattering of disused nail holes. Now somebody would have to try to match these holes on the wall with the original nail holes in the carvings.

Poor Gibbons, treated with no less neglect and casual brutality at Hampton Court than he had been almost everywhere else. Masterpieces of seventeenth-century carving, moved about, broken off, half dangling, crudely added to, begrimed, sanded, varnished, painted, stained. Hanging backward. Hanging upside down. All the more reason to campaign for a conservation strategy that would restore his works to something like their original appearance.

T he warm days went on and on after we arrived, as if London were a Mediterranean city. No rain, a few trees already turning brown. For some reason I felt as stalled as the changeless skies. I began composing a draft of the article. To give myself a break from writing, I started sharpening my tools. My hundred weapons, carefully selected for this campaign, needed to be brought to a pitch of readiness for the engagements ahead.

Some trades are barricaded against easy entrance. Before you can learn their primary skill you have to learn other, different

skills. Presharpened chisels (which aren't very sharp to start with) only postpone the day of reckoning. There's no way around it: to use a chisel you have to learn how to sharpen it. But learning to sharpen is hardly less daunting than learning to carve. Even for those experienced in the trade, putting an edge on a gouge is an arduous and time-consuming procedure. A full sharpening often begins with restoring the bevel, the angle that leads to the blade edge. You grind it down on a high-speed wheel, dipping the blade in water occasionally so as not to ruin the temper of the steel by overheating it. Then you take the gouge to a medium oilstone (lubricated with mineral oil) and begin grinding by hand to create a microedge, laboriously moving it back and forth in a rocking motion. You have to make sure that the angle at which you hold the gouge to the stone is consistent at all times.

Next you move on to a finer whetstone, also lubricated with oil. Then on to the finest of all, a slick white Arkansas novaculite stone. Some have rounded sides that allow them to serve as a slipstone for taking the burr off the inside edge of the gouge. Then to an abrasive-charged leather strop for the final conditioning of the edge. At last you can test the blade on wood. Sometimes the edge isn't quite right, and you have to go back a few steps and start again.

Not an enticing invitation to woodcarving. A hedge of thorns. Like an early painter facing the grueling task of grinding lapis lazuli and extracting ultramarine before he can render the Virgin's robe. Laborious preliminaries, survivals from a less specialized world.

We've grown accustomed to a principle of easy access. Yet sharpening teaches fine and subtle things about chisels and wood. It's a ritual that forces carvers to become intimate with their tools. They learn to monitor and conserve the blade as they carve, learn when to take it back to the strop or the stone. And sharpening is not

without its hypnotic charm. To its adepts the honing of Samurai swords is a near mystical experience.

To be honest, I'd rarely been able to meditatively immerse myself in sharpening. Skills aimed toward the means of making never seemed as satisfying as skills associated with making itself. I found the process of sharpening fundamentally wearisome. What's worse, I was never entirely satisfied with the edge that resulted from my labors. That last sentence may explain the one before it.

However, I'd made a discovery that simplified the process. Just after we arrived in London, on the advice of a cabinetmaker friend, I'd bought a large slow grindstone that ran in a bath of water. It was an early version of the sophisticated grinder I have now, which has an array of jigs that hold the tool at a perfectly consistent angle during the sharpening process. I'd never tried a water-cooled power grinder before. Soon, with careful use of the tool support, a consistent application of pressure, and a rhythmic twisting of the gouge, I found that this waterstone could be made to produce a uniform bevel that went right to the edge of the blade.

I'd done this for a few gouges and was about to move on to the painful hand grinding on the oilstones, when I realized that there was no mineral oil in our flat. It was an English Sunday afternoon. No ironmongers or chemists were likely to be open. I drew my finger across one of the blades. The edge felt cruel and fine already, even without a microedge, and there was no perceptible burr. On impulse, pausing only to dry the tool, I took it to my leather strop and gave it half a dozen vigorous downward strokes. Then I tried it on a piece of lime. The blade entered and left the wood almost imperceptibly. Even tough end grain seemed almost easy to work, hardly different from cross grain. Without touching an oilstone, I seemed to have produced as potent a blade as I'd ever held.

With its consistent bevel and uniform razor edge, the tool

seemed to stand out like a Stradivarius among my orchestra of more ordinary instruments. The fine bevel meant a greater danger of notching or breaking the edge, of course. Stabbing down too hard, for example, so that the blade rammed into the benchtop board below, would wreak havoc. All would have to be slicing and persuasion, as it should be anyway. Fineness of edge, fineness in use.

It would take days to bring all my chisels to an acme of sharpness, even with this faster process. Another excuse for staying in Hampstead. Then one night the world suddenly tipped toward autumn. We woke to a low sky and a gusty wind driving small-dropped English rain. Darkness in the air. The gray slate roofs glistened palely, the most distant of them obscured now and again by mist. My blood started up again. The time had come. I telephoned Mike Fishlock and we agreed to meet the next day.

At Hampstead Heath Station that morning I caught the North London Line westbound 9:38 service, and in a little two-car aboveground train bumped my way around the perimeter of the city to Richmond. There I changed to a train that crossed a bridge over the Thames, then passed through an ever more salubrious townscape to Hampton Wick, where I disembarked. A pleasant back way to the palace, as convenient as any from faraway Hampstead.

Outside, I began the wait for a bus to take me down the long straight road to the palace's front entrance gate. Then I realized where I was. Just across the road was the bottom end of Hampton Court's vast park. The mist was beginning to clear and I had twenty-five minutes until my appointment. So I set off, in what I judged to be the right direction. A long pond on my right, then a flat, open, featureless heathlike landscape, a close-cropped brownish pasture with many animal droppings. Off in the distance I could

see some sheep, and then a herd of deer. The roar of traffic behind the high brick wall receded. No sign of the palace, but ahead there seemed to be the entrance to an avenue of huge lime trees. I made for it, thinking that it must be one of the two that radiate out from the grand east front.

These were once the fenced saplings admired by Evelyn. Trees Gibbons might have strolled under. Some still thriving, most battered, many turned to dotards. Still no palace in sight, however, unless it could be that little dot at the far end of this mile-long allée. Like the first glimpse of Pikes Peak from the Colorado plains: surely not that molehill on the horizon?

The dot grew, became rectangular, loomed higher and higher as more architectural details resolved themselves. Was the purpose of these vast straight avenues leading to palaces to induce a growing sense of deference in the visitor? The sheep trotted about, the deer gamboled on either side. And suddenly I was there, pushing open one of Jean Tijou's beautiful wrought-iron gates into a riot of garden color. A bell was ringing eleven o'clock, and after my solitary walk I found myself surrounded by families of visitors.

I remember pushing the tall gate shut with a clank and crossing a threshold into a scene not quite of this world. Palace bell ringing, people strolling about beneath a grand facade. A sudden clarity to the air, colors uncanny and saturated. Like the crisp autumn day of your first arrival at school or college or university, intoxicated by expectancy. Seeing yourself as from a distance, part of a world charged with intensity.

I made my way around the corner between the east and south fronts. Just there, an open ground-floor window. Inside was a woman bending over what I knew, by its wavy dark intricacy, was a Gibbons carving. That glimpse is still radiant in my memory. A woman in a paneled chamber who might have been Elizabeth Sid-

dal, the pre-Raphaelite model, with a strong nose and voluminous coppery hair, bending over a curled shadowy thing, like a sibyl reading a prophecy. I'd arrived at a workshop, whether mine or not I didn't know. It was like peeping into a sanctum. A dozen or so tourists were also staring in, murmuring speculations among themselves. I stood amidst them, at the end of a road three years long.

I've been writing this on and on into the depths of winter. Words pile up. Snow piles up. Almost every day a fresh mantle outside, sometimes an inch or two from a quick squall, sometimes much more from the big storms that belly in from the lakes. Thirty-one below when he went out to the barn the other morning, our farmer neighbor reports. Fahrenheit or centigrade? It hardly matters. The two converge, when it's cold enough. Under your boots, not a crunch but a squeak. On snowshoes or skis, levitation; you look down on familiar things from a new angle, two or three feet off the ground.

So cold the snow stays powder, blowing this way and that. The field is a storm-tossed sea, with swells and troughs, and white waterspouts. Comes then snow scur on the river, and jade covers the world, says Pound, acute in his meteorological observations. One morning we look out to find that even our fast-flowing river has frozen across.

Now I've made it to the safety of my Hampton Court notebooks, life rafts on a sea of memory. They lie here on my desk, reassuringly, an hour-by-hour record to cling to. A harvest quick-frozen on the very day. A retrieval system. When I read them I have something like a Freudian abreaction: the reexperience of past events as if they were happening in the present. In these notebooks time repeats itself endlessly. I need only open the covers.

In the evening twilight I decided to go cross-country skiing along my trail by the river. Five degrees Fahrenheit, new snow, low moisture content. The skis were silent, and went like the wind. At the bottom of the field I looked back at the hill and saw a white luminescence rising behind it. The full moon was breaking over the ridgeline, backlighting the trees on the lip of the escarpment. For a minute or two, the moon's face, poised on the edge, sublimely defined every branch and twig in front of it. Drew them with marvelous intricacy, in the blackest ink.

Then the moon broke free and sailed up into the sky. The moment was lost. I began to ski back to the house, nestled at the base of the hill, directly below this drama. To my wonder, as I sped in that direction the moon stopped its ascent and began to reverse itself, falling back toward the ridgeline.

Hah! I could make time run backward. If I kept up my pace, I could force the moon down into the trees again. Soon the calligraphic moment came again, and I skied at the correct speed to freeze it in place, so I could scrutinize it more closely than before. The spectacle held steady until I ran out of room under the hill. I had to stop, and the moon climbed free again. A parallax effect, halting time's inexorable march. The past was freed from the future, and for a while you could dawdle in it.

In the notebooks time has stopped and I can dawdle in it. The palace bell rings on, the sibyl still bends over her prophecy, my plans and ambitions and fears moil away unendingly. There's no slanted light over the scene, cast by my knowledge of what happened next, and what happened then, and what happened after that. One thing was clear enough at the time, though. The clang of that Tijou gate sounded the end of one journey and the beginning of another. I'd made it to the port and a vessel was waiting, puffing her sail.

Back field, thirty below, river steaming.

The Fascination of What's Difficult

A few months after I picked up a chisel for the first time, I found myself talking to an old carver in front of St. Paul's Cathedral. He was employed replacing damaged stonework. He must have been a septuagenarian, and he had an air of unassuming benevolence. It was one of those English spring days when the light suddenly expands and contracts, as sun and cloud follow fast upon one another. I told him I was interested in carving, and he replied by saying that I ought to think twice before taking it up as a career. "You know what they say," he told me. "Carvers are starvers." The first time I'd heard the saying.

He listed a catalog of woes awaiting anyone who embarked upon so dubious a pursuit: poverty, obscurity, sore muscles, and all the rest. A hedge of thorns. But we talked along good-humoredly, and after a while he saw that I was not going to be deterred. Something hardened in his manner, and he gave me the kind of look that searches out the heart. Suddenly all deference and shyness fell away. "Oh yes," he said, in a sunburst of pride, "it's the only life for a man." I don't

☛ *Left: Right-hand drop, west door, King's Drawing Room. The damaged companion of the lost carving, in its coffin, photographed in sections.* © *Crown Copyright.* NMR

know that I'd phrase it that way exactly. (Some of the best carvers I know are women.) But I'd already decided that it was an honorable profession, where cheating shows and virtue has its own rewards. And though you may not starve, it will keep you fit and lean.

Soon after we arrived in our South Downs valley, I met an even older carver, a nonagenarian this time. He'd lived his whole life in Sussex. Like the cook in Chaucer's *Canterbury Tales*, he was brown as a berry and happy as a goldfinch. We invited him to our cottage. He strode down the long steep drive, and when tea was over, he strode straight back up it again.

I visited his home in Eastbourne. He showed me yellowing photographs of architectural ornaments he'd made before the Great War. He was still carving, for himself now. I looked about for his tools but could see only a cheap modern set. He saw the puzzlement on my face, and explained that the tools he'd had all his life had been lost a while ago. I stared at him, and he explained that before he'd gone off on a holiday he'd wrapped his chisels in paper to keep them safe. His daughter had mistaken the bundles for trash and thrown them out. A woodcarver's nightmare. It's hard to describe the bond between carvers and their chisels and gouges. I told him I would have run amok. The old man gave a rueful smile, but he seemed unperturbed. No wonder he'd lived into his nineties.

Two old men, radiating contentment. Something finer grained than you'd associate with the horny-handed noble craftsmen of John Ruskin's and William Morris's romantic vision. Something that flowed from the pride of their delicate skill, the pride Yeats imagined in his Byzantine mosaicist?

Their trade seemed to have been a refuge for them. Perhaps their serenity came from making things that gave pleasure to others. Or making things they knew would outlast them, give them a little power over the grave. Leaving behind physical evidence that they

had lived and were creative agents in the world. Maybe it was that they had spent a lifetime swimming in a sea of harmonious form, that this had osmosed into them, and then as the years went on it began phosphorescing out in a cloud of benign tranquillity. Or was it something in the activity of woodcarving itself that gave them, at last, their moral radiance?

T he palace bell had finished ringing eleven. The longer I stood gazing into the window at the sibyl and her carving, the later I'd be to my appointment with Fishlock. I turned away and proceeded along the south front, then left through the Fountain Garden, fiery with late summer colors. At the Banqueting House, Mike was nowhere to be found, but a message came asking me to go to the works entrance. I retraced my steps to the barrier at the construction site, just along from the window where I'd paused.

Standing next to Mike was a younger man. "This is Simon Thurley. English Heritage's man on the ground here." I recognized the name. We'd had a telephone conversation a few months before. After I'd received my employment contract, I'd telephoned to ask for a print of the missing drop. He rejected my request with puzzling acerbity, saying that he was a member of the carving committee and hadn't seen any contract yet.

Then over the summer I'd learned that someone from English Heritage had created ripples by suggesting that backward or upside-down carvings shouldn't be remounted correctly, unless the nail holes documented a specific position with airtight certainty. It wasn't enough that those complicated hole patterns established that the carvings had been taken off the walls more than once. Or that the evidence of the senses made it clear that they were mispaired or the wrong way up.

As we stood talking, it dawned on me that the person from English Heritage was none other than Simon Thurley. And the same dawn now lit up another shadowy corner. I should have known. Standing next to me was the leader of the faction that wanted only British carvers at Hampton Court. The man who'd fought against my appointment and then had his victory reversed by ministerial decree.

For the moment he seemed busy, self-important, and perfectly civil. The three of us walked back around the corner and entered the east front of the palace. Then down the arcade of Fountain Court, with its echoing splashes. Through sets of doors, past a hidden back staircase, and into a beautifully paneled room with a foliage overmantel in dark oak. The conservation workshop.

There was the sibyl, who went by the name of Ruth Davies, and beside her the chief conservator, David Luard. In the center of the room, under bright floor lights, incongruous worktables had been pushed together. Lying on them like an anaesthetized patient was a carving I recognized: the central crowning section—what's called the cresting—of the Audience Chamber overmantel. A huge, lucid, boldly overscale composition, with two cherub heads, two cornucopias spouting fruits, and, in the center, crossed trumpets and a laurel wreath. All these embowered in flowers and leaves. The feeling of delight welled up as it had on my earlier visits. Like seeing an old friend. No, more like seeing a girl you have a crush on, when you're a callow schoolboy.

Also on the tables were brushes, bottles of liquids, odd scrapers, piles of gooey detritus, all giving off a laboratory smell of solvents. Davies and Luard had begun the painstaking task of removing the wax from Gibbons's weltering surfaces. Luard had the arrogant manner of a young Guards officer, but he also had an inquiring mind unlikely to rest content with a conservator's repetitive scraping. He'd thrown himself into the enigmas of the carvings, and

seemed to enjoy seeking out questions as well as answers. He showed us transparent sheets on which he'd recorded the nail holes on the wall, rigorously noting the character and date of each: modern round nail, early nineteenth-century handmade square nail, and so on.

To my surprise Thurley suddenly weighed in. From his satchel he produced photographic evidence that the overdoor carvings in all the apartments had been removed and stored for safekeeping during World War II. Luard responded, saying that this explained the modern pencil notes on the backs of the drops, some of them indicating the present wrong positions of the carvings. They'd been taken down and then after the war slavishly put up again in the same wrong places.

Thurley added that there was also evidence that the carvings had been temporarily removed, for unknown reasons, sometime in the nineteenth century. I looked closely at him as he spoke, and saw a man who'd also been caught up in the chase, almost despite himself. By the time he'd finished talking, he'd conveyed the sense that he would no longer raise objections to remounting the carvings right side up and right way round. Luard said that it was clear from his nail-hole analysis that each time the carvings were remounted the workmen had been unable to "locate" the previous holes and had contented themselves with driving in the new nails in the general vicinity of where the old had been.

Then came another revelation from Luard, who'd also been delving into palace records. The layer of pigmented wax he'd been removing hadn't been applied in early days. "Not in 1820. Not in 1920. But in 1975, believe it or not." Luard had gone so far as to trace down the man who'd applied it. "He's alive and kicking. As a matter of fact, I've invited him here next week for an interview."

We'd all have questions for the enthusiastic waxer. In a few

secluded places Luard had encountered a bottom layer of what looked like old white wax. What was that? What did the carvings look like when you arrived? I wanted to ask the man. Did you clean them before you slathered them? How did you clean them? What came off? What did the bare wood look like at that point?

For that matter, I wondered to myself, what does it look like now? I could see before me that Luard and Davies had begun to reveal the bare wood again, but I didn't step forward to scrutinize it. Plenty of time for that. The morning's bright complexion remained unclouded. It would be a few more days before I'd draw close enough to look carefully at Gibbons's wood, and see something that would upend one of my most cherished ideas about carving. For the moment I was thinking about how well most of Gibbons's work had come through the sooty smoke and the spray of the firefighters' hoses. Maybe the grisly waxing wasn't such a bad thing. After all, a thick water-repellant coat applied a few years before a disastrous fire? A stroke of luck, maybe.

After a while Davies went back to casting her spells over the wood, and Fishlock, Thurley, Luard, and I made our way to the adjoining room. Architect, preservationist, conservator, carver, sweeping along like the Four Apostles. Or the four cardinal virtues guiding the project.

Enigmatic as Buddhas, those two old carvers. I don't think their serene glow had much to do with pieties about doing good or cheating death. Something in the process of carving must have transferred its tincture to them, like Coleridge's worm turning green from eating leaves.

Now that I think back on it, carving began to color me during those first months in Sussex. No sign of moral radiance. But I noticed

that I was growing closer to Marietta, for almost professional reasons. She was replacing missing hands on eighteenth-century Derby figures, or repainting the delicate designs on Chinese bowls. I was trying to make a flower that looked like a flower. We were both struggling to create graceful forms of one sort or other.

I began to be able to recognize where she was succeeding and where she was falling short. She, the same with me. We could give each other advice that struck deep, that wasn't obvious. We were players in the same game. Before us was the same luminous thing, always beckoning and always just out of reach. There was much to talk about. Dinners lasted late into the night. When it wasn't undrinkable, the beer I'd brewed was smooth as oil on the tongue, and fresh as springwater.

I grew closer to the writers and painters in our acquaintance. Our conversations had a new zest to them. And I grew closer to writers and painters long dead. I seemed to be perceiving all the arts in a more inward way. I started hearing music with more than my ears. Even movies seemed more interesting.

The same was happening with things that weren't made by man. Glistening moss, a smudge of sunlight on a faraway hill, leaves streaming in the wind, the thousand little things that give passing pleasure to everyone now stopped me in my tracks. Carving had pressed some celestial Enhance button. Now that I was trying to add to it, I was haunted by the beauty of the world. I thought back to my academic days, when I'd stood on the hill overlooking the Fens and felt the world receding from me. Now it was rushing back, with colors and shapes that had a new savor to them. Rushing back, reenchanted.

It was as if the old dream were true, that some single Platonic form of beauty flowed through the human and natural world. And gave a camaraderie to those who chase after it, whose hands produce it and eyes are attuned to it. You didn't need to be doing it for

a living, either. It's one of the best reasons for taking up the arts as an amateur: to hone your senses. Make their bevels finer, so that you can get a better angle on the beauty of the world.

"Here we are, David. Your monkish cell," said Mike Fishlock with mock gravity.

Unbeknownst to me, the carvers' quarters had been moved from the cramped chamber described by Trevor Ellis. The paneled room we'd entered was even more elegant than the one we'd left. Beautifully carved moldings enriched the walls. Above the fireplace was another overmantel, this one with musical instruments. To my delight, there were two tall south-facing windows admitting a flood of morning sunlight.

Originally, these ground-floor apartments were fitted out for the Earl of Albemarle, William III's special favorite among his courtiers. Just how special is suggested by an adjacent private bedroom made for the king's use. It was hung with night scenes, and reached from the Great and Little Bedchambers on the *piano nobile* above by means of the little back stair we'd passed earlier. The bedroom had special locks with no door handles on the outside. It was the only room in the palace that could be entered solely by the use of a key.

But the workroom was one of Albemarle's large chambers. Under a window, Richard Hartley was carving the replacement for the badly burned top section of the companion piece to mine. I tried to avoid looking at Hartley's work or making any direct comments. Out of professional respect, I told myself, but perhaps it was something else altogether. To tell the truth, I was dumbfounded at the sight of a pale, freshly made, intricate piece of high-relief limewood foliage carving that I hadn't done myself. I couldn't recall ever having seen such a thing. Some kind of violation here!

Somebody's stolen my work! It had come to that, so isolated had my professional life been.

For a thief, Hartley had an air of pleasant modesty. I hoped he'd be amenable to the questions I was burning to ask. I tried to sound casual.

"So, how are we finishing our surfaces here?" I couldn't help noticing that his carving seemed quite smooth.

"No sandpaper," answered Mike at once. Hartley nodded. For years I'd been harping in public and private about how Gibbons never smoothed his surfaces with any kind of abrasion, how he took his work straight from the chisel, how the little facets broke up the light and made the wood softer looking. Mike's words were balm to my ears. I felt emboldened to press on.

"And what about this gap at the top of the carving? There must have been something there. I see it's missing in the old photo, too. Are we going to fill it in?"

I was looking at a print of the 1939 glass plate Hartley had hung to the side of his workbench, as if this were my first sight of it. The answer would reveal the direction the project would be taking.

"No." Mike was the first to speak.

Hartley chimed in. "It would be speculative. No speculative carving. I thought that was the philosophy."

I could have jumped for joy. One last question to venture.

"What about that fragment of drooping acanthus tacked on there?"

"It's spurious. I was going to just put it aside, but I think I've found its original place. Farther up. See the way it fits into this broken edge here?"

Each word was sweeter to me than the last. He could have been reading from the repair specifications I'd written. Written, while worrying all the time that a carver actually at the workbench might

just ignore them. But Hartley was attuned to letter and spirit. I felt as sunny as the beams that poured in over us as we spoke, catching the motes in the air and burnishing the old oak paneling. For years I'd felt alone in my engagement with the carvings. But in the last hour other streams had joined my lonely brook, and for the moment at least, we all seemed to be flowing together as one current.

Thurley, so caustic in his rejection of my earlier request, now seemed more than happy to produce a print of the archive photograph of the lost carving. My plan was to have the print made up to precisely life size. Almost seven feet long. Then I could not only copy and saw out the outline with accuracy, but while I was carving I could use dividers to transfer the measurements of an individual flower or leaf or fruit directly from the photograph to the wood. As Thurley dashed off to his next appointment, I said I'd telephone him with the length of the missing drop. Over his shoulder he assured me that the image would match it exactly.

Fishlock and Luard and I dismissed to a pub across the river. I steered the conversation toward my dreams of a Gibbons exhibition. Enthusiasm grew with each swallow of malty Fuller's beer. Mike couldn't imagine why the palace administrator would be against the idea. Over his crisps David grew animated at the thought that we could bring Gibbons's masterpiece, the so-called Cosimo panel, from Florence. It hadn't been seen on British shores since 1682, when Charles II commissioned it as a gift to the Grand Duke of Tuscany. The greatest woodcarving in the world, which by a stroke of grim luck had just sustained serious smoke and scorch damage from a gas explosion at the Pitti Palace. Not unlike the damage at Hampton Court. David could transfer to the Cosimo panel the cleaning skills he'd be practicing in the coming months. And then we could reveal to an astonished world, alongside the Hampton Court carvings, a magnificent sui generis piece of sculpture.

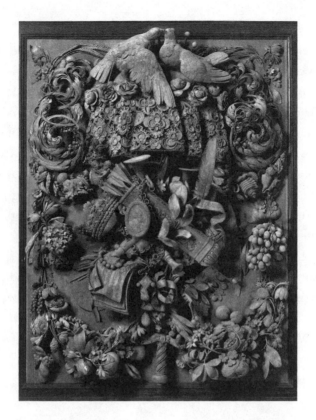

Back across the bridge. Clouds now streaming over the palace's towers and ornate chimneys, pinnacles against a darkening sky. Gibbons could have crossed here only by ferry. But from London he probably made the whole journey by boat, on the tide. We walked directly to the south front, where we donned hard hats, climbed up outside scaffolding, and clambered through the window of the First Presence Chamber. More titan coffins, holding a harvest of carvings awaiting conservation and repair. Fifteen-foot-long drops and eight-foot-wide crestings, pried off the walls by the courageous Luard. Every movement of his wedges had courted danger.

By the time he'd finished these dismountings, he'd become an expert on the structure of a Gibbons carving. He showed me how Gibbons had glued wide thick boards together side by side to produce a huge swath of material from which to carve the bottom layer of the composition. I probably would have band-sawed out smaller sections, carved them to completion, and then glued them together. But Gibbons, with no band saw and a large pool of skilled assistants, seems not to have worried about vast, time-consuming excavations. In fact he seems to have gloried in them, just as he gloried in grueling undercutting below delicate leaves and stems.

We bent over the coffins and scrutinized the details of the carving from every angle. They were meticulously executed even in places that would be hidden to a viewer standing fifteen feet below. The scrupulousness of it! Almost perverse, by any rational standard. What's the point, when no one's going to notice? When in some places it was actually invisible? Laymen's questions, but I was asking them as a carver.

When the afternoon was over, I walked out the palace gate to the bus stop opposite. A fine rain had begun to fall. Untold hours of industry for effects that, to all intents and purposes, would be seen by no one. That evening I talked over the day's events with Marietta, with Flora on my knee and a glass or two more wine than usual. Marietta reminded me of the old tales of pious cathedral sculptors completing the backs of their statues because God can see everything.

"That's preposterous."

"Not preposterous," she said. "It's a metaphor."

"God seeing the backs of things? A metaphor for what?"

I asked the question, but I already knew the answer. What I'd seen that day was bringing to full consciousness things I'd already learned

in my own practice. First, that diligence is a kind of insurance. You never know for certain how a piece carved horizontally on a work-bench will look when it's hung vertically on a wall. It's only prudent to model with extra scrupulousness to allow for unforeseen viewing angles. You overbuild the house. You add more arguments to the report you're writing, because you can't be sure what angle the world will take on it when it's posted. When it's up for all to see.

But the zealotry in Gibbons was out of all proportion. An en-slavement! Is this a profession for high-functioning obsessive-compulsives? Perhaps, but there's another reason for such zeal that is even more fundamental. Early on I discovered a curious thing about carving. Fifty percent of the effort will achieve ninety percent of the effect. Another discovery followed on quickly. If you allow yourself to stop at that ninety percent, then the carving can never succeed, never really succeed. Never raise the hair on the back of anybody's neck. The last ten percent, that final zone of difficulty, is everything. Even to a casual viewer, casting a single passing glance.

The consequences are cruel. Pursuing this marginal advantage means devoting vastly more time to the carving, maybe even half again as much as you've already put in. And just as the end is in sight! It means plunging into uncomfortable, unglamorous, thankless-seeming tasks. Paring stems to an ever more dangerous thinness. Undercutting yet more radically beneath them, even at the risk of hearing that appalling crack. Excavating farther and farther down, so that you make use of the full thickness of the board. Continuing a spray of forget-me-nots into still gloomier depths, into corners where they're unlikely to be seen. Watching your earnings from a piece dwindle with every extra day of work. Poverty and sore muscles, as the old carver warned. The fascination of what's difficult will dry the sap out of your veins, Yeats complained.

But there's every reason for this perdition of carving in an

underworld where few eyes will penetrate. What you don't see influences what you see. The back cleaves to the front, spreads its influence over it. A crucial part of the appearance of an object is the point at which it disappears from the observer's view. The edge of a leaf, or the side of a peach just where it rounds away out of sight. This border area establishes the profile of the thing, and what leads up to it from behind it is nearly as important as what leads up to it from the front. Especially when viewers will be looking at the piece from different angles. So it's pragmatic to model the back as if it were the front. The unseen is perceived in the seen, the unspoken is heard in the spoken.

I remembered an incident from a few years before the Hampton Court fire. One July morning a much loved member of Marietta's family died. That afternoon a familiar pickup truck came down the drive. It pulled to a stop next to a group of us standing in the shade by the side door. Out stepped our neighbor from along the road, a lifelong friend of the family. With his head down, he went around to the back of his truck and retrieved a cardboard box. "Here are some beets. I dug them this morning. They're pretty good this year. Some carrots. Some little zucchinis, too. They made it through the frost last month just fine. Nini picked some wildflowers." He handed over the box, climbed back in the truck, and drove away. Not another word. I seemed to be watching a scene from *The Winter's Tale*.

Later I thought, if only carved flowers and fruits could carry silence and meaning in the way that Stanley Gilbert's carrots and beets did that day. Maybe what's been carved away, the empty space that's left, is like silence. The dark shadow that defines the pale form. And what is unspoken is like what's out of sight, the part of the carving that's unseen but perceived anyway.

Wanting to push forward obsessively to the very end eventually

becomes habitual and instinctive, and satisfying for its own sake. Virtue becomes its own reward. At the end of his life, looking back on his career, Poussin said, "I have neglected nothing." Not what you'd call a vaunting of godlike powers. But carvers will understand what Poussin meant, and regard it as a proud boast.

Because carvers revere the god of unseen effort, of hidden work, of the backs of things. The god of assiduousness, reigning over obsessives and perfectionists. Writers who delete whole chapters in the slender hope that what's gone will shine through what's left. Computer scientists who write beautiful code, programs that are more elegant than necessity demands. Why stop there? The cleaner who does more than an employer will ever notice, the night nurse who holds the hand of the unconscious stranger. If you're looking for glamour, you've come to the wrong place, but it's where you'll find two old carvers whose serenity seemed to flower out of a lifetime of scrupulous work. Maybe it explains their venerable age, too. Somewhere I read of a study that identified not optimism or happiness or serenity or sociability as the psychological trait most predictive of longevity, but a more homespun one: conscientiousness.

U p a stone staircase to the palace offices. The administrator had only a temporary caretaker appointment, but it was a powerful position nonetheless and he was conscious of this. In the letter he'd sent me the month before, his rejection of the idea of a Gibbons exhibition had a tone of confident finality. He wouldn't be easy to budge. I wanted to find out what was at the heart of his resisting of this irresistible proposal, and then persuade him to reconsider. Maybe I could at least buy time so that I could rally public support.

I had barely seated myself before he launched forth in the same vein as his letter. Their investigations had convinced them that a

Gibbons exhibition was not likely to be a commercial success. It did not fit with their plans for presenting Hampton Court. There was no question of changing their minds. Grinling Gibbons could be adequately covered, for their purposes, by the fire restoration exhibition they were mounting at the palace in November. I said I was so convinced of the value of such an exhibition that I might try to hold one anyway, elsewhere. With what carvings? he asked. I would seek permission to borrow yours, I said. You would not get it, he said.

I'd prepared a stirring account of the discoveries we were making and how they would interest the public, but plainly this would have run straight off his back. We talked along, and after a while a slender ray of light pierced the clouds. His most evident fear seemed to be of losing money. Supposing Hampton Court were indemnified against loss? Well, he said, if the sponsors were not objectionable, if an exhibition did not harm the dignity of the palace or interfere with its public purposes, then perhaps a proposal might be entertained.

He confirmed that William III's beautiful little Banqueting House, overlooking the river, with its single large upstairs room, would be empty over the next few years. He said that the palace had no objection in principle to charging for admission to that building. But its use had to be consistent with Hampton Court's strategic plan for itself. I decided not to bring up the question of timing. It might have jeopardized my slender gains. I feared that the administrator would insist that the carvings be in place for the reopening two years hence. I wasn't sure that would leave time enough to finish the conservation work and organize and stage an exhibition.

I walked back down the staircase, thinking of what had transpired and dreaming of things to come. I needed to muster public support and financial backing. Marietta had warned me of dissipating my energies by conniving rather than carving, but it was too late. What with the thought of an exhibition, and my growing

worry about the color of the carving, I was already hopelessly entangled. Like the Trojan priest Laocoön in the famous sculpture, trying to fend off the sea serpents sent by a god to strangle him; except in this case two encoiling snakes were of my own devising.

That night I laid my photograph of the lost carving on the kitchen table in Hampstead and examined it anew, with a mind now freshly charged by the sight of Gibbons's carvings. Like a mountain climber at base camp, mapping out routes up couloirs and arêtes. I could see that there were hardships ahead. But at least I had a photograph. I didn't have to design the piece before I carved it.

That spared me a daunting task. Inventing a design that would rigorously pass for Gibbons's would be nearly as demanding as carving it. Designing *any* high-relief foliage carving is a plunge into a labyrinth. It must be like trying to write good prose, I thought. There's pressure on every line. It has to win its own victory and at the same time contribute to a whole. The best architectural draftsman I know once confessed to me that there was a moment in every drawing when he felt desperate, as if he were on the edge of calamity.

Gibbons's skill as a designer goes hand in hand with his skill as a carver. His drawings are charged by his understanding of what makes a carving win its victories. The hand that holds the pencil has held a chisel. Designs for a carving take several different forms. There's the shorthand sketch for privately working out ideas. Then there's the drawing for the patron, intended to elicit a commission. Sometimes that is a casual sketch, more evocative than literal, and sometimes it is a highly finished composition, a so-called presentation drawing. Gibbons's surviving designs include examples from all along this spectrum. His finished drawings, with their assured,

casual line and delicately applied color washes, are often beautiful works of art in themselves, good enough to frame.

Christopher Wren knew that Gibbons was trained on the Continent, and he may have had the carver in mind when he complained that young British artists, unlike their European counterparts, were never properly taught to draw. Wren had made that comment shortly after Gibbons's stunningly accomplished chimneypiece proposals for Hampton Court crossed his desk. Those designs were never executed—Queen Mary suddenly died and the project was delayed and simplified—but Wren never handed Gibbons's drawings back to him. They remained among Wren's papers, which is why they survived.

Like Gibbons, I use pencil or pen and paper to conceive a design and work it up to a small sketch. Then my path veers into a place beyond his imagining. Into my computer and virtual space, where I prepare the detailed working drawing for the carving. Like a writer composing in longhand, then uploading the manuscript for revising.

I draw out the design in Adobe Illustrator, using a stylus and tablet. The digital form allows endless easy revision. You can quickly explore alternatives, drag individual elements around to your heart's content, rotate them, distort them one way or another, change their size, without constant erasing and redrawing. The final working drawing, digital or physical, must show all the layers of the carving, in readiness for tracing onto the wood. What Gibbons's working drawings looked like we'll never know, since none survive. Mine have an X-ray complexity that makes them almost unreadable.

Computer drawing programs might have been invented by a woodcarver. They are organized in exactly the same way that a high-relief foliage carving is structured: in layers. You can design each layer independently, and it can be easily extracted, printed out to scale, and transferred to a board for sawing out and carving.

A new technology put to an old purpose, but to a carver the process remains intuitive.

That's not to say that a computer doesn't alter the experience of designing. Ceaseless, restless experimentation tends to take the place of deliberate and purposeful pondering. Gone, too, is the physical pleasure of drawing. The feel of a stylus on a tablet, slick and unresisting, is an impoverishment of the feel of pencil on paper. And the common complaint is well-founded: a computer line is soulless. You wouldn't want to show these raw printouts to a patron.

There's every reason to feel equivocal about designing with computer software. Nonetheless, the fluidity of digital drawing, with its endless potentialities, can sometimes toss a beautiful shell onto the beach. And the real design still remains where, in any subtractive art, it always has been and must be: in the carver's mind. A carving chisel is a predator of anything in two dimensions. It will obliterate traced-out designs almost immediately. Only your powers of visualization can save you then. The only picture left will be in your mind.

At Hampton Court, in 1989, the designing process would be entirely manual. And it would run backward. It would be a re-design using forensic evidence. Somehow Gibbons's layering structure would have to be deduced from the archive photograph. Then those layers would need to be turned back into working drawings that resembled Gibbons's. Then the clock could run forward again. The drawings would be transferred to the wood and sawn out.

During the actual carving I hoped that the photograph would serve as a kind of enhanced design drawing, like a model in two dimensions. But I worried that I'd break my stride every time I had to look over at it. Gibbons could be spontaneous in his carving. He could change things at will. But I'd be trying to replicate without deviation. There'd be no room for maneuver, no question of little local redesigns to help me scramble out of difficulty. I hadn't copied

anything since the early days. Back then I scarcely knew what I was doing. I hadn't yet developed my own way of working. Now I'd have to suppress my habits and make my carving motions coincide with Gibbons's. It occurred to me again: something would have to rise out of those coffins at Hampton Court to guide my hands.

N ear the end of winter now, the river unfrozen. Snow still deep on the roof, but some afternoons I can keep my window open a crack, and hear dripping from the eaves. Many months into that large piece with lilacs and peonies, and in front of me is just the kind of cumbrous task that carvers often face. Earlier in the day I'd excavated deeply between two blossoms, wanting them to seem to be floating amidst shadows. At the bottom of that valley, leaves had to be modeled. I was using a small front-bent gouge, designed to provide access to such places. But there was only one angle of approach that allowed the blade to get down to that low level, and this put it in such a configuration that it could only cut against the grain. The wood kept tearing out. Meanwhile the shank of the blade kept bumping against the edges of the petals above, sometimes damaging them. I could only work the surface by a series of uncomfortable side strokes. A clumsy, punishing, unavoidable, entirely familiar predicament.

The afternoon began to wane. I decided to give my body the exercise that small detail carving denied it, and at the same time liberate my sore eyes from their five-square-inch world. Down to the mudroom, on with the snowshoes, out into the growing chill, shuffling down the frozen Swale Pond to the Bass Pond, at the bottom of a steep escarpment. Above me was what the eighteenth-century naturalist Gilbert White called a "hanger," an old word also used by William Cobbett in the next century, who defined it as a wood on the side of a very steep hill.

I started up the alluring slope. It is as sheer as a forested hillside can be, the soil held in place only by the roots of undisturbed big trees. So steep that as I climbed I could reach out and touch the slope in front of me. The snowshoes had crampons, so if I kicked in hard I could usually get a good purchase. Three secure points always. Two poles anchored forward, left foot locked. Kick in right foot, move left pole up, kick in left foot, move right pole up, and so on.

But the snow was deep and heavy, and in places the warmer afternoons had produced a glaze of ice that was hard to kick through. Sometimes it was difficult to extract the snowshoe, and when it came out it bore a heavy load of snow. Other times when you shifted your weight from one foot to another the snow underneath would give way. To stop yourself from sliding back you had to lurch forward and cling awkwardly to the poles. Higher and higher, past the point of no return. Pieces of ice dislodged. Over my shoulder I watched them roll away, break into a bounce, gain dizzying speed and mass, turn into snowballs that eventually crashed into trees or slid out onto the frozen pond below.

This is difficult! I thought. I tried to make my movements precise and rhythmical, and to shift my weight carefully. This is still difficult! It would be no matter how good your technique was. Difficult for anybody. Difficulty is intrinsic here. There was nothing to do but accept it, and turn the mind toward making whatever movements had to be made to continue ascending. Eventually I clambered onto the level ground at the top, the Edmund Hillary of our three-hundred-foot escarpment. Below me, like a reward, a pair of large birds were wheeling over the pond with lonely screeches. Eagles, seen from above.

The stoicism enforced by the little ascent turned my thoughts back to the workbench. Carving grows easier with practice. You learn to rough out more quickly, excavate more boldly, model with

more assurance. But there are difficulties that no amount of expertise will eliminate. Ticklish modeling in cramped places, excavations where you can't find a comfortable purchase, brutally tough end grain you have to cut into. It will never be easy to get petals to come together to form that complicated vortex that is a hybrid rose, or make a thin tendril twist down over a bunch of grapes.

Effortless work is an ever receding mirage. Improving skills will only unleash new ambitions, and new ambitions will engender new difficulties. The somnolent British oak carvers of 1670 may have thought that the technical problems of their profession had been solved long before. Then came Gibbons to shake them awake with extravagant forms that demanded unimagined skills.

Fortunately, carving changes not just the way your muscles work, but the way your mind works, too. Difficulty loses its sway. You learn to turn it into another part of the workplace environment. At the end of the year at Hampton Court, my fellow carver Trevor Ellis asked me what the hardest part of the carving had been. I couldn't think of an answer. Difficulty had ceased to be part of my classification system. Eventually I worked my way to an answer by remembering what it was I'd had to pay particular attention to. But at the time? I was just inching my way up the couloir, thinking of nothing but where to put my foot next.

The fascination of what's difficult, grumbles Yeats, will drive spontaneous joy and natural content out of your heart. But notice: not what's difficult, but the fascination with it. That fascination may have enticed you to a project in the first place. But if you're going to make it up the steep slope successfully, without the sap in your veins drying up, then you have to break difficulty's spell.

And there's more to it than that. These daunting parts of a carving, like that challenging last ten percent, are the parts that are likely to give the purest delight to a viewer. They're the shining peaks of

any composition. It's uncanny, but the hardest parts to carve are the parts that end up looking as if they were the easiest. They make the viewer think that wood can be shaped effortlessly. These are the exhilarating passages where the medium seems to be something other than the familiar thing we know. Where Bernini's marble looks as if it could be molded with his bare hands. Daphne's hair flies in the wind, Neptune's fingers press into the flesh of Proserpine, Scipio Borghese's jowls dimple. Or where Gibbons's limewood looks like a pliable thing. Long graceful stems, tulip petals soft as flesh, curling corners of musical scores, fine threads in point lace.

They look easy. They are not easy. The paradox of the admiring gaze: what looks most spontaneous and fluent is often what's most painstakingly mechanical to produce. Conversely, if a thing looks as if it was difficult to bring off then it hasn't been brought off. "You must have a lot of patience" is a compliment I dread. Yeats again: a line of poetry may take hours, but if it doesn't seem a moment's thought then your work has come to nothing.

A carver's objects of virtu should seem struck off like trifles. Renaissance courtiers strove for sprezzatura, that nonchalance that makes great accomplishments seem like child's play. (You can bet that out of sight of the Urbino court they struggled mightily with their horsemanship and their poetry.) Sprezzatura is the reigning principle in a good piece of carving. The poignancy of the admiring gaze: struggles go without praise, because if they're successful they disguise themselves in a cloak of effortlessness.

I telephoned around to ask the restorers of the other drops from the King's Drawing Room to measure the length of their carvings. Eighty-two and a half inches, said Plowden and Smith. Eighty-one, said Carvers and Gilders, with another inch or more for a missing

turk's-cap lily. Richard Hartley said eighty-three, if you allowed for some missing work. For the full-scale blow-up image of my missing drop, then, I decided on eighty-two and a half inches.

This full-size photograph would be the model I'd be working from. But upon reflection I realized that the camera's position at the midlevel of the carving, and perhaps four or five feet away, must have created distortions in the resulting image. The features in the center, which projected six or eight inches, would appear larger than they actually were. Those at the top and bottom ends of the carving, which were both less projecting and farther away from the camera, would appear smaller. So even if the photograph was the right length, I could take measurements from it only at my peril.

The idea came to me to also order a blow-up of one of the surviving drops. By comparing that image with an actual carving, I could see what sorts of distortions there were in these photographs. Then I'd have a sense of the compensations I'd need to make when measuring from my own photograph. Well, first things first. I was burning to find out how clearly my own glass plate would print at full size. I telephoned Simon Thurley's office at English Heritage. King's Drawing Room, west door, left-hand drop: eighty-two and a half inches. Repeat that, please, I asked the technician.

That left a workbench to order. I was relieved to discover that the palace carpentry shop would construct these for Trevor Ellis and me without charge. But they needed measurements. So: the top had to have enough room for a hundred chisels and the longest section of the drop. The drop was divided into two separate parts; the top piece was about four and a half feet long, the bottom about two and a half feet. A bench top six feet wide and three feet deep ought to accommodate everything with room to spare. Just about the size of my workbench at home.

Now the key measurement, the height of the bench top. I'd

forgotten how high my own was, but remembered a trick known by carvers. Stand straight up with your arms loosely at your sides. Bend one elbow. Have somebody measure the distance from it to the floor. Subtract two inches from this. That's the height of a comfortable workbench. I had the palace carpenter take the measurement. He knew about this formula and was businesslike in his measuring. I decided to subtract four inches, thinking about the thick boards I'd be working with. Besides, you can always raise the level of thinner pieces, or delicate work you need to be closer to, by putting a board or two underneath it before you clamp it down. So, forty-one and a half inches high. "And you'll make it sturdy?" I wanted to ask Ted, the carpenter. But I looked at him again and decided that the question was needless.

* *Grinling Gibbons, unexecuted design for a chimneypiece (detail), circa 1689–94.* By courtesy of the Trustees of Sir John Soane's Museum

CHAPTER V

The Art That Arrives
Even to Deception

What crazed impulse led Gibbons to carve a lace cravat? Was it on a dare, as I like to imagine? Or, spurred by his own compulsion to push limewood to its limits, did he cast about for the most delicate thing in his experience to copy? Perhaps it was a gauntlet thrown down to other carvers. Or a sprezzatura gesture for his fashionable patrons, making a trifle out of one of their expensive accoutrements. Needleworkers might slave away, but Gibbons could strike the thing off nonchalantly, in wood, as a jeu d'esprit.

Whatever prompted it, the intricately stitched Venetian gros point lace, with its airy openwork, seems to have hit its mark. Gibbons went on to include showy lace in several carvings. The most complete version, an independent trompe l'oeil object with a beautifully tied plain bow and lace tail, came into Horace Walpole's hands in the middle of the eighteenth century. I have, he boasted, a "point cravat" by Gibbons, "the art of which arrives even to deception."

🔹 *Left: Grinling Gibbons, cravat carved in limewood, date unknown. Owned and once worn by Horace Walpole.* © *Victoria and Albert Museum, London*

Perhaps a baroque delight in illusionism still flowed in Walpole's veins. But the pleasure is older than the baroque. Maybe it's part of the original DNA of art. Anecdotes of deception go as far back as the fifth century BCE. Birds flew in the window to try to peck at grapes painted by Zeuxis. His competitor Parrhasius then painted curtains so realistic that Zeuxis asked that they be opened so he could see the painting behind. Apelles's talent was ratified when Alexander the Great's horse neighed at the sight of one of his painted horses.

Walpole's phrase similarly implies that the goal of artistic skill is to produce a perfect counterfeit of reality. As if a carving succeeded most where it most deceived. But how easily can a piece of woodcarving, or any sculpture, bamboozle a viewer into thinking that it is literally the object it portrays? The color of the wood will have to match the color of the object, for one thing. This can happen. Once I carved in limewood a straw basket with grasses and leaves and flowers. I was told that one visitor to the room where it was displayed walked in, glanced at it, turned on his heel, and walked out again, scornfully muttering, "Dried flowers!"

Linen thread is close to the color of limewood, so Walpole's cravat, which survives in the Victoria and Albert Museum, is also a good candidate for literal illusionism. To test this, Walpole once tied it around his neck and wore it to a diplomatic reception. Anything for a jape. Were the guests taken in? Walpole reported, ambiguously, that the foreigners wondered whether this was the normal dress of an English gentleman.

One morning in our cottage in the Downs I'd just finished a five-foot-long drop with fruit and foliage and flowers. It was arranged in two gatherings with a narrow waist of stems in between. An old trick for evaluating a design is to examine it from an unfamiliar perspective. You turn the thing upside down, for example, or look

at it in a mirror. Though it was too late to make changes, I couldn't resist holding the piece up to the only full-length mirror in the house, which was in our bedroom. There it was, a converse ghost that (unlike most ghosts) appeared in mirrors and nowhere else. A doppelgänger from a dream world, at once familiar and alien.

There was an unexpected knock on the front door. I laid the carving down on the unmade bed and went downstairs to answer it. The postman was delivering a box. Then came a telephone call, then breakfast, and the day was launched. I had to go out, and soon enough I'd forgotten all about the carving upstairs. Late in the afternoon, thinking about something else, I wandered back into the bedroom. Suddenly, in midstep, I saw something out of the corner of my eye that made me gasp. Amidst the tangled sheets a naked woman was lying in our bed, all creamy bulges. The curvaceousness of the botanical forms began the deception, and limewood's Anglo-Saxon pallor pushed it further.

But how many objects have a uniform color that matches bare wood? The only alternative, if you want to deceive the viewer into thinking a carved object is literally real, is to paint the piece. But then it loses its identity as wood and might as well be made of anything. The fineness of the surface detail is lost, and even the understanding that it is a carved object. There's more enterprise in walking naked, said Yeats when he announced his intention of writing in an unadorned style.

Besides, unless you are a conceptual artist bent on exploring issues of reality and unreality, what is the point of peopling the world with zombie objects? If the viewer is truly deceived, then the effect of the art object is no different from that of an actual object. I might as well have hung real dried flowers on the wall, and Walpole might as well have worn a real cravat. Viewers might eventually see through the ruse, it's true, or after a delay you could spill

the beans, to the amusement of all. A conceptualist might reveal everything in one of those all-important explanatory labels.

But then the so-called uncanny valley effect would come into play. A Japanese scientist found that the closer he designed his humanoid robots to look like people, the more people were repelled by them. (The "valley" is a plunge in the graph of the viewer's acceptance of a robot as it becomes more humanlike.) Simulacra are disturbing. We want to know where we stand with a thing. We want the terms to be clear.

We want reassuring differences. If a carved flower is bare wood, you don't have to worry whether it's real or not and you can enjoy the art of the thing without ontological anxieties. Limewood carving traffics in this intermediate kind of deception. It's a half-fooling that beguiles the eye for a moment, surprises and delights it rather than commits a fraud upon it. "That looks so real!" a viewer will say of a peony carved in plain limewood, even though its color sends a clear signal to another part of the brain that it cannot possibly be real.

Most of the time the monotone of wood keeps us out of the uncanny valley of too literal a resemblance. And the pale uniformity of lime liberates us from something else as well: our received image of wood. It makes us half forget what it is. Limewood's unfigured whiteness leaps free of the curse of brown, wood's sincere old raiment. Leaps free of the curse of beautiful grain. The curse of woodworking, the curse of craft, the curse of all that baggage. Unworldlike, unwoodlike, the lightness of limewood gives it lightness of being. It rises from decoration toward sculpture. It wheels our attention upward to an otherworld where wood is not quite itself.

Limewood's paleness is the color of transformation, of magical possibility. The color of ghosts. The color of dreams, of surprise.

The color of the spirit, that has no color. Like the substrate of a Platonic world of pure form—the wood version, where carved objects have an ethereal presence to them. "What's that made of?" is the comment that pleases me most. Most woodworkers would take it as an insult. To me it suggests that the art of the work arrives even to deception in a broader and better sense than Walpole's.

And sometimes, in those moments of carving when chisel and wood are responding to each other with easy familiarity, my own answer to "What's that made of?" might almost be "I'm not sure." Limewood's unearthly appearance foretells the unearthly refinement of its working properties.

L uard, Fishlock, and I were gathered around the worktable in the conservation apartment. The door opened and in came Mr. Young, the waxer, escorted by a palace guard. Introductions and small talk. A pleasant artless fellow, retired three years now. His firm had made a business of refinishing oak paneling around London, much of it from the seventeenth century: administrative boardrooms from Stuart days, the halls of City "companies" (as London's old craft and trade guilds are called), a royal palace or two.

Including Hampton Court. He told us that in 1967, almost twenty years before the fire, he was at work on the paneling in the King's Apartments when he noticed the filthiness of the carvings. He suggested to the Department of Works manager that they needed attention. "I didn't know anything about Grinling Gibbons. To be honest, I'd hardly heard of him."

Luard went straight to the point. "What was on the carvings at that point, aside from the grime?"

"I think they were bare wood. Except there were traces of lime

wash here and there, mainly in the corners and crevices. Either lime wash or limed wax."

It was lime wash, I was sure. Whitewash. Calcium oxide mixed in water, turning to calcium carbonate when exposed to air. In the 1938 photographs I'd noticed a faint chalky haze on the wood, more concentrated in declivities. Luard had found traces of a white substance in corners, underneath Young's wax. Samples were about to be sent out for analysis. We were betting that it would be lime. And since all the evidence was that Gibbons had left his wood bare, it was expected that dirt would be found on the underside of it— proving that this wash had not been applied on the new wood. When was it applied, then? And why? The answers would have ramifications for the restoration project.

Young said that he was invited to try an experimental treatment on the overdoors in the First Presence Chamber. He decided, reasonably enough, to match the old wash by mixing lime with turpentine and beeswax. "Then I painted the mixture on."

"Did you clean the wood first?"

"I blew on it to get the dust off."

The Department of Works manager had deemed the resulting color too light, and so did officials from the Office of Ancient Monuments and Historic Buildings. Wood should be brown! Everyone knows that. Brownish, at least. Certainly not white. "They thought the carving should harmonize more with the oak." Young was sent to look at the color of the carving on the pulpit at St. Paul's Cathedral, and told to devise a formula that would match it.

But the St. Paul's pulpit and its decorative carving are a modern addition. They were made in 1964, and a dark yellowish wax was applied to the limewood to give it a "golden oak" tone agreeable to the taste of the time. I began drifting off a little, trying to remember which circle in the *Inferno* it was that Dante reserved for perpe-

trators of fraud and falsification. Young talked on. He'd left out the lime in his beeswax and turpentine mixture, and in its place used yellow ocher pigment. The new color was approved, and on he went, blowing off dust and brushing on the wax.

He added that he thought the carvings had been treated with linseed oil in the 1950s. Someone had told him that whenever an important delegation was about to visit the palace, the manager would send a carpenter up a ladder with a bucket of boiled oil to freshen the carvings. Luard remarked that mold loved linseed oil, and this might explain the bloom of red mildew he could see in a few places.

Young developed an interest in the Hampton Court carvings, and for some years after he gave talks in village halls about his activities with Gibbons's work. He'd never read any books on the carver, though, he explained. Then he leaned forward and became conspiratorial. "I'll tell you something else. There's been a big mistake. Gibbons didn't use limewood, he used pear wood. People said limewood but they really meant *limed* wood. Wood that's had a lime wash on it." Silence. "That's my theory, anyway."

In another aside Young talked of the peculiar modern replacement carving I'd noticed at the bottom of one of the upside-down drops. He said that it had been added within the last decade. Apparently the authorities were unable to find a woodcarver and so they had a stonemason do the work.

Soon the well was running dry, and it was time to dismiss to the pub. Halfway through our pints it transpired that Fishlock and Young shared an interest in amateur dramatics. In fact they'd been in a production together in 1947. Fishlock remembered playing Icarus. Perhaps Young had played Daedalus? He couldn't recall this. Even so, it established an early association with the ill-fated use of wax.

Young left, spirits undimmed. The three of us walked back

across the river and climbed up into the Royal Apartments. The last of the carvings had just been taken off the walls and set in their coffins. Simon Thurley joined us. We talked about the lime wash. The conversation gathered momentum. I decided to propound my theory and make my proposal, without an inkling that I was sowing the wind and would reap a whirlwind.

W hy do we think of wood as brown? The day I first saw it I was astonished at the form and content and execution of Gibbons's altarpiece at St. James's Piccadilly, but its varnished appearance seemed perfectly natural to me. When it comes to carving—or paneling or furniture, for that matter—some shade of brown is the default setting of our expectations of wood's color.

But brown is not the color of the fresh-cut wood of almost any tree. The forest that lapped our valley in the South Downs was predominately beech, with occasional plantations of sycamore and ash. I sawed up blowdowns for firewood, so I could see that those three species produced light-colored wood. In the American woodlands here in these northern marches, this disputed borderland between cultivated field and wild forest, a dozen or more species of trees grow together amicably. If you look out from this workroom toward the river or hill, you can see in one glance—unplanted by man—sugar maple, red maple, yellow birch, basswood (the American version of linden), white ash, green ash, red oak, hornbeam, white poplar, black cherry, beech, a few doomed little elms, hemlock, white pine, white cedar, spruce, and fir. Probably some others, too.

Black cherry yields wood that is yellowish brown to start with, then soon deepens to a reddish chocolate. White oak is a grainy light brown. But the raw wood of all the other trees is decidedly pale, with only an occasional tint of color, usually in the heart-

wood. When the wind tears off a bough in the forest, you can mark the wound from a distance by a splash of white. True, many woods darken over time. But what has planted the "wood is brown" bias in us is not wood itself but stain and varnish and shellac. Brown is the habiliment we give to wood when we invite it indoors and put it to functional or decorative use. You could blame this on Victorian taste. But even in the seventeenth century the grainy brown of English oak would have been the normative color of woodcarving. And often as not, in Gibbons's day, too, the oak carving would have been varnished along with the paneling it was mounted on.

The world turned upside down, then, when Gibbons picked the palest wood in the forest to carve, and then left it untouched, applying no finish whatsoever. "So thinn the wood & all white natural wood without varnish," wrote an excited seventeenth-century traveler, Celia Fiennes, at first sight of Gibbons's new work at Windsor Castle. The carving floated ghostlike over the darker oak paneling. No longer simply marginal texture for the eye, it had a striking pale tone that pushed it to the forefront of any decorative scheme.

As we stood by those yellowy brown forms in their boxes that afternoon, talking about Mr. Young, I began to wind my way into my argument. It was understood from the start that limewood's pale tone was essential to the effect of this new kind of woodcarving. As soon as he'd finished at Windsor, Gibbons was given an allowance of one hundred pounds per annum to cleanse and preserve his work. A gentleman's income, to ensure that the white natural wood kept its tone, remained readable.

But Gibbons's is an unstable form, like contemporary art made with perishable materials. The years wore on. Fashions changed. Gibbons died. The wood grayed from exposure to light and, far worse, it was besmirched by coal and tobacco smoke. Before the

eighteenth century was out, Gibbons's carvings almost certainly would have grown quite dark, their distinctive white flash long gone.

But the memory of their earlier appearance was not lost, and at some point the royal Office of Works decided to try to recover the original effect. Lime wash was applied. Not a bad solution. A wash isn't paint. You can see through it to the wood underneath, so you know that you're not looking at plaster, for example. Depending on when the treatment was applied, it would mean that the carvings were light for a good part of their history. They were either fresh limewood or whitewashed.

So, shouldn't we restore this lightness? I launched into the argument that I would find myself rehearsing many times in the coming months and years. Two criteria should guide a restoration project's decisions about the final appearance of an object: either the artist's original intention or, failing that, the traditional appearance of the work. Sometimes these two standards war against each other, as with the Sistine Chapel restoration of the 1980s. But here the two converged. Gibbons intended his carvings to be pale, and pale they likely were, for one reason or another, throughout most of their life.

The idea is to return the palace to its state before the fire, said Thurley. Surely that doesn't mean slathering on yellow wax or linseed oil? I asked. No, he said, a return to an appropriate state before blunders. Thurley didn't dismiss outright the idea of lightening the carving. But I could tell he had doubts, and it wasn't hard to guess what they were. Introducing a pale ghost into these rooms would imbalance their tonal ensemble, to many people's minds. It would certainly violate the public's expectations. Anyway, did we know for sure that this really was a lime wash, or how thickly it had been applied? How much had it really lightened the wood? When had it been applied? It might have been a recent aberration, like the lin-

seed oil or the wax. An eccentricity of the 1920s or '30s, perhaps. Thurley remained collegial, but he began to look at me more narrowly. What does this person want now? Fishlock, polite and politic, stayed silent, and so did Luard. Round one to brown.

A n art that deceives. I was given my first taste of the little triumphs over the eye that carving can perpetrate on the day I first sold a piece of my work. Early one June morning, when the sun hadn't spilled over the brow of the eastward hill but the blackbird was holding forth in the walled garden, I arose to make my preparations. I'd spent six weeks carving a little flowered mirror frame I was hoping to sell at a crafts fair organized by the local Conservative Party. It was to be held in the long barn of a manor house in the next valley over, the valley of the winding Cuckmere. You could drive a circle route to get to the place. But we didn't have a car, so I proposed to walk the three miles directly across the Downs, with my carving and my tools in a pack on my back. A journeyman out of Thomas Hardy.

From bed Marietta dozily wished me luck, and off I went. Up Snap Hill, climbing into the sunlight, past the old dew pond, then onto one of the forest rides. A rollercoaster of up and down over folds of the Downs, before the path issued out into Charleston Bottom, the remotest of the valleys. Along a lonely farm track through a scrub of hawthorns still in bloom. Bright new leaves on the beeches, dew turning into mist, skylarks and a hovering kestrel, some warmth in the day now. Across a field with frolicsome heifers, through a gate, then finally in the back entrance of the manor gardens. An apparition out of the wild, that for a moment stilled the Tory ladies' preparations.

They gave me tea. I laid out some chisels on a table and clamped

a piece of limewood to it. I set the mirror among the tools and, like a stallholder, awaited my first exposure to the public. Soon visitors streamed past. I pretended to carve, pretended to be a carver. They asked a repeating set of questions but their curiosity was heartening. I felt like a spokesperson for a trade I hardly knew myself.

People kept touching the carving, and I kept explaining that the wood was unfinished and would pick up oil from hands, that even I didn't touch a carving unless I had to. Eventually I wrote an admonitory sign. A woman came and said she just couldn't resist it, as she ran her finger along the arch of a stem. She said she could see that I'd carved that little branch and then just bowed it into its curve. Some kind of cognitive dissonance was going on here, or some kind of confusion about the medium. She must have known that wood couldn't be flexed in that way, but for a moment she was reasoning with another part of her brain.

Later a man appeared who gave signs of being similarly duped. We talked a little. He went off, then returned and bought the piece. I watched him walk away, holding it in front of him with both arms outstretched, a smile on his face as he looked in the mirror. My carving had been replaced by pound notes. I thought about this transaction, and a first seed was planted of the attitude that has stayed with me ever since. I would work for other people, not for myself. On commission, if possible, or at least always with a purchaser in mind. I'd allow other sensibilities into my workroom and let them have a hand in shaping the carving. It would belong to someone else even as I was designing and making it, and the moment I'd finished it, it would disappear.

The full consequences of this way of working gradually revealed themselves. If I wanted to move my work in a certain direction, then I would have to convince a patron that he or she wanted that kind of carving. It was the way the arts used to work. You don't

imagine that Michelangelo or Bernini made a practice of carving sculptures to their personal whims, then putting them up for sale in fashionable galleries on the Via Giulia, do you? There's a price to be paid for working only on commission. I don't own any of my carvings. If you walk through my house you won't guess my profession. The shoemaker's children go barefoot. Around here carving is a verb (well, a gerund), not a noun. Nouns leave the house.

The sun lowered and the craft show drew to a close. A long summer evening was upon us. I packed up my tools and walked home through a purply gold landscape that Poussin and Plotinus had collaborated on. Beauty flooded the world. Body floated in soul. Maybe Van Gogh had grabbed a brush, too. Through the Arcadian dales and then into a grand hallway between hills, opening northward to a vignette of the shadowy Weald stretching into blue. In the slanting light I felt as gilded as the woods and meadows. Down the last slope to the cottage by its circle of elms. Marietta was working in the garden. We went into the house together. I threw a hundred pounds down on the kitchen table. *What do you think of that?* The money rang.

Other cheering little deceptions occurred. Before we left London I'd come to know a dealer in old frames and carvings. He was a former Polish partisan, a non-Jewish assassin of SS officers. He'd survived Auschwitz and Buchenwald and now spent his days in Belgravia among eighteenth-century mirror frames and an occasional school of Gibbons carving. One day he gave me a little seventeenth-century limewood decoration and asked if I thought I could copy it. It was a stylized pomegranate flower, with a seed head that morphed into an acanthus leaf and a spray of forget-me-not flowers. The wood had turned gray with age. I picked up the carving like a gauntlet and went back to the cottage. Three weeks later I brought my pale new version back to show him. He looked at it for a moment.

"Oh," he said, "I see you've cleaned it up." I said nothing, trying to contain my pleasure as I reached into my bag and handed him his original.

He laughed, and told me to keep both carvings as a reminder that I'd managed to hoodwink him. Every few years I take them out from a shelf under my workbench. Mine is darkening with age now, so it's a little harder to tell the two apart at first sight. But put them side by side and it's easy enough to see the fine decisive cutting in one—to see that I was no match for the earlier carver. Not long ago it occurred to me that the canny dealer may have known exactly which carving I'd handed to him, but had decided to encourage me. Perhaps even to suggest to me that a streak of trickery runs through the arts. I wonder if he calculated that the time might come when I'd look at the two carvings with a more informed eye, and realize who'd been duped that day.

I was managing to make a little regular money by copying mock-Georgian ornaments for a mantelpiece shop in London. Stylized urns, shells, drapery, and other thin little appliqués, in pine, for a pound or two each. I hoped that the speed and efficiency this piecework taught might have a spillover effect on carving that was less repetitive. The owner of the shop, a carver himself, encouraged me to do my own work and show it to him.

In a compassionate gesture, Marietta's brother said he'd pay me $250 for a carving. I had the idea of doing something that incorporated insect damage, torn leaves, and broken stems. Gibbons's cloud had already drifted over me, and this was my first attempt to steal out from under it. I did an arching tangle of foliage and within it a hybrid rose whose stem was half broken, so that the blossom dangled face-down, out of place, disrupting the flow of the carving. It succeeded in one sense, anyway. I took it to show the mantelpiece carver, and when I unwrapped it he said, "Uh-oh, you've had a

break there. I can give you some glue." It delighted me to trick the eye of professionals, in those days when I was trying to dupe the world into thinking I was a woodcarver. An old story. The young Giotto painted a fly on one of Cimabue's faces and watched his master try to brush it off.

As I write this spring barges in, late, with warm breath and copious tears. They turn the world into a brown study, with only a few chalk highlights. Sleigh bells at night, the chorus of little frogs, spring peepers, getting the season wrong as usual. Freshets, vernal ponds, mud everywhere, the dirt road a quagmire: surface water kept there by the frozen ground below, winter's last redoubt. Now warmer still and the chalk accents disappear. Traffic jams of Canada geese honking their horns. The river floods and makes its accustomed shortcut across the pasture, neatly banked by bright new grass as if it always flowed there. A chill of snowmelt in the air around it, winter expiring. Birds sing, the flood makes its *shwshw-shwshwsh*.

A long winter in the workroom is over, too, now that I've finished a strange and arduous project. Seven small carvings, each in a different native American hardwood. I hadn't worked in anything but lime since the days of the pine mantelpiece ornaments. Seven would-be trompe l'oeil compositions, each with the wood's name incised in the patron's handwriting on a curling piece of paper, embowered by the leaves and seeds or fruit of that tree. Ash, beech, birch, maple, cherry, elm, and oak. I can look out at the hillside now and see each of these trees just beginning its reverse dance of the seven veils, about to don one alluring chiffon after another.

For years I'd been tempted to break my old thralldom to lime and discover what the harder woods could teach me. Stonecarvers

plying their iron dummy mallets had always seemed enviable to me, strong and athletic. My heavy lignum vitae mallet stood handsomely on the workbench, used occasionally for quickly removing wood that is clearly superfluous, but never for modeling. I liked the feel of it in my hand, and I liked the other hand's delicate thumb- and fingerhold on the chisel, so different from the way I usually grasped a tool. When you carve without a mallet, the continuous propulsive force of one hand is restrained by the strong grip of the other. With a mallet, what drives the chisel is the single sharp impulse from a blow, hard or soft. The function of the hand holding the chisel isn't to restrain that impulsive force, but to direct it by delicately adjusting the chisel's angle of attack.

So, mallet in one hand, chisel in the other, I began the wasting away on my first little design, in white ash. With the first blow I found myself in an unfamiliar hard place. Old pleasures fell by the wayside. I was no longer carving with my full body, twisting my torso with every large stroke. Striking with the mallet was a localized arm motion, from the shoulder down. My arms grew tired but I did not. There was a violent abruptness to the work. The house rang with the crack of the blows. I decided to wear earplugs. The information that fed back into my hands was of lower quality. It was harder to enter into the private life of the wood and sense its grain structure. Even light taps of the mallet couldn't establish the intimate relationship gained by using the hands alone. Use a second tool, the mallet, and you take another step back from your material. A twice-mediated experience, now.

It was a dangerous world. Just to make sure we understood each other, the first thing the ash did was break the fine edges of my blades. No subtle discourse from now on, no long thin bevels. For these ironlike woods I'd need short stout angles, which meant many hours of modification with the grindstone. Even then, if you

didn't work obsequiously with its grain the wood snarled back. Tore out. When you cut across it, instead of a delicate zip there was a coarse protracted crunch. The woods were rough and oversensitive at the same time. They existed in a culture of honor, where a request perceived as unseemly elicited a vicious response. Push them too far and they'd just split.

Ash was a hard case. Birch and beech, thuggish recidivists. Sugar maple (called "hard maple" for good reason), the worst bruiser of all. I'd hoped that the lark of the project would be to model these new woods as if they were lime. Turn their thick torsos into elegant thin figures, to test the hypothesis that almost any species could be carved to a limewood fineness if you had gumption enough.

I wrestled with one wood after another, and finally pinned my last hopes on oak. Once at Hampton Court I'd bet Mike Fishlock five pounds that some heavily varnished foliage carving high on the wall of the Cartoon Gallery was limewood. Oak, he'd insisted, and when I went up a ladder I saw that he was right. It might have been that Gibbons's workshop embraced the old medium for an unknown reason. Perhaps they really had run out of lime this time. Or maybe it was the work of a clever carver in the English tradition. Jonathan Maine, for example, a patron-enraging "sawcy rascal" who obdurately refused to give up oak, and learned to model it with something like limewood fluency.

My oak piece may have been more like lime than some of the others, but if you looked closely you could see where the modeling fell short. The edges of leaves didn't make a strong, clean, thin line, the stems weren't strikingly slender and flexible looking, the undulations of the surfaces lacked extravagance and subtlety, the undercutting never rose to that radical extreme that gives carving an ethereal floating quality. Not to mention that the oak's brown tone instantly distinguished it from limewood. Still worse, the handsome

strong grain wended its merry way across the carving, distracting the eye from the forms. Even the five lighter species of wood I carved didn't have the unblemished pallor of limewood. It turned out that John Evelyn was right when he said that lime's "candour" dignifies it above all the woods in the forest.

I'd tried to lead those seven woods toward that upland place that limewood occupies, but they balked on the path like recalcitrant mules. There was no moment of transubstantiation. Nothing to disturb the hairs on the back of your neck. The experiment is over. I've returned those woods to their world of tables and chairs, cabinets and paneling, floors and mantelpieces and turned bowls. They were happy to go. Not a glance over their shoulders.

So, back to limewood, as a voyager to his native country. The end of all our exploring is to arrive where we started, says Eliot, and know the place for the first time. I'll tell Penelope that I appreciate her pale soft flesh as never before, and promise not to leave her again. Really! I've made tokens of commitment. After penitential days with grindstone and strop I've repaired the damage that those embarrassing flirtations with harder woods inflicted. My gouges' long fine bevels have been restored. There they are on the workbench, keener than ever for their old partner.

In early October, still awaiting my workbench and a life-size print of the missing drop, I used my forays to Hampton Court to drink deep draughts of Gibbons's work, and plan my own carving strategy. But idle hands are the devil's workshop, so I found myself scheming about the rejected Grinling Gibbons exhibition. I'd just finished my article about the upside-down and backward carvings. It ended with a plea for a Gibbons show at Hampton Court.

It would be published in a few days. The editor wanted to print

an illustration, so I asked Mike Fishlock about using one of the palace's photographs. He gave me the name of someone in the Property Services Agency's press office who could help me. Then he added that I would be expected, as a matter of course, to submit a copy of the text for approval by that office. Oh? Yes, he said, this was an obligation of all employees, even independent contractors.

I was taken aback, but I said I'd telephone the press officer. The man turned out to be smooth and ingratiating, and to speak with the voice of the devil. Yes, he expected to be given a text to approve. "I do not think you will find me difficult in this matter." But he also would have to submit a copy to the palace administrator, and he couldn't answer for his reaction. "I don't know his own strategy for marketing the palace." What? Every article had to conform to a marketing strategy? Wasn't Gibbons's work part of a common cultural heritage, and shouldn't it be the subject of a free exchange of ideas? As if the function of these carvings was to help in the selling of Hampton Court Palace!

Up on a high horse I vaulted, Gibbons's champion, brandishing a righteous sword. You have to grow tense with some sort of violence before you can find your work, said Yeats, but maybe a transgressive streak is needed afterward, too, sometimes. The press officer's final comment stuck in my mind. I told him that I didn't think that the journal, on principle, would publish censored articles, and his response was concise: "Don't tell them." The fumes from this conversation had grown sulfurous.

On the walk home, under the lime trees, I decided that I would tell this prince of darkness that I'd decided not to use any photographs from his files and that I wouldn't be submitting my article to him. I'd give Fishlock and the administrator the text, saying that it was being published shortly and I thought they might enjoy reading it. At a dinner party that night I canvassed two writer friends.

One urged caution, the other approved of the plan. A politician sitting opposite endorsed it for robust civil libertarian reasons. He slammed his fist down on the table and told me to publish and be damned. Not a reassuring use of the famous phrase.

A few days later I dropped off one copy of the text at the administrator's office and delivered another into the hands of Mike Fishlock. Later, walking through the Eden-like Fountain Garden, I encountered a besuited young man. He was wearing a cross on his lapel. He announced that he was the press officer, and that he'd hoped to catch me so he could collect the article for his office to look over. I declined his request. He rehearsed his arguments, I mine. He said he would have to report this to his superior, and added that he knew the administrator would want to have a copy. "He has one," I said. "No," he replied, "I've just discussed the matter with him and he does not."

I told him that I'd given both Fishlock and the administrator copies of the text as a courtesy. He replied by saying that he knew Mike Fishlock didn't have a copy, either, since he'd just spoken to him, too. After he wound his way out of the garden I went to the administrator's office and was told by his secretary that she'd placed the text in his hands. Had neither he nor Fishlock told the press officer that they had the piece? Or were they all conspiring together to see whether I would go through the proper channels by submitting it to the PSA press office? If that was the case, now they knew.

I might as well be working in an office! Or in the dour sixteenth-century part of the palace, under Henry VIII during his reign of fear. In the days that followed I had a feeling of calm before the storm. But no storm broke. The article was published. I suppose my views were noted. The switchboard of the palace wasn't jammed by a public outcry for a Gibbons exhibition.

David Luard took a copy of the printed article to Mike Fishlock and relayed back to me his comment that he didn't see how I'd got it past the PSA press department, and didn't think this outside publicity would do the exhibition any good. Later Fishlock asked me whether I'd had any reaction to the piece. I said I hadn't. He said he didn't think it was too critical of anybody (the closest thing to a compliment I was likely to get from him, I thought), and asked if I'd cleared it with the PSA. I said I'd refused to submit it. He said he thought I could get away with that once, but if he were me he wouldn't try it a second time.

S till no workbench and no photograph. Halfway through this book and I still haven't picked up a chisel at Hampton Court. I apologize. But those September and October days reaped a golden, disconcerting harvest. One afternoon I slipped into the conservation room to look at a patch of bare wood newly revealed by Luard's cleaning of the Audience Chamber overmantel. I stared at it, bent closer, stared at it some more, and by the time I straightened up the world had collapsed about me. Well, a long-held article of faith anyway, a notion I'd made into a guiding principle of my own carving and incorporated into the specifications I'd written for the carvers at Hampton Court.

Gibbons did not use any kind of abrasion to smooth his surfaces, of that I'd been certain. It was one of the foundations of my understanding of his carving technique. Two weeks earlier I'd been gratified to hear Richard Hartley vowing obedience to my rule that sandpaper should not be used on the replacement carving. Gibbons had taken his work straight from the chisel, and if the new work was to have an authentic Gibbonsian appearance, then so should we.

Long ago I'd been seduced by John Ruskin's eloquent scorn for

sandpaper and the "the smooth, diffused tranquility" of the surface it creates. It reminded Ruskin of machine work, or of the work of men who "turn themselves into machines." The best finish, he argued, "is oftener got by rough rather than fine handling." I translated this into meaning that the little facets left behind by a carving chisel break up the light and give softness to the surface. I'd developed a method for smoothing with a gouge: a scraping-like series of little strokes, often with a reversed tool and from several different directions, that evened out irregularities. The surface that resulted from this painfully slow procedure wasn't exactly rough, in Ruskin's sense, but it had, I thought, some character to it.

But there in front of me were surfaces that were appallingly smooth, smooth as paper. The thin edges of petals and leaves had been subtly rounded over as well. When Luard wandered in, I tried to retain my equanimity. Maybe Gibbons used scrapers, steel plates of various sizes and shapes with a burr on the edge that neatly takes off a very thin layer of wood. I had a set that I'd experimented with, given to me by an old furniture carver. But the surfaces of naturalistic foliage carving are complicated and often not easily accessible to scrapers.

And there was something else I'd noticed even before Luard drew my attention to it. The wood had strange abrasion marks on it, striations that sometimes went with the grain and sometimes across it. Luard looked at me and dropped his military self-assurance for a moment. "What are those?" he asked. I said I hadn't the faintest idea. But that one, I said, pointing to a tiny long single scratch that looked as if it followed a chisel stroke, may be the mark that's left behind when your blade has a little notch in it. (I was gratified to see that even Gibbons's men sometimes kept on carving for a while even after there was a nick in the blade. I'd always regarded that as a moral weakness—you should go straight to the stone and

remove the nick before it got worse—but it was a vice I regularly fell prey to.)

Luard pointed out that most of the striations didn't look like blade nicks. They were made of several parallel lines. "I know, I know," I said, and floundered for a while. Another idea struck me. Maybe these scratches and scorings were left behind by crude Victorian attempts to clean the wood with wire brushes. Luard took out a magnifying glass and scrutinized the wood. "Well, the lime wash was put on after these scratches were made." So the cleaning attempt must have been made quite a long time ago. But that could be, couldn't it?

I clutched at this straw, but felt myself sinking. The next day I was in the carving room, as usual staring at a piece of Gibbons's work, a drop that had just come down from the apartments upstairs. Luard appeared and said he had something to show me. He was back in his arrogant guise again. Not a good sign. I followed him through the door. He had just pried off a superimposed layer of carving from the overmantel. It had been attached to a platform in the layer below by a handmade square nail, now rusty and loose, which was to be replaced with a more secure modern screw.

There was every likelihood that this layer of carving had been undisturbed since the day Gibbons's men nailed it on. It extended out from its platform to conceal about four square inches of carving on the lower layer just beneath, which therefore would have been inaccessible to lime washing or cleaning. It was virgin territory, free from all later manipulation. A treasure, a time capsule, looking into the light of day for the first time in three centuries. And there, if anything more prominent than elsewhere, was the same smoothed surface, and on it the same curious striations. I grasped for other straws but found none. Down I sank. Everywhere I looked now I saw those tiny parallel scratches. They softened chisel cuts, smoothed

the undulations of surfaces, rendered consistent the edges of leaves and petals.

Some kind of abrasive process. Sanding, perhaps? But Gibbons didn't have sandpaper. It wasn't invented until the nineteenth century. In a piano factory in Bristol, it is said. The word first appears in print in 1825, in a volume with a title that would give ammunition to Ruskin: *The Operative Mechanic and British Machinist*. "Glasspaper" had appeared ten years earlier in an American journal.

Besides, those sets of parallel striations didn't resemble anything left behind by sandpaper. Neither Luard nor I could think of a tool or a substance that might produce them. At once the marks became the primary clue in a puzzle that would occupy us for months to come. It had to be solved if we were to know for sure what the final step of our own carving process at Hampton Court should be. Or would sandpaper suffice to create an approximation of Gibbons's surfaces?

And what were the implications for my own work? If I embraced a shortcut like sanding, would it drain life out of my carving, as I'd feared? Should I discard a sophisticated technique that yielded good results, for the sake of saving time? For that matter, why should I tag along behind Gibbons in this respect? Perhaps he was corrupted by his high-volume workshop operation and compromised quality for the sake of profit. Blasphemous thoughts welled up.

More revelations. The beautiful composure of these carvings suggests consummate control over their design and execution. But beauty, says Yeats, is a storm-tossed banner. Luard began to find evidence that there had been some little dramas in the making of these carvings. Look at them from the back and you can see their backstories: the scrapes and shifts and modifications on the fly that went into their construction. In one pair of drops a spray of

leaves arched out to the side in a mirroring way, at the top of each carving. Gibbons had extended the spray a little farther in one of the drops, by cutting a step or rebate in the back and pinning in another couple of leaves from behind. Plainly he hadn't liked what he'd seen when the two drops were finished and placed side by side, so he made this inelegant but effective adjustment. We found other little nonce repairs, pinned and glued in at the last minute to modify designs or conceal gaps. Restless fiddling, to the very end.

Another day Luard showed me the back of a carving where instead of the usual smoothly planed surface, there was a random pattern of deep gouge stabs—damage from blades violently rammed into the wood at various angles. Some of the cuts were so deep they nearly went through to the front of the carving, and the whole board was dangerously frail. At a glance any carver would recognize these stab marks as the damage you see on the top of a carving workbench (or rather, on the board you put under a carving to protect your workbench from damage). Gibbons or his workshop had used this board for such a purpose, and then press-ganged the board itself into a service for carving. Why? The only explanation would seem to be that Gibbons had run out of lime-wood and was in desperate straights.

Product often conceals process. What the viewer can see or deduce of the making of a thing is smoothed over by the completed thing's serene presence. Besides, get far enough away in time or space and everything looks choreographed. In an aerobatic airplane show the spectators on the ground see a smooth dance of close-formation flying, but inside the cockpits it's said to be a chaos of jittering control sticks and lurching adjustments. The slipping and sliding climb of a snowshoer becomes a stately progress. A little slipping and sliding, too, on the way up the steep slopes of Gibbons's carvings.

Another backstory gave a glimpse into the sensibility of the men

who climbed those slopes. The separately carved layers of work are attached to little concealed platforms in the layer below. Luard found graphite marks on these platforms that coincided with marks on the bottom of the attached layer. When I make such placement notations, I use numbers or letters, without the least thought for their appearance. What we found here, though, were elegant patterns of looping lines, like ciphers or flourishes in fine calligraphy. What could have motivated Gibbons's carvers but the pleasure of making handsome forms? The sense of beauty that ran in their veins couldn't be repressed, even in simple notations that would disappear from view immediately, and probably forever.

Gibbons's control over his workshop wasn't sufficient to extinguish the individual personalities of his assistants. The forward showy blossoms in these carvings, it's true, are astonishingly consistent in their modeling, as if Gibbons himself had always intervened at critical junctures. Or as if he had a single specialist for each species of flower or leaf. Or as if, over the years, his workers had developed an almost clairvoyant sense of their employer's approach to any given modeling task. But as I grew more familiar with the carvings in the King's Drawing Room, the hands of different carvers were beginning to be identifiable in their treatment of the simpler repetitive forms.

The lower part of each of the four overdoor drops had a thick rope made up of trefoil leaves, rather like shamrocks, and the modeling of these varied slightly from one drop to the next. In one the leaves were longer and narrower. In another they had central veins. In the missing drop, judging from the photograph, the spaces between the shamrocks were larger and more deeply excavated. It wasn't that there was more latitude in the treatment of these repetitive elements, which allowed the carvers to express their personalities. In fact there was less latitude, less scope for flourishes.

It seemed that the very simplicity of the forms had freed their individuality.

Once I gave some lessons in foliage carving. I proposed to the students that we reject the idea that carving should be a means for self-expression. That we banish the culture of narcissism and exhibitionism from the room. The assignment would be to carve a laurel leaf, a leaf of extreme simplicity. I asked the students to throw themselves entirely into the leaf, seek its essence and express only that, putting aside their personalities and carving only with hands and eyes. I mentioned John Keats's praise of Shakespeare as a chameleonlike artist who could lose himself completely in his subject.

And at the end of the day? There were eight individual leaves, some more compelling than others, but each distinct from all the rest. The leaf had been perceived in dissimilar ways and this had led to different saliences in the resulting carvings. Trying to express the leaf, the carvers inadvertently had expressed themselves. But it was a superior kind of self-expression, coming not from narcissism or exhibitionism, but from a union with their subject. It was unconscious, unintended: an unimportant side effect. The little shamrocks Gibbons's carvers did without thought also ended up mirroring their individuality. (Since the nineteenth century art historians have used such unconscious habits in modeling minor details as a way to identify individual artists.) If you want to express yourself, stop expressing yourself.

Better yet, stop wanting to express yourself. One of Poussin's greatest paintings is a landscape with Diogenes in the foreground, casting away his bowl when he sees a young man drinking from a pond with his hand. Diogenes has given up the last of his possessions, the last extension of his selfhood, and what does he get in return? Stretching away behind him is a landscape of luminous beauty,

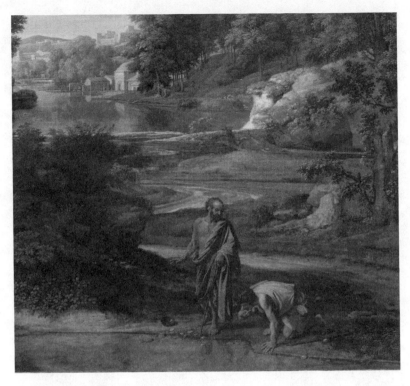

Nicolas Poussin, Landscape with Diogenes *(detail), circa 1657. Louvre, Paris.*
Réunion des Musées Nationaux/Art Resource, NY

hill and lake and high meadow, garnished with gorgeous palaces and solemn temples. He has gained the whole world. His perceptions have been cleansed. He will live in tranquil union with nature.

Not many of us can emulate Poussin's Diogenes. But in the little world of the workroom? You can cast away your bowl. That would be my advice. Forget yourself. It will improve your work. Let the things you make proceed by their own design. When they cease to be an instrument for some other purpose, the shadowy leaves and blossoms and half-hidden stems that stretch out on your workbench will be their own luminous landscape.

Finally the full-scale image of the missing carving arrived from English Heritage. Cropped to the shape of the drop, it unrolled like a narrow seven-foot-long Chinese scroll. I pinned it up temporarily in Mike Fishlock's office in the Banqueting House. This was the two-dimensional model I'd be scrutinizing incessantly in the months to come. Taller than I, this slim figure. I stared at it and it stared right back. Few of the elements pictured there were unidentifiable, and only a few were seriously damaged. The forward petals of a prominent tulip were missing, and I knew I'd have to throw myself into Gibbons's conception of the tulip form to figure out the likely shape of their replacements. One platform was empty of carving, and following my own specifications I would leave it that way rather than speculatively carve something to fill it.

The photograph had been lit from below. What shadows there were fell upward, giving the piece an odd theatrical look. I feared that it ratified Bernini's remark that if you wanted to alter the appearance of someone, light their face from below. The surviving three drops suggested that this carving projected six or eight inches in places, but here in the photograph much of it appeared flat as a pancake. The topography wasn't easily decipherable. Was that group of little cinquefoil blossoms forward from the pair of crocuses next to it? You couldn't tell. Still worse, it was hard to determine what the syntactical units of the carving were. The forward layers would have been grouped into separately carved pieces, but it wasn't clear how this tangle of foliage was portioned out. I would need to turn the photograph into a design drawing before I could saw out the separate components in preparation for carving. But it wasn't at all clear where to draw the lines.

A couple of days later my workbench appeared. That morning I'd walked down the lime allée through a cold misty rain, then

along the north front of the palace to the security office on Tennis Court Lane where passes are collected. Hardly a soul on the palace grounds. I was told that the conservators were taking the day off, so I'd have the place to myself. For the first time I was given the key to the apartments. As I walked down the echoing passages, stone sweating with damp, I looked in my hand and found a seventeenth-century chased silver key, fine as jewelry. The Earl of Albemarle would have held it once, perhaps even the king himself. The lock turned easily, and I felt my way through the dark conservation room to the thin lines of light I knew leaked in around the shutters, found the iron bar and hook, raised the latter and lowered the former, and swung the oak panels open, letting in enough light for me to proceed on my way to the carving room next door.

There I opened the shutters on both windows and surveyed my new home in the intimacy of solitude. Outside all was quiet and gray, the low wet clouds moving swiftly over; inside quieter and grayer, as if three centuries of stillness had deepened the silence. My workbench had been lifted through the window and now stood in the middle of the room. I pushed and pulled it over to the right-hand window, which offered a view of nothing but construction shelters, a good nonview for a carver. Then I found a vacuum cleaner in a closet and spent the next two hours Hoovering floor and tables and bench. I rearranged the furniture to indicate work spaces for Trevor and me, each with its window. Then I unrolled my photograph and carried in Richard Hartley's drop from next door and experimented fitting my photograph to it. The sizes didn't seem to match, but I decided to worry about this later. Then I did more housekeeping in the room, like small talk with a stranger as your acquaintance grows. Outside the gray afternoon rolled on, inside the light faded and the silence grew deeper. I laid my four tool rolls, carefully sewn by my mother, on the workbench.

B ut there was delay after delay and the tool rolls remained tightly tied up until the first day of November, nearly two months after we'd stepped off the plane. The previous afternoon had been dazzling, with dark blue sky and piled-up clouds of brilliant white, lacking only reclining gods to make it like a painted ceiling. This morning the rain had begun again. I pulled the dripping brim of my hat down over my brow. The palace grew larger and larger at the end of the allée. To amuse myself I tried to compose the sort of invocation that might once have been used to sanctify grand endeavors. I got as far as "Grinling Gibbons from your rest / In the islands of the blest / Come into this quiet room . . ." but with that the muse gave up on me.

Trevor Ellis wouldn't start until tomorrow, so I was alone in the workroom. I turned on the beamlike photographic lights we'd set up above our workbenches, and began the ritual of opening out the tool rolls, removing the chisels, and arranging them on the bench top. There was hypnotic pleasure to shaking hands with old acquaintances and putting them in their familiar places. It occurred to me that they were almost all Sheffield tools, so it was like a homecoming for them. S. J. Addis, with a Masonic compass and square on the blade, Herring Brothers, Prize Medals—old makers long gone. Some early Acorn tools, a few with the Alec Tiranti name on them. Buck Brothers, Sheffield immigrants to the United States, one or two Hero tools, made in Germany. Some of the carvers had inscribed their names on the handles. Burtenshaw, Richardson, Heyman. Long dead, all, but their chisel blades are perpetually reborn. Now they were as razorlike as they ever had been. They inflicted little cuts on my fingers as I slid them out of their pockets. A few drops of blood, like a sacrifice or a bond.

The rows of tools lengthened. I placed the blades toward me as

always. Once I was told that this was so the carver could look at the blades and pick out the needed tool quickly. It isn't that. When you put a tool back on the bench after use, you might nick it on another blade if you set it down with its blade forward. So you flip the tool and lead with the handle, which will neither do damage nor be seriously damaged. Now, like a parade ground, the bench top was filling with rows of shining steel, with handles the color of Madeira wine, from pale Sercial to burnt Malmsey. They seemed companionable with the oak wainscoting, as if they, too, could bring something of stature and history to the room. Soon David Luard wandered in to admire and comment. I tried to remain nonchalant, but I grew more and more pleased with the mise-en-scène spreading out before me.

Luard wandered off. I clamped a piece of limewood to the workbench, then picked up a large skew chisel and gave it the flip that makes the handle plop into the palm. Other hand to the shaft, then into the wood the blade went. Each sweep of the chisel seemed to sweep away annoyances. The long wasting-away strokes awakened the large carving muscles in shoulders and back and stomach. The prisoners were let from their cells. A sense of well-being washed over me, as if I possessed my fate again. As if a winter had loosened its grip. The lime was dense and sure and almost oily in its smoothness, and the blades were as fine and wicked as could be, never skittering off line, leaving in their wake a polished swath.

I was so flooded with gladness that I had to stop, put the chisel down, and walk about the room, back and forth, to give vent to my excitement. After a while my cheeks began to ache, and I realized that I'd been smiling the whole time, like an idiot, with a painfully wide smile. Meanwhile the cuts had started up again and my fingers were dripping blood on the floor.

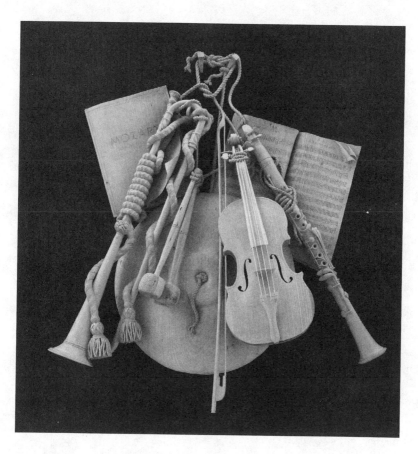

 D. E., *musical trophy, limewood, 2004.*

CHAPTER VI

Begin as a God, End as a Slave

I was settling down to carve again when Mike Fishlock appeared, accompanied by a distinguished architect he was showing around the project. They left before long, but in their wake came a journalist who stayed to ask questions. Next at the door were Simon Thurley and his boss from English Heritage, Juliet West. I'd better get used to this. The carving room had already become a destination on the grand tour. Luckily I'd managed to get my smiling and bleeding under control. And the chisels and gouges gleamed on the workbench, giving visitors something to enthuse over.

Thurley's boss delivered a paean to the tools. How had I acquired them? I told her I'd bought some new and found others in antique shops and street markets, but most had come to me by good fortune. Twice in America complete strangers had telephoned to ask me to look at some old chisels that had come down in their families. Both times I was amazed to find, spread out before me, dozens of magnificent Sheffield veterans, varied and subtle in their

◆ Left: The 1907 glass plate photograph of the King's Drawing Room overmantel. The chalky remnants of an earlier lime wash treatment can be seen. © Country Life

shapes. I told both families that their chisels and gouges were exceptionally beautiful and that they would be quite valuable to collectors, who would display them decoratively. Both families replied that I misunderstood their motives. They were following the wishes of their ancestors, European immigrants who had been professional carvers all their lives and wanted their tools to stay in the trade. I was to repack the tool rolls and take them away with me. They would not accept my money.

West grew businesslike. She began asking about the backward and upside-down carvings. She said that her director had thrust my article into her hands. English Heritage didn't adhere religiously to an "as found" policy, she volunteered, but they were inclined to require excellent reasons before allowing changes. Like nail holes that matched up.

Conversation turned to the drop that Trevor Ellis would be restoring, which had just been brought down from the Audience Chamber. West and Thurley stared at the victim in its coffin. It was badly burned on the right side, with extensive charring and some outright destruction. They inquired about plans for conserving the piece. I said that Mike Fishlock and others from the Property Services Agency had decided, along with Ellis, that the state of the drop was so dire that the best recourse would be to recarve the whole thing. Or anyway, to saw off all but the undamaged strip on the left and recarve the rest. West and Thurley expressed horror. To their way of thinking, every possible part of the original should be consolidated and retained.

Two bureaucracies were circling each other over Gibbons again. What were these carvings, really? Decoration or sculpture? In PSA's view they were fundamentally the former, part of the fabric of the building. They were, well, fungible. Replaceable. Ellis's work would be crisp and undamaged, and so in a sense more correct

than the charred and reduced forms the fire had left behind. By contrast English Heritage—for the moment anyway—was inclined to regard the carvings as unique sculptures, to be preserved in the original wherever possible. Gibbons was hiding out in his usual border country, eluding capture by either side. West and Thurley decided to arrange a Yalta conference with the PSA. The meeting would define Ellis's task by drawing a boundary line between what should be replaced and what should be consolidated and conserved.

Poor Trevor! He was expecting to replace the whole piece, or almost all of it, but now he was likely to face a more finicky task. Trevor was pragmatic and adaptable, however, beneath his strong-willed manner. We'd first crossed paths four years before. He was one of the carvers I'd assigned to make leaves without expressing themselves. The others in the class were beginners and hobbyists, but Ellis was an experienced professional who'd decided to branch out into limewood foliage work.

Like me, but even later in life, he'd taught himself to carve. He'd brought to the trade hands that were skilled enough to land planes on aircraft carriers. His first career was as a Royal Air Force pilot. Robust and blue eyed, he looked every bit the part, though he was taller than I by a couple of inches and must have pushed the maximum pilot height limit. I'd never met a better carver. It had been between him and me for the job of replacing the lost drop.

He arrived with Mike Fishlock the next morning in seeming mild spirits. When Fishlock left, though, he strenuously asserted his desire to replace the whole drop rather than just the charred section. I hinted that he might have to preserve even more original wood than he feared. He gave me an exasperated look, though there was no sign of frothing anger beneath. I knew Ellis was proud of his versatility. If you wanted it carved, he would carve it for you, whether it was an architectural ornament or a walking stick or a

ship's figurehead. Not that this adaptability had diluted his skill or his ambition. Recently he'd picked up Gibbons's gauntlet and made an almost flawless copy of the point lace cravat in the Victoria and Albert Museum. He would have no truck with pretension. He called himself an artisan. Not for Trevor the term "artist-craftsman," a phrase that throughout most of history would have been regarded as redundant, and now seems at once pretentious and demeaning.

Ellis took pleasure in repetitive work. I think it allowed him to set himself games of timing and efficiency. Two months before, Uppark House in West Sussex, not far from Trevor's home, had burned to a shell, and the National Trust had just announced its intention to restore the house to its state on the day before the fire. Five years of carving work! Trevor reveled in the prospect. But that was a formal Georgian interior, and almost all the carving was painted shallow-relief architectural ornament, tediously repetitive. There would be hundreds of feet of incised molding decoration to do, for a start. Trevor embraced the idea with gusto.

A bracingly old-fashioned attitude. After all, Gibbons himself may not have spent his days doing egg and dart moldings, but his workshop turned out thousands of feet of such architectural enrichment. And the payment accounts at Hampton Court suggest that this work brought him more money than his showy limewood carving.

S till, for all its hypnotic pleasures, repetitive carving of this kind is the work of people who, in Ruskin's phrase, have turned themselves into machines. People who can be replaced by machines. Who are *being* replaced by machines. With the invention of computed numerical controlled (CNC) machine tools, a millennia-old history of carving repeating decorative patterns by hand is drawing to a close. Almost any relief work without undercutting can be

produced by machines controlled by CAD/CAM (computer aided design/computer aided manufacture) programs. All the old molding ornamentations, with their colorful names—egg and dart, guilloche, Greek fret, acanthus and dart, bead and reel, among others; capitals of the Tuscan, Ionic, or even Corinthian order; brackets, rosettes, bosses, shallow friezes; anthemion or palmette designs; incised or raised lettering. In fact whole trades are being undermined. Marquetry and mosaic, for example. The hand-making of all such things is going the way of pit saws and treadle lathes. Routine work of every sort, in fact, white collar no less than blue, seems headed toward extinction: legal researchers are no less threatened than bracket carvers. Who knows who's next?

Yes, there's a nightmarish regularity to computer-controlled modeling. The machined surfaces it produces are dead moonscapes of doughy forms. Cuts don't have the depth and sharpness that a chisel can make. These aren't so much carvings as simulacra of carvings. Someone once showed me a picture of an acanthus-scrolled relief panel, unmistakably produced by CAD/CAM, and asked me to carve it by hand. A touching attempt at authenticity, I suppose. But it would have been easier to raise Lazarus. The thing had been drained of blood. It was one of the undead. And on what circle of hell would I be placing my workbench if I'd accepted?

But CNC work costs pennies and nothing will stop its advance, especially when the resulting objects are intended to be covered with paint or varnish or gilding. The robots are at the gates, invading body snatchers out to usurp the human hand for almost every kind of rote work. Carving is being redefined. The old neighborhood is being lost to technological sprawl. To tell the truth, much of what's falling away is stylistically moribund anyway. Producing it by machine will only render it more fully dead. The final nail in the coffin. Driven not by hammer but by nail gun.

To compete against machines on their own territory is demeaning, and economically suicidal. Yes, to a discerning eye the small irregularities in hand-carved enrichment keep it from looking like CNC machine work. But as the CNC cutting mechanism grows more refined, its modeling of edges and surfaces will improve. And how long will it be before some bright programmer gets the idea of writing randomness into the CNC code, and so introducing nearly imperceptible changes in angles and depths and spacing that mimic the spontaneous inaccuracies of the human hand?

What choices are left for woodcarvers? They can throw away their chisels and ply a new digital trade in front of a computer screen. Or they can start where CNC machines leave off. What makes handwork inimitable is what will allow it to survive. Nothing else. CNC has seized the soft lowlands. Carving's redoubt is the mountain fastness where it thrives best, the overhanging peaks, sharp arêtes, and shaded hollows that defy the geometrics of machine tools. In the last lines of his *Histories*, Herodotus recounts the advice Cyrus gave the Persians: better to live in a rugged land and rule, than to farm a soft plain and be slaves. Or be put to the sword, in this case, professionally speaking. Easy rote work is gone forever.

In those Hampton Court days, though, CNC was no more than a cloud on the horizon, "a little cloud out of the sea, like a man's hand," in the ominous biblical image. Trevor's mechanical pleasures at Uppark House were unthreatened. As yet the cloud was no bigger than the hand of a carver.

John Henry, the steel-driving man, could still defeat the steam hammer, and Trevor, with his size and strength, would make a good John Henry. He took a hardheaded approach to a project. For him as for David Luard, taking the job down a notch was a preparatory ritual. Before the matador, the picadors. Trevor pronounced the Hampton Court carving nowhere near as good as some of

Gibbons's other work. In fact it was "churned-out commercial stuff," a comment that probably wasn't meant to be wholly pejorative. He was gathering his energies, drawing the work into his ken. I gave him my lecture on scale and strength of line and readability in large spaces. He gave me an indulgent smile. Trevor's impatience with anything highfalutin was a tonic for me, though I always drank it with a dash of salt.

The piece of wood that my starving skew chisel bit into that first morning was a slightly curved block nine inches long, two inches wide, and three inches thick. It would occupy me for the next nine workdays. An inch a day. It was part of the double rope of trefoil leaves, like shamrocks, that twisted down the middle of the bottom section of the carving. One of the ropes bulged outward toward the viewer. The little block on my workbench would be that bulging section. I was taking my cue from the three surviving drops. They had similar twisting shamrock ropes, and in each of them the bulging part was a separate piece that had been glued in place.

Wait, glued? All the other added-on layers I'd seen in Gibbons's work had been nailed onto rough little platforms. Perhaps he used glue this time because the fit here was more precise and exposed than usual. The shamrock rope was a seamless continuum, from upper layer to lower. Somewhere in the shadows between shamrock leaves were the two connections with the lower extension, but from the photograph you'd never know where the glued-on part began or ended. The three surviving drops had provided clues, however. If you looked at them from the side, you could easily see the superimposed piece, and measure its length.

I'd taken the average of the three, extrapolated it to my photograph, and tried to guess where the glued-on part began and ended.

The only likely shadowy areas where the joint might be concealed made the piece an inch shorter than in the three other drops. That seemed odd, but what choice did I have? So I traced its outline, transferred that to a board, and band-sawed it out. After my first few strokes, it looked like a giant half-formed banana. There was puzzlement on the faces of the English Heritage officials as they looked at it that first day.

After they left I picked up my chisel again and continued wasting away along the edges of the block. The blade bit deep, the long strokes felt smooth and strong, and again the visceral memory of what it is like to carve flooded in. One hand against the other. A double grasp of the tool, which locks in both arms right up to the shoulders. In consequence each long stroke makes the torso swivel in countermovement, with the sweet inevitability of a natural force. That *contrapposto* countertwist. For a few golden hours the old motion seemed newly minted. The morning dew was on it.

Other old muscular habits presented themselves afresh. I'd always supposed, idly, that when you work with a hand tool your goal is to make the tool part of your hand, make *it* a part of *you*. Just now it felt the other way around, as if the body were being turned into a part of the tool. The butt of the chisel handle was hard against the heel of the propulsive hand. I looked down and saw that my forearm had become a shaft running straight away from the handle as if it were an extension of it. As if my arm had become a component of the chisel.

Did Giotto feel something like this when the pope's messenger asked for a sample of his work, and he fastened a paper to a wall, anchored his elbow against his chest, turned his forearm into the arm of a compass, and proceeded to draw an apparently perfect circle? I was holding my upper arms close to my body as an anchor of a different kind. They were locked into the muscles of shoulder

and chest, the big muscles that give stability and power. The lower arms became shafts that connected the tool to its motor, the twisting of the torso. So the arms hardly moved, in these deep long strokes. The torso did the work. The whole body carved.

I feel the same fresh pleasure here at home this spring morning, as I return to limewood after those months of using a mallet on its hard-hearted cousins, maple and ash and oak and the others. I've been roughing out a head based on Bernini's marble portrait bust of Scipio Borghese. I've decided to turn the plump cardinal into a celebrity chef. His cardinal's hat will become a chef's toque, and his face will be made out of vegetables and fruits he might cook: tomatoes for cheeks, a pear for his nose, eggplants for jowls, and so on, in the manner of the sixteenth-century painter Giuseppe Arcimboldo. The idea may be wacky, but the execution is deliciously familiar.

Carving as I remember it. Though I'm quickly removing wood, the softness of limewood allows me to hold the gouge in my hands. The body, unaided by mallet, delivers intelligent power to a small cutting edge. Big muscles harnessed to a delicate task. The principle is known to glamorous athletes and obscure laborers alike. Put your body into it! Age-old advice. Power and endurance come from adding heft to the small muscles that are proximate to the task. (The principle goes beyond the physical world. A good scholar puts a whole body of knowledge behind every sentence.)

And do you think that it's only the aristocratic muscles in the fingers, hands, and wrists that are educable? The body is more democratic than that. The big muscles behind the archetypal movements —lifting, pushing, pulling, twisting, swinging, throwing—can be brought in from their primordial wild and domesticated to finer tasks. To hoeing or scything, throwing a spear or a ball, swinging

a sword or an ax or a bat or a racquet. Or wasting away wood with a chisel.

Later in the day the mergansers began quacking their irresistible siren song. Time to exchange the blade of a chisel for the blades of a kayak paddle, for the first time in this new season. The river had finally come to its senses. Flattened grass was all that was left of its frantic shortcut across the pasture. Rain had tempered the snowmelt. The dangerous cold was out of the water. Shadbush blossoms had come and gone and the hillside had begun to don its various pale green veils. I lifted the long thin boat from the shed, dragged it down the path by our little walled cemetery to the swimming and put-in spot, and in showery mist kayaked through a world as empty as a Confucian scholar's landscape.

Upstream along the eddy line, then out into the current, paddling with a motion near of kin to the one I'd just left behind. Twisting to move a blade through water. Arms locked to become stiff connecting rods. Pushing off a foot, pivoting the torso forward, swiveling the shoulders slightly toward the stroke as the blade bites into the water, and then driving it with the muscles of the stomach and chest and back. You could invite that movement straight into the workshop. For that matter, even the most ordinary daily motions prefigure what happens at the workbench. If you've raked leaves, or swept with a broom, then you've tasted woodcarving's *contrapposto* twisting. What's out here is in there. Not only leaves and flowers and human artifacts, but the muscular motions that turn them into carvings. All that's needed is a little translation.

History isn't made with innocent hands, and woodcarvings aren't, either. The lovely novelty of the carving motion at Hampton Court that first day included an awareness of the violence

of the roughing-out process. Putting the big muscles to the service of a sharp chisel makes it a formidable weapon. When you stab out an outline, you position the blade carefully with one hand. Then you either use a mallet to give the tool a violent blow, or grasp the chisel with the other hand as you would a knife you are going to stab with, then put your shoulder to the butt of the handle and lean on it with all your weight.

Or, when you are wasting away wood with long strokes, with or without a mallet, the cutting is fast, deep, and unhesitating. Turning the block of wood into a banana shape sent chips bouncing off the old paneling and the seventeenth-century window glass. The assault is importunate, swift, and one-sided. And the stronger the carver's powers of visualization, the more pitiless the attack.

The ruthlessness goes deeper than that. Every woodcarving is tainted by an original sin, a primal crime at the start of everything: the killing and dismemberment of a fine big tree. Twice I've watched a noble lime felled for no other purpose than my own use. I saw each topple majestically and watched its branches being lopped off. Both times I hung my head as I walked away. It would be absurd to feel remorse every time you sit on a wood chair at a wood table. But this was like having to kill the lamb before you eat it. Perhaps the carving is an apology to the tree? No. You can't apologize or atone. A carving doesn't expiate anything. But good limewood is a rich bounty, the bright gold of the forest, and it behooves you not to squander it.

The beautifully irregular trunk is butchered for human consumption. It is milled into regular boards—though if the boards are for carving they usually are sawn right through the whole width of the trunk, keeping their "waney" bark edges, so they retain some individuality. At Hampton Court, a few days earlier, I'd picked out my plank from the pile at the construction site, then rode prone on

top of it in a tiny van with its back door open. There were delightful receding views of palace walls, gardens, yew trees, bushes, gateways, and the curious faces of tourists as we bumped along the narrow ways around the palace to the carpenters' yard.

The board must have come from a large tree. It wasn't cut through the center of the trunk, yet it was three feet wide. And eight feet long and three inches thick. It must have weighed a hundred pounds. Before my eyes Ted, the adept carpenter, cut the board to size as cleverly as I've ever seen it done. We muscled the plank onto trestles and I marked the width I wanted it rip-sawn to. Next to my marks he clamped a long one-by-three-inch slat to use as a template. Then he set the depth of his circular saw to one-eighth of an inch less than the thickness of the board, so he wouldn't damage the trestles or have to move them. Then he made the long rip cut, pausing to insert a wedge so his blade wouldn't bind. When he was finished, he struck the plank with a mallet and it fell into two perfect pieces, one just the width I needed.

Successively I would harvest meat from this board with a band saw. First to be cut out was a tracing of the rope segment. I carried this little fillet back from the butcher's shop, through the echoing sixteenth-century passages to the carving room. There I glued the block to a backing board with a sheet of newspaper between. I could G-clamp that board onto the workbench, and the carving would be firmly held until it was finished. Then I could pry the piece loose from the board by inserting a long thin spatula I'd commandeered from our kitchen, to tear through the flimsy newsprint and free the carving. I'd learned of this method from a how-to book on carving years before, and used it ever since.

It might have worked perfectly well for a shallow-relief carving, frontal and planar. But I'd never rethought this method, and in the coming months it became clear that it wasn't the best way to

secure high-relief foliage carving. Access from the sides was difficult, and from the back impossible. The forward layers of Gibbons's work, those separately carved ethereal delicacies, must have been secured some other way, one that facilitated radical undercutting from all directions.

By the time I left Hampton Court I had adopted what I decided was Gibbons's system. I left tabs on the sawn-out boards, temporary extensions of the wood that you could clamp onto while carving and then cut away when finished. If the tabs were cleverly designed, they could be used to secure the carving facedown or sideways, so that a chisel could get at the work from any direction. But on that first day the block I was carving lay immobile on its back, glued to a board as my chisel played Old Testament deity to it, smiting it into shape.

B right and clear next morning, with a hint of frost in the air. My second day of carving. On the right just inside the park gate, Hampton Wick Pond steamed in the chill. The resident pair of swans floated among the vapors like apparitions. I walked on, thinking about the archive photograph I had begun to carve from, the print Simon Thurley had dropped off a month before. I'd had difficulty matching the length of the carving in that photograph with the length of the surviving drops. For good reason. The print was the wrong size. The image of the carving should have been eighty-two and a half inches long, but it was five inches too short. Thurley was all apologies and promised a replacement. Two weeks later it arrived, exactly the right size and perfect in every respect but one: it showed the wrong carving. A surviving drop, not my lost one. More apologies, and assurances that a replacement would arrive in two days.

While I was waiting, it came to me that I'd once toyed with the idea of ordering a full-scale photograph of one of the surviving drops. That way I could see how well that image fit with the actual object. That comparison might teach me about the distortions in the photograph of the missing piece. Now, serendipitously, this latest error had provided me with just what I wanted. I placed the drop on its photograph, and the outlines coincided perfectly. But sure enough, when I took a caliper to a forward daisy in the carving and compared it to its image in the photograph, I found that the image was decidedly larger than the real thing. Being closer to the camera, the forward parts of the carving appeared about five percent too large.

I suddenly remembered that the first photograph Thurley had delivered to me, the one of my missing carving, was just about five percent too small. So might it not be a good guide to the actual size of the forward elements in my carving?

As I dawdled along in the park that morning I recalled how yet another stroke of luck had provided a way to confirm this. The week before, David Luard had wandered into the carving room with a little piece of wood in his hand. "Look what I've found. It must belong to one of the drops." He put a conjoined pair of crocus blossoms down on the table. They shared the same principle stem, which was broken off, but otherwise they were virtually undamaged. Luard assumed the piece had become detached from one of the surviving carvings. But the flowers seemed familiar to me, and sure enough, when I looked over at the photograph of my missing drop, there they were, in the most forward-appearing part of the middle section. Early in the fire a falling timber must have broken them off, allowing them to be safely buried in the rubble on the floor before the rest of the drop burst into flame on the wall above.

Now I could test the accuracy of the too-small photograph. I unrolled it, laid it on a table, and placed the crocuses on their image.

They fit exactly. The image on the print was like a tracing of the object. Out of the blue I'd been given a helpmeet for figuring out the size of projecting elements. I sent silent thanks to the blundering photography technician. I would be able to trace from the smaller photograph that added-on bulge of the shamrock rope, with some confidence that it would be close to the correct size.

Was there a way, even, of using the differentials between the wrong- and right-size photographs to calculate the whole topography of the carving? I was trying to puzzle this out as I walked past the swans that chilly morning and entered the lime allée. In the distance I half heard what sounded like a dry branch breaking. I heard it again, now closer, and finally I looked up. In front of me were two fallow deer stags fighting. Other deer had gathered to watch, and some voyeur sheep as well. The stags banged antlers and tried to push each other backward. Then a third male joined in, smaller than the two contestants. They promptly forgot their battle and joined forces to chase the intruder off.

I was in the Forest of Arden, where there were tongues in trees, books in brooks, sermons in stones. Clearly this was English Heritage and the Property Services Agency battling it out over Gibbons, and nature's lesson was that I shouldn't try to intervene. The jousting stags wandered away companionably and I walked on, thinking about the impending confrontation. A jay squawked, full-grown lambs gamboled in the now peaceable kingdom. A rook flew down to land on the back of a deer, then walked up and down, pecking here and there, to the perfect contentment of its host.

At the Yalta conference three senior English Heritage brass appeared. Their side was strengthened when the conservators embraced their argument that as much original work as possible should be preserved. Luard asserted that he could consolidate the charred elements with resin, producing a solid surface that could be colored to

match the wood. Not only that, but he could use resin to model replacement elements.

For the PSA Mike Fishlock, supported by Trevor, responded cleverly by seizing the moral high ground. To manipulate the carving in this way would be to violate and degrade it, he argued. It would show the piece more respect to put it in storage, preserving it in unmodified form. To "museum" it. But Thurley and the English Heritage architect, John Thorneycroft, had agile tongues. They commanded the metaphors. Preserving original work in storage, said Thorneycroft, was "a tributary up which we do not want to paddle."

I could understand that position. But the idea of modeling new work in resin vexed Trevor, and it vexed me, too. I forgot about nature's sermon and entered the fray. By all means use resin to conserve charred elements, I argued, but on principle all replacement work should be in wood. To my surprise this was quickly conceded, and Luard went on to assure Trevor that he'd provide him with good surfaces for attaching his carving. Swords were sheathed. The "saw line" was drawn so as to preserve much of the charred area, with the understanding that the boundary could be adjusted by negotiation between Luard and Ellis.

A glow of goodwill filled the room. Gibbons's double nature had been incorporated into the work itself. Each posse could believe it had got its man. On one side of the saw line was sculpture to be preserved at all cost; on the other side, a fungible realm where new work could supplant the damaged original. This solution didn't so much resolve the dispute as embody it.

Darkened or yellowy waxen shapes now crowded into the carving and conservation rooms, and spilled over to the little anteroom between them. Wherever you turned, nighttime creatures lay

in coffins or on backboards propped against walls. The white flash of fresh limewood was nowhere to be seen. I missed the playful daylight pleasures of the unmarred Gibbons style, carving that is redolent of sun-drenched orchards with burgeoning leaves and twining vines. A little *allegro* needed to replace all this *penseroso*. Restoring their bright hue, I thought, would shake these carvings awake.

One morning I took the Northern Line tube, itself a dark and sooty experience, from Hampstead to Waterloo to pursue clues about the surface treatment of the carvings. The traces of white found beneath Mr. Young's wax had been confirmed as lime wash. But if this liming turned out to be no more than another eccentric and fleeting twentieth-century treatment of Gibbons, it wouldn't give much ammunition to the argument that the carvings should be whitened again. They were certainly pale for their first decades, but if they were dark for almost all of the rest of their existence, then lightening them wouldn't be restoring their historical appearance.

The 1938 archive photographs did give some support to the idea that the liming wasn't a recent application. The pictures showed carvings with a whitewash that had the appearance of being in the last stages of wearing away. Forward surfaces were dark, apparently old bare wood, but many of the protected lower parts were light, especially the crevices and protected valleys. It was like a high mountain face in July, with the snow melted away except in the couloirs and shadowed slopes.

This was a good start. But as it happens, there exist photographs that provide a still earlier glimpse of the carvings. The first book on Grinling Gibbons was published in 1914, under the imprint of *Country Life* magazine. It contains clear black-and-white images of the three great overmantels in the Royal Apartments at Hampton Court. They show the carvings paler than in the 1938 photographs, with the surface somewhat less weathered. In fact the appearance

of the carvings during these Edwardian years was close enough to the tone of natural limewood to have duped the book's author, H. Avray Tipping, into thinking that their surfaces had never been tampered with.

I had telephoned the *Country Life* photographic librarian to ask whether their archives held still earlier photographs of Hampton Court (*Country Life* began publication in 1897). Or, failing that, whether they happened to have the original glass plate negatives for the images in their Gibbons book. I hoped that a good print taken directly from a negative would be more revealing than a published image from a 1914 book. Negatives might still exist, said Ms. Costello, but only if they happened to have been used in a magazine article. She quickly went through her files and reported back that she could find no trace of Gibbons.

I resigned myself to making the best argument I could based on the book's images. But Costello's interest had been piqued, and she didn't give up her search. A few days later she telephoned to say that she had found some boxes of glass plates that I might like to come down and look through. The *Country Life* photographic library was in a basement on the South Bank, not far from the National Theatre. Costello's dog greeted me, followed by its equally friendly owner. I was led to a table with four boxes of eminently breakable glass plates, which I raised nervously to the light, one after the other. Nothing but facades of stately homes, some with Edwardian ladies standing in front, and numberless drawing rooms and pieces of furniture.

Costello apologized. I stood up to leave. Then she said, "Oh, and there *are* these . . ." As in a melodramatic movie. She handed me a box of quite large plates. I sat down and plunged back into the world of Rupert Brooke. But near the bottom, as all hope was vanishing, six Hampton Court carvings appeared: the overmantels

that were published in Tipping's book and some unpublished images of carvings as well. They were dated 1907. The plates were smudged and one was broken in a corner, but Costello said that when they were cleaned they should print up well.

The next week I returned to collect the prints. I was rushing for a train at Waterloo, where Marietta was meeting me, so I delayed opening the manila folder until we were in the carriage of the Hampton Court train. And there they were, in my lap, beautifully crisp images showing beyond doubt that the liming of the carvings dated back at least to the nineteenth century. The chalky surfaces were less weathered than those in the archive photographs from three decades later, but even in 1907 this lime clearly had not been freshly applied. The white had worn off many exposed surfaces, creating an odd reverse highlighting effect.

There was one last piece of evidence, the most decisive of all. Ninety years before the *Country Life* prints, the artist W. H. Pyne published his *History of the Royal Residences* (1817–1820), a collection of color aquatint views so lavish that it landed Pyne in debtors' prison. I went to the library at the Victoria and Albert Museum and ordered up the volume that included Hampton Court Palace, not quite sure what interior views I would find. There weren't many, but where limewood carvings appeared they shone bright white. It was decisive proof that the liming could be traced back to the beginning of the nineteenth century at least. I began preparing the arguments I would make again and again in the months to come.

Later I found that it wasn't just Gibbons's Hampton Court carvings that were lime-washed around the turn of the eighteenth century. His work at Windsor Castle, Petworth House, Oxford, and Cambridge had received the same treatment and remained a weathered bone white into the twentieth century. There was every historical reason to wake the sleepers, to restore the transformative

paleness that brings Gibbons's carvings to life. But there was that flood of Victorian varnish that still stains our sensibilities about the color of woodwork. We'd have to shake ourselves awake first.

A carver begins as a god and ends as a slave. I concocted this aphorism long ago and couldn't stop using it. It was born of experience. This trajectory repeated itself with each successive project. In all of them the balance of power progressively shifted from the maker to the made. The wood began as a submissive, put-upon thing, then gradually came to life, like Pygmalion's statue. The carver's ideas steadily lost their power, while the object grew imperious. Obeying its ever more queenly instructions, you refined detail after detail, undercut ever more meticulously. You bestowed on the carving that crucial last ten percent of fineness. But the work stretched on and on, became slavery, until in exasperation you threw down your tools.

It occurred to me that this account reflected two warring conceptions of the artist in Western thought. In the Neoplatonic tradition, which flourished during the Renaissance and the seventeenth century, artists are above nature. They take their vision from the world of pure forms, and fashion a second nature, more beautiful and real than the one around us, by embodying those forms in their medium. Artists, says Plotinus, give no bare reproduction of the thing seen, but go back to the ideas from which nature itself derives. They can avoid the mishaps of bodily life, add where nature is lacking, and create a world of universal truth.

In the Romantic tradition, by contrast, the artist sits at the feet of nature. "The green casque has outdone your elegance," says Pound. The world around us is not to be corrected but imitated. Wordsworth proclaims nature his anchor, nurse, guide, guardian,

and moral soul. There's no otherworld of Platonic forms that an artist can rise to. The imagination feeds on earthly experience, and although artists can't create with the internality of nature, nature guides their hands.

The experience of carving suggests that these two kinds of artists are really the same artist seen at different points in the creative process. You start as the one kind and then gradually turn into the other. You start as a godlike creator, imposing ideas on a passive medium, and you end up grounded in the life of this world, taking instructions from the thing in front of you. I began to imagine that I'd come to the bedrock, the archetypal rhythm of making anything, from a table to a novel.

Two transversely crossing trajectories. A crisscross, a reversal. What grammarians call chiasmus (from *chi*, the Greek letter for X). The carver begins as a god and ends as a slave; the carving begins as a slave and ends as a god. A rhetorical formula for something I'd experienced at the workbench time and again. But that formula only hinted at what awaited me as I wound deeper into the carving at Hampton Court, deeper into the heart of the matter.

The little block of wood had become a curved tube that resembled nothing so much as a Slinky spring toy. I worried that it humped out too far. Or not far enough. In the other drops the superimposed sections of rope projected two inches above the lower layer, give or take an eighth of an inch. Mine also projected two inches, the average of the others. However, the length of my rope section had turned out to be about an inch shorter than the others, and this made its bulging curve more acute than theirs.

Should I carve it down to make it protrude less, or keep to the height of the others? This was the first carving decision I'd had to

make at Hampton Court. I knew that as soon as I added surface detail the shape of the rope would be frozen irrevocably. I measured again and again, I inferred from the visual evidence, I brought my instincts to bear. All paths seemed to lead to a prominent bulge. Didn't the photograph show the rope casting a shadow as if it was quite forward? In these storm-tossed landscapes wasn't it better to err on the side of drama? Gibbons was not a timid artist, and so long as I remained within correctly calculated measurements, I shouldn't be timid, either. And wasn't this exactly what I was here for, to cast myself into the mind of Gibbons and make the judgments he would have made?

But a few weeks later, as I looked back on what I'd done, a deeply buried seed of fear began to sprout. Was my logic flawed? Did it assume its conclusion? Measuring the forward section of the rope from the too-small photograph would be accurate only if the rope really *was* far forward enough to appear bigger to the camera. As far forward as those little crocus flowers that fitted so well on the middle part of the too-small photograph. If it wasn't, then the section of rope I measured from the photograph would be too short—especially if I didn't pick the right connecting points among the shadowy parts of the rope on the photograph. And if it was too short, then to reach the height in the other drops it would have to bulge out too abruptly.

There was other evidence against me. If I'd looked at the photograph more carefully, I would have seen that the shamrocks in the added-on part of the rope were hardly larger than the ones on the lower level. A blinking red light if ever there was one. And Marietta warned me as well, on a visit she made to the carving room during those days. She looked at that arched form and lifted one fine eyebrow to a similar shape. My best and worst critic, and I ignored her.

I was impatient to plunge ahead. There had been weeks of delay, and days more would pass before the big band saw was installed that

would allow me to cut out the lower layer and begin carving it. I had to do something! At least I could finish off this little rope section. So I made the classic beginner's mistake. I modeled surface forms before the underlying shape had been properly established.

Before I even thought about carving in the shamrocks I should have put the rope in place and roughed out its continuation in the lower layer of carving. Modeled the whole rope as one, as Gibbons clearly did. Later Luard found little pinholes in the upper rope section of one of the surviving drops, evidence that the piece had been temporarily fixed in place while its extension below was shaped. When the time came to fit my rope, on the other hand, it was already finished and too late to make adjustments.

First this, then that. The motto of mottos, for a carver. Or for anyone facing a daunting project. On the one hand it's a heartening reminder that a large undertaking can be divided into manageable tasks: this and that. But it's also a warning that those tasks have to be tackled in the right order: first this, then that. A golden chain of sequential toil. No one learns the cost of violating the rules of succession more painfully than those in the subtractive arts. But anybody can forget what they've learned, in the heat of the moment when many forwards are contending for attention. The use of time is fate. The management of sequence is fate.

Worse than that, I hadn't yet accepted my station in this new life. I was at the beginning of a carving, with a seeming tabula rasa in front of me, and I'd fallen into the accustomed role of imperious maker. Something, the ghost of Plotinus, or maybe just ingrained habit, was pushing me up into the mind. Probably I was drifting among my own ideas, though I thought I was consulting the spirit of Gibbons. I was trying to imitate Homer. I should have been imitating the *Iliad*. I'd forgotten I was a copyist. A slave at the beginning and the middle of the carving, not just at the end.

My instructions had to come from the model in front of me. There it was, hanging next to the workbench, tall and slim and commanding. Just now, here in my workshop at home, I've retrieved that same full-scale photograph from a cardboard tube in the corner of the room, unrolled it, and pinned it up on the wall. My companion from long ago, blinking in unfamiliar surroundings, still carrying the aura of those days.

Nothing else but carving from it finally taught me to read the photograph correctly. Now it's easy to see that the design rises to a climax in its central section, where the highest and airiest of the added-on layers of carving are, with their eye-catching thin stems and arching forms. To these Alps the top and bottom sections are foothills. The leaf rope in the bottom section is not meant to attract notice by its protrusion. It isn't a soloist in this composition. It sings harmony. But in my carving that bulge pushes to the front of the choir and sings too loudly. It overprojects.

You say you're looking at a picture of my carving now, and the shamrock rope seems perfectly acceptable? That I'm making a mountain out of a molehill? That nobody, *nobody* would notice, except for me? After all, it's just a little skirmish within a design, not the Battle of the Bulge. In the grand scheme of things, what's half an inch? Well, it's everything. I can't gloze any of this over. I've been in its jaws for twenty years.

To turn the knife in the wound, the worst possible thing happened. A year after I left Hampton Court I found myself in London and decided to return to my old haunts for a visit before the restoration program drew to a close. I went to the carving room and shared reminiscences with Mike and David and Trevor. The end was in sight. There was a serene feeling to the place. Passions were mostly spent. My carving was on a board leaning against the wall. Pale and ghostly. It looked to me as if it had been done by somebody else.

🐾 *The bulging leaf rope in the replacement carving (detail).*

Later I met Trevor on the train back to London. "Mike was re-lieved that you didn't notice the charred fragment that was sitting on the shelf next to your old bench. He meant to hide it away."

"The what?"

"After you left, somebody found the original lower part of your carving. It's badly burned. But you can see the forms."

"I would have given anything for that last year."

Trevor said that they'd been showing it to visitors. "To let them see what you were up against. The queen came through and she was really interested."

"I think I bulged out that flower rope too much."

Trevor didn't answer. He didn't have to. It was clear to me that this discovery revealed my error to every passerby, in the most embarrassing possible way. Couldn't they have found some other piece? For the next twenty years the thought of that scorched lump

was my talisman against professional arrogance. And it would be archived like the other remnants of the fire, waiting to humiliate me to generations unborn. Mortification without end. Proof that I'd begun my journey at Hampton Court with a stumble. I felt a deathly curiosity about what the piece revealed, but I wasn't enough of a masochist to want to go see it.

And yet. Being bloodied by Gibbons at the very start cleansed my perceptions. It heightened my awareness not just of possible pitfalls, but of their obverse: the fine subtleties of Gibbons's design and execution. My mistake added luster to things. What's a landscape without shadows? It gave gravitas to those days. And it made me change my ways. I wouldn't go so far as to call my blunder a felix culpa. But I wonder whether I could have succeeded in the end if I hadn't failed at the beginning.

The phone rang after dinner one evening in Hampstead, and a New York voice came on the line. It was the personal assistant of a patron of mine, saying that her boss was just boarding a plane to London, and that he wanted to take us to dinner the next evening. It would be a chance to canvas a possible benefactor for a Gibbons exhibition. At least someone who knew his way around the worlds of art and money. The next night we found ourselves in a private dining establishment started by a socialite whose parents' house, oddly enough, was the site of the crafts fair years before, when I'd sold my first carving. Sporting art, beautiful flowers, soft chairs, rich paneling, a nanny figure to tuck you into your chair and place your napkin in your lap for you, and British comfort food as it might be in heaven.

The fourth guest at the table was an art historian who had just published a magnificent catalog of the Sèvres porcelain at the Wallace

Collection, and who a few years later would become the director of that museum. She and Marietta, who as a china restorer had repaired many a broken Sèvres piece, had much to talk about. What with that, and the many other windings the conversation took, I wasn't able to manage the talk around to Gibbons or Hampton Court. It was nice to have the night off. After dinner our host suggested we walk around the corner to Annabel's, the famous nightclub owned by the same socialite.

As we walked through Berkeley Square, my patron urged me to get in touch with his lifelong friend Sir Geoffrey de Bellaigue, who was then surveyor of the Queen's Works of Art and director of the Royal Collection. He'd written to tell him to expect a telephone call from me. *La dolce vita* vanished in an instant. I was all ears. Gibbons's carvings at Hampton Court were technically owned by the queen, and the head of the Royal Collection would have to give his approval for them to be exhibited. If he were to actively support the project, he would make a powerful ally.

For reasons that escape me now, a month passed before I telephoned. I found myself talking to a quiet, humorous, entirely charming man. At one point, as the conversation turned to my exhibition proposal, I said, "What the palace administrator really wants to do is . . ." And here I paused, about to continue with "make sure that he doesn't lose money on this." But the voice broke in to finish, "Get rid of you!" I began laughing uncontrollably, fueled by nervousness at the thought that he knew more than I thought he did, and wondering how that could be. But he went on to say that he felt that disasters should be taken advantage of, and while not exactly endorsing an exhibition, he seemed sympathetic to the idea. He said he wanted to have us to lunch at his house in Windsor Castle. The prospect of this delighted Flora, who had become an ardent royalist.

Next day, as luck would have it, my New York patron's assistant

telephoned to say that he was making another visit to London. He would be landing at Heathrow at eight forty-five in the morning the day after next, and hoped to come straight on to Hampton Court for a tour.

As I was making arrangements with palace security for this visit, it occurred to me that if I could get the beautiful painted chamber in the Banqueting House opened, it could be a way to spark a conversation with my visitor about a Gibbons show. Besides, making this request might let me pick up with the palace administrator on the same high note that had ended our previous meeting. True, in the meantime there had been the fracas about my uncensored article. But I had to take the measure of the man's attitude at some point, and it might as well be now.

I walked to his office and wrote out a note saying that a philanthropist with an interest in a possible exhibition would be visiting next day, and might it be possible to give him a quick look at the Banqueting House, where we were hoping to hold the show? I couldn't forbear to add that he was an old friend of Sir Geoffrey de Bellaigue. The administrator's secretary, taking the note in, asked if I wouldn't prefer to speak to him after he saw it. A few minutes later I walked through the door, and straight into a brick wall.

"I thought we had settled this. We don't want an exhibition."

"I thought your position was that you would entertain a proposal for an independently financed show."

"Yes, we will do that."

"Well, I'll be making a proposal. But it's hard for me to proceed unless we can show potential supporters the venue we hope to use."

"We have decided not to allow the Banqueting House to be used, anyway."

He'd changed his position, and the note of malice in his voice suggested that Fishlock was right about the damaging effect of my article.

I thanked him for his time, stood up to leave, and instinctively reached to take my note away. "I'll keep this," he said, and for a moment I thought we were about to play tug-of-war with a piece of evidence. Was he composing some kind of dossier? Did he think I was? I shrugged my shoulders in an unconvincing display of indifference, and left.

Out into a daylong unlifting fog. It shrouded the chimneys of Chapel Court, and made the cobblestones sweat. I walked into the dark passage that led to Fountain Court. A visitor looked at me quizzically as I stalked past, plainly wondering why I wore such a scowl on my day out at Hampton Court.

I'd convinced myself that I'd shaped the rope segment correctly, so I started to carve in the shamrocks. Or clover, or whatever these trefoil leaves were. They formed a filigree surface of raised simple shapes, defined by deep excavations between. If this were my own work, I would carve them freehand, as Gibbons's men undoubtedly did. I would improvise their spacing as I went along, aiming for the free disorder Walpole praised in his encomium to the carver.

But this wasn't my own work. Each leaf had to be placed just where the Gibbons leaf had been placed, and modeled just as his leaf had been modeled. Laboriously I drew the shamrocks on the rope, using my measuring compass to determine their size and placement from the photograph. Where the leaves disappeared around the curving sides of the rope I extrapolated as best I could. Can you learn spontaneity by mechanically copying it? I could only do the letter of the thing, and leave the spirit to its own devices. Eventually the rope was covered with penciled-in shamrocks, each varying slightly in size and shape.

Then I selected a gouge with a blade whose curve was close to

the curve of the leaf lobes, and began stabbing out the shapes, keeping about an eighth of an inch away from my lines. Next I wasted away outside the stab marks, and the forms began to emerge. I cut out four or five shamrocks in this way and then began excavating more deeply between them. As I scooped away with a front-bent chisel, the shank of the tool occasionally dented into the edges of the leaves. I'd left the little cushion of wood between my stabbed line and the drawn outline in anticipation of this.

A few inches of progress along the tube during the first day. Several more the second day, when I worked alone into the glooms of the evening. Luard had left earlier, the construction workers outside were long gone, and Ellis wouldn't begin carving for another week. Security police visited twice, puzzled that anyone should labor so late on a Friday night. After a while they grew accustomed to my staying until six o'clock, when the palace fully shut down and I was required to leave. I prized this final hour of solitude. It was the closest I could come to my old habit of carving into the early hours of the morning. I was in an island of light, lapped by the soft sounds made by a chisel, in a sea of blackness and quiet. The paneling grew companionable in the stillness. When a cold wind rattled the window, I'd close and bar the great oak shutters and imagine myself in the hold of a wooden ship.

By the end of the third day all of the shamrock forms were stabbed out and the gulfs between them were deep and dark. I repaired the leaf edge damage by stabbing down right on my drawn outlines. Now I could begin modeling the shamrock surfaces. Using a medium-size flat blade, I angled them back so that their stems would appear to flow naturally under the next leaf behind. This somewhat elongated the leaves. Then, following the model of the other drops, I angled the leaves slightly to one side or the other, breaking the original convex plane of the tube. This distorted the

forms a little more. (Though seen from directly above—as in the photograph—the apparent shapes would be unchanged.)

I'd often done something similar in my own carving. You draw a daisy squarely frontal, using a compass to give it that geometry that is the armature of every growing thing. Then you stab out the outline. Then you slice the form down to an angled plane, which distorts the circle into an oval. The final flower, when you model it, is enlivened by this asymmetry. Life takes your genetically given qualities, the original plane of your being, and carves it to an angle, giving you the personality you bear in the world.

The next day, in a madcap rush, I covered an area six inches long and three inches wide. David Luard and I ate lunch together. He spoke of the seeming tedium of his finish-removal work. But if you are a real conservator, he said, you break through this and find the process continually interesting. I propounded the idea that boredom was like difficulty: just part of the workplace environment that you ignore. Then I thought about it some more, and changed my mind. Luard was right. Tedious work, when you plunge into it, often loses its tedium. I told Luard that, like his scraping, the carving I was doing just now might seem utterly monotonous to an observer, but like him I wasn't in the least bored. Every movement was singular, every little goal of the blade different. Every motion had to be conceived and executed and evaluated. The hours streamed past.

Next day I pushed forward and made four inches. I began to model the surfaces of the shamrocks into the little hills and valleys that were discernable in the photograph. This was the first expressive landscape I had encountered so far. The effect of copying it was slightly perplexing. Normally I would look at a real leaf and translate it into that heightened form that makes it lively in a wood medium. But here somebody had done the translating for me. I had to overcome my instinct to translate the translation. When I copied

it, mimicking the earlier carver's chisel in its free modeling, I felt an uncanny sense of impersonation. I was remaking his aesthetic decisions, placing one foot after another in his footprints and getting a sense of his gait. What would it be like when I got to the high Alps farther up the carving, where the modeling was exquisite, perhaps touched by Gibbons's own hand?

As the carving grows delicate you reach for smaller chisels and gouges. Now the blade's focus is not so much on removing wood as on shaping it—although in a subtractive art like carving, where shaping *is* removing, that distinction ultimately is a false one. The tools grow more specialized in their forms. Back-bent gouges, fine veiners, fishtail blades.

One glance down at your hands reveals that something has changed in the chisel's relationship with the wood. When the work becomes delicate, the propulsive hand stays where it is but the other hand inverts its position. Instead of grasping the shank of the tool as it might the rung of a ladder, the hand turns over to hold it from below. And hold it not in the palm, but between the thumb and the first finger (or sometimes first two fingers). As if it were taking the pulse of the tool. It's true that you can't grasp a tool as firmly with your fingers as you can with your fist. But the other hand's push needn't be as forceful now. And as always, the hand holding the shaft is anchored on a solid surface, though now it's not the heel that rests on the bench or the carving, but the back of the hand and fingers.

Holding the gouge in this way confers a crucial advantage. The pads of the fingers are far better sensing devices than the closed fist. Or rather, since the tool is the sensing device, the fingers are far better at picking up signals from it and responding instantly to them. If I handed you a chisel and asked you to carve, you'd see

what I mean. Trying to make an accurate slice in a varying terrain, you'd realize that gathering information about that matrix of grain and rays and pores is as much the blade's job as cutting it is. You can't rely on your eyes, which tell you little about the local structure of the wood. Besides, the cutting occurs out of sight, below the surface. What your muscles need is immediate tangible feedback from the moving blade. You have to take the pulse of the chisel as it cuts. A safecracker's sensitive fingers, to break the code of the grain.

When the carving grows still more delicate and smaller in scale, then sometimes even the propulsive hand shifts its position to take further advantage of the fingers' sensitivity. Instead of grasping the handle in a handshake-like grip, with the butt end buried in the palm, it holds the handle as if it were a pencil: a three-point grip between the thumb, the index finger, and the side of the middle finger. As a surgeon holds a scalpel. Small gouges and chisels have commensurately narrow handles, so they can be held comfortably in this way. I've noticed that this is the only time that ambidextrousness in carving loses its sway, and my right-handedness asserts itself. It's as if I'm drawing or writing, something I'm unable to do with my left hand. In these ticklish situations some primal propensity comes forward and seizes control, brooking no opposition. Taking charge as if it were an emergency.

It was once part of a camshaft, attached to a powerful engine, but now the propulsive hand is happy to move the blade in tiny strokes. Holding the gouge like a pencil, steadied by the other hand's fingers on the shaft, it can operate the tool with a draftsman's precision. Unearthly delicacies spring from these finer hand positions. Thin tendrils spiraling down a bunch of grapes, point lace stitching, the curling edge of a paper, tiny berries with minute stems, a knotted string, the finely toothed edge of a small leaf, the deep striations on a Belon oyster shell.

Have the big muscles in the shoulders and torso fallen still? The arms can provide more than enough power, surely. But even when I was making those valleys and hills in the shamrock leaves, or stabbing out their frail stems, I could have sensed little tightenings and loosenings in my shoulders and back as the blade made its miniature movements. The *contrapposto* swivel still occurs, imperceptibly, even with the smallest stroke, like an unheard basso profundo. No matter how subtly it engages the wood, the blade is still driven by the whole body. The whole body still carves.

Flora was taking on the coloring of her surroundings. The leaf was turning the caterpillar green. She wrote a melodramatic poem about John Keats walking up Christchurch Hill past our door, visiting his dying brother in the house around the corner, then dropping dead himself. One day her mother and grandmother brought her to Hampton Court to inspect my professional accommodations. She asked questions, pleased to be involved, for some reason anxious to establish that tourists were not allowed in the carving room. Later she hung on the railings outside the window and tried to persuade me to jump over them and accompany her around the palace. I watched her go off with Marietta, hand in hand, practicing the silly walks she used when she was shepherded back and forth to school each day. The scissors walk, the eggbeater walk, the hopping walk, and others yet unnamed.

After her visit, as a school assignment, she wrote a little story called "The Live Carving." It concerns a girl whose father is making a carving for Hampton Court Palace. He's so busy that she and her mother never see him. Finally it's done. You could almost taste the fruit and hear the wind rustling through the leaves. She asked her father if she could go with him to deliver the piece. As they

were carrying it through the palace gardens the carving started to change into real-life colors. She took a bite of one of the fruits. "It was delicious! Her father rushed into the palace to ask if they could keep the carving outside in the wild. They said yes. To this very day you will see it there. The work of a true woodcarver." A rare framed early manuscript of this story, signed, dated, and illuminated by the author, hangs above my desk. To this very day.

We went back to the *valle incantata* in the Downs for a sentimental visit. Violent squalls raced in from the Channel, followed by a double rainbow against receding black clouds. Old friends at dinner, cold frost in the morning, time running backward a little. I thought about the old hard life, the mornings when you woke up and the first thing you saw was your breath. Over the high garden wall or through the stone gateway you could catch glimpses of a rose-washed cottage. New people were living there now. We slept in the big house. Marietta and I shared an Elizabethan canopy bed, in a beamed chamber that was old when Wren was building at Hampton Court.

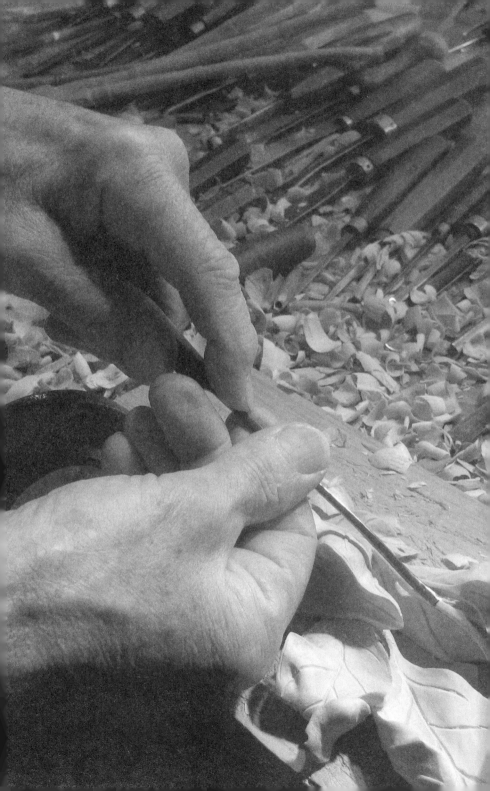

CHAPTER VII

The Thinking of the Body

What self-respecting sculptor makes his own work these days? Assuming, that is, that *making* something comes into it at all. Your work might, like a recent one of Antony Gormley's, consist of members of the public successively spending an hour atop the empty plinth in Trafalgar Square, doing whatever they choose to do. Gormley's Fourth Plinth project was a sparkling addition to a long tradition of endgames against conventional art. It needed a conceptualist to think up, an event planner to organize, an impresario to promote, and a decoder to explicate. But to create this art? No action whatsoever by the artist was required. Not only its execution but its content was outsourced to others.

Even sculptors who do create physical objects now often feel no compulsion to make them with their own hands. If they want to represent the human figure, they tend to cast a body rather than carve or model it. This removes a whole set of technical worries. The beauty of handiwork no longer is part of the work's meaning.

❧ *Left: A small gouge fashioning a stem.*

You can focus on other things. Gormley was one of the first sculptors to use casts of his own body as the basis for his sculpture. Now, with the confidence of success, he is forthright in his evaluation of this life-casting method. "There is no expression, no virtuosity in the way they're made," he told an interviewer. You simply stand there while a mold is taken, and then it's cast in iron. As for fine modeling like, say, Rodin's? "None of that pertains to my work."

Skill is unnecessary. Technology and outsourcing stand ready to do your command. The two most successful sculptors in the Anglo-American world, Damien Hirst and Jeff Koons, can neither model nor carve. Many other artists, trailing in their wake, are also content simply to organize the manufacture of their works. You can life-cast a form, or take a three-dimensional photograph of it, or, if you must, make a little maquette of what you have in mind. Then you can digitally scan it, edit and scale it (a drag of the mouse and it's forty feet high!), and send it off to an art fabrication factory with sophisticated CNC machines. Send them the disk. Or just e-mail them the file. The piece will be ready in a few days. They can smooth and color it for you, too, if need be.

Skill is worse than unnecessary. It sends out the wrong signals. Often as not it's a term of condescension among contemporary art critics. The adjective "mere" attaches to it like a barnacle. Skill is the folk costume donned by sculpture when it leaves the world of thought and wit and irony and descends to craft. The only craft should be in the craftiness of the conceit. Art is ideas, and ideas reside in the brain. The rest is simply execution. In fact, having someone else do it for you preserves your purity. Koons, according to his Christie's cataloger, "prefers to remain at a responsible distance from the construction of his work so that he is accountable for the ideas at their foundation. In this way, he avoids being weighed down by discussions of the finer points of execution. For Koons is

interested in ideas, and wants the dialogue to be a dialogue of ideas." He is "a conceptual artist on an exceptionally pure level," and his distance from making gives him integrity.

Conceptualist sculptors are like Plotinian artists. They do not descend from the world of ideas. Their objects, found or assembled or gleamingly manufactured, are the receptacles of ideas and the communicators of ideas. These artists remain at the start of the chiasmus, the top of the X. They are godlike creators whose concepts retain mastery, as if they were Platonic forms, over the contingent world of whatever processes and materials it takes to embody them. (For Plotinus, cause is always superior to effect.) Its making is not part of the object's content. The long journey of carvers is not one that conceptualists have to take. There is no months-long engagement with the medium, no learning from it with your hands, no listening to the growing voice of the object. The idea isn't ambushed and replaced by something else, some other guiding force that's not easily described.

But suppose you don't e-mail your digital file to an art fabricator in New Jersey or South London? Suppose, like Koons, you go to Pietrasanta or Carrara, or Oberammergau or Ortisei, and hire skilled stonecarvers or woodcarvers to execute your ideas for you? Around the same time I was working on Gibbons's flowers and fruits at Hampton Court, Koons was having his *Large Vase of Flowers* carved in Italian and German workshops. The piece is described as polychromed wood, though covered metal wires appear to be used as stems. Koons's bouquet plunges the viewer into the uncanny valley, at least when seen from a distance. Its colored blossoms are simulacra whose ontological identity is unclear. Closer up, it's obvious they're not real flowers, but what they *are*

made of is problematic. The petals are stiff and coarse; the paint is thick, gaudy, and unvarying in tone. Injection-molded polymer, perhaps?

The master of a workshop establishes authority by superior skill and experience. Gibbons was a better woodcarver than his assistants. But when a conceptualist sculptor hires a fabricator, this hierarchy of technical skill does not apply. Koons hadn't the slightest grasp of woodcarving. It wasn't his business. As the Christie's cataloger says, he didn't want to be weighed down by questions of execution. He'd leave all that to his carvers. They, on the other hand, were in much the same position I was at Hampton Court. They were executing to somebody else's design, though in this case the design was conceived by someone with no understanding of carving, no sense of its potentialities and limitations. It must have been dispiriting work. And to make matters worse, this *Large Vase of Flowers* is not a unique piece of sculpture. It is an edition of three, plus an "artist's proof." The poor carvers had to make the piece and then remake it three times. As if it were an endlessly reproducible product, and they were a CNC machine.

Did Koons hire bad carvers? I've entertained the fantasy they were good carvers with their tongues in their cheeks, who pranked their prankster employer by producing bad carving they knew wouldn't be recognized as such. But it's more likely they were good carvers who were unfamiliar with the genre. Koons thought that by going to Bavaria or the Dolomites he could tap into a surviving baroque tradition. But there is no tradition of foliage carving in Oberammergau or Ortisei, whose workshops have always been focused on the human figure. The carvers' inexperience radiates from the carving. They are betrayed by timid modeling, and by their construction methods. Koons or his carvers seem to have thought that introducing stiff wires would allow flowers to sit at

the end of thin stems, as they do in life, and this would improve the realism of the composition.

Making that choice, they denied themselves what is distinctive in the appearance of baroque foliage carving in wood. Form follows medium. The appearance of the flowers and foliage derives from the carver's solution to the problem of wood's breakability. You give blossoms physical support by doubling and tripling them, so that their multiple stems can reinforce one another, or by anchoring the blossoms to half-hidden flowers or leaves below.

Structural weakness thereby produces formal opulence. In Koons's bouquet one blossom stands next to another, uniform in size and unrelievedly frontal, all stuck onto the ends of their hidden stems. But Gibbons's open sprays of multiple flowers create melodic flow lines, dramatically exposing an array of thin curving stems. Gushes of blossoms press realistically against one another, defined by deep gulfs of shadowy space between. Koons's piece is said to be a play on the baroque, but it certainly isn't a play on baroque dynamism, or even rococo refinement. It's a static, tightly packed mound of bright blossoms. It's a Teleflora bouquet.

But what do the carving's defects matter? As everyone knows, Koons has donned a bulletproof vest of irony. He's just kidding! It's a cartoon, can't you see? A caricature, a plastic David in bright colors, an exercise in kitsch. A joke shared with a knowing viewer. The physical object is just the beginning of the exercise. Look at the catalog, listen to what the artist says, read those long reviews. The art is in what's happening in your brain. Koons can't go wrong with a project like this. Ignorance of the genre, ignorance of technique, ignorance of the medium, even the inability to intelligently choose and direct fabricators: all conspire to produce exactly the object needed for a conceptualist exploration of bad art.

One of the four *Large Vase of Flowers* pieces recently was auctioned

for $5,682,500. But why rage and fret and bite at the wheels of contemporary sculpture? Especially when raging and fretting is part of the calculus of this art, has been for generations, ever since the days of Marcel Duchamp, and still is now, in the long mannerist sunset of modernism. Besides, who is anyone to say that artists shouldn't do whatever they want, shouldn't make intentional and unintentional jokes, shouldn't armor themselves with irony, shouldn't get all the money they can for their work?

Meanwhile, in another part of town, and in another part of history, a different kind of art goes about its business. Its making follows a different trajectory, and its claims are upon a different human capacity.

L uard and I carried Richard Hartley's carving, and the charred original fragment, up to the room where the Hampton Court fire exhibition was being hung. Two days before the opening party, and nobody in the carving or conservation rooms had received an invitation. I tried not to grow indignant. It was ever thus, after all. Princes took credit for the work of their artists and craftsmen. When Charles II commissioned the Cosimo panel—Gibbons's masterpiece—and sent it to the Duke of Tuscany, the letter of thanks the king received back was informed and effusive. But the duke's compliments were directed to Charles. There was no mention of the name Gibbons had so carefully carved on the piece ("G. *Gibbons Inventor*").

Champagne corks still pop more often for administrators than for the workers who physically carry out a project. Perhaps this was just another case of toffs ignoring cloth caps. But cloth caps weren't much in evidence in these rooms, and we all suspected that other motives were in play. Luard discovered that English Heritage

and the PSA had passed their lists to the palace administrator, who then issued the invitations. That would explain my absence. David thought he was being punished for his insouciance with English Heritage. But why Trevor and Ruth? Later I was a little mollified when I learned that Richard Hartley had been invited and would appear.

Then, on the morning of the exhibition opening, Luard discovered, to his unconcealed disgust, that the invitation list included even the apprentice laborers working on the building site. "This shows what they think of the importance of our work," he said. Demoralized, he walked out the door. "I feel ill. I'm going home." A few minutes later I encountered Mike Fishlock's boss, who told me that he wanted to bring *his* boss to the carving room after the opening. Later Fishlock telephoned from the party to warn that the palace administrator had been persuaded to accompany the group. I'd thought I was safe from the man here in the carving room. Mike had told me that the week before he'd invited him to visit the workshops, but that his interest would not be piqued.

In due time the four arrived. Just tagging along, announced the administrator. Then three press photographers appeared, and everyone crowded around my bench. Cameras snapped. I said the usual things. Fishlock chimed in helpfully about how uninformed previous Gibbons restorations had been, how remarkable the present situation was, and how much we were learning about Grinling Gibbons. The PSA director asked a number of questions. The administrator stood wordless in the back row. Then the nobs moved off and the photographers took turns with me and with what really attracted them, the beautiful chisels.

I arrived home that night to find an envelope with "On Her Majesty's Service" engraved on it. It was from the government minister who had intervened on my behalf when I was being excluded

from consideration for the carving job. He had seen my article and was now offering to raise the matter of an exhibition with the minister for the arts.

A few nights later we went to dinner with a couple who swam in the sea of the great and the good in London. The conversation turned to Hampton Court. I launched forth. Why couldn't other people look over the shoulders of the carvers and conservators and see what we were seeing? Puzzling striations on the wood's surface, ad hoc additions pinned in from behind, a carving with a violently scarred back, fine calligraphic placement notations, different kinds of layered construction methods, undercutting so radical that in some places it went through the front surface of a petal or leaf. Mysteries and revelations that would captivate anyone!

Our hostess grew enthusiastic and said she would telephone some friends, including the editor of *The Times*, the head of the Arts Council, the director of Christie's, and the Prince of Wales. Ah, England. Not to be outdone, our host walked to the phone, rang up a distinguished filmmaker and, on the spot, pitched the idea of a documentary on Gibbons.

Glittering forces were gathering behind the exhibition. But in my heart of hearts I had grown discouraged. Time was not on our side. The shadow of the project's end, and with it the reinstallation of the carvings I wanted to show, was even now on the horizon. The administration could argue that there was already an exhibition at the palace that included Gibbons material. It would continue right up to the reopening of the Royal Apartments, and for that unveiling surely all the carvings ought to be back on the wall.

Later our hostess, wise in the ways of the world, took me aside and warned me that when those in power appoint lower managers, they are inclined to kowtow to their judgments on specific issues. She was referring to the royal family's practice, but even I could see

that this was probably a general principle of management. We could muster our knights with gleaming arms, but in the end they might cede the field to their lieutenants.

I'd finished the rope segment and roughed out its continuation below. Now it was time to move on to the other elements in that lower layer, which were ranged on either side of the twisting ropes. On the left, a leaf tip peeking out, a daisy, plums, peas, a flat rose, and acanthus leaves. On the right side, two long thin leaves, a stiff tulip, a large pomegranate or quince, an empty little platform that once held a forward layer of carving, some forget-me-nots, a water lily, a couple of bunches of currants, and more peas. Many of these were set low, so there would have to be some excavation before I could begin to shape them. If this were my own carving, I'd quickly waste away down to an appropriate level, then draw the shape on the wood and start to model it. Or I might rough out a form and model it down lower and lower, experimenting with different shapes as I went, settling on one when I reached the right level.

But I'd learned my lesson about charging forward spontaneously, carving from what I speculated were Gibbons's intentions. I was determined from now on to shackle myself to the design that I'd traced from the photograph and transferred to the wood. My method would be to stab down the outline of an element all the way from those lines on the board's surface. Even if the flower or leaf or fruit was set two inches below. This mechanical procedure wasted time, and I ended up with overtall cookie-cutter forms to model. The malleable larval forms I was used to working with, in this intermediate stage of carving, were replaced by a cityscape of oddly shaped postmodernist structures. But the outlines and placements of these elements were tied directly to the drawing.

A little skyscraper city. Working to a traced design in this way was like being a beginner again, when your powers of visualization are not fully formed and you are desperate to preserve the drawing on the board for as long as possible. It's your life raft. You peer over the side and see the frightful abyss of three dimensions. You haven't accepted that carving is a journey where maps are made only to be destroyed.

I'd rummaged around the architectural stores in the Banqueting House and found some crystal clear plastic sheets that could be drawn on by felt-tipped pen. They were better than the usual semi-opaque paper when it came to tracing accurate lines from a blurry photograph. Later I found the plastic's clarity useful even after I'd transferred the design to the board's surface with carbon paper. When it came to modeling an element at a low level, I could stretch this plastic sheet above it on the plane of the forward surface of the board, look straight down through the design from above, and mentally project the lines of the drawing onto the wood below. I could even redraw the lines accurately onto the roughed-out leaf or flower, reaching my pen under the plastic.

A beginner clinging to mechanical measuring and tracing, drawing and redrawing. This wasn't the immersion in Gibbons I'd thought awaited me at Hampton Court. I'd come intending to impersonate the man, but here I was, slavishly copying a photograph. Working not with any powers of empathy, but with dividers and ruler. When I summoned Gibbons, it was a calculation, a number, a measurement that replied.

Deep fog this morning, hardly thinning in the afternoon, thicker than ever by nightfall. I carved quietly through the day, in an empty room. Gibbons had floated off and I was doing the same. No strong notions were shaping the wood, just small judgments followed by small tasks. I began to destroy my little skyscrapers by reducing

them toward their final shapes, and with that the sense of mechanical copying faded. I moved from one object to another freely, bringing several along simultaneously. Stabbing out individual flower petals, putting a curl in a long leaf, digging some of the force-line valleys that give life to petals and leaves, shaping those famous Gibbons pea pods, setting out and beginning to round the individual currants with their delicate stems. Familiar motions, which soon enough created a familiar half-modeled jumble of forms.

A wilderness of potentials, a carving in midcourse. All at once time seemed to evaporate. In the twinkling of an eye it was an ordinary afternoon in London in 1699. A doppelgänger had entered the room and I looked through his eyes. I saw the same choices that presented themselves to the original carver at this point in his making of the piece. The objects were telling me what they'd told him. They were defining the possibilities of their modeling. I continued to take instructions from the photograph wherever I could, but now I found that usually I already knew what it was telling me. In the primordial landscape below me, the range of choices had narrowed and the path forward could be discerned.

I'd made that landscape, so if there were instructions in it I suppose I must have hidden them there myself. But they had the feel of newness to them, and a growing imperial power. Who was in charge here? Alongside me and my phantom predecessor, taking our cues from the photograph or from Gibbons's design, an upstart new authority had materialized: an embryonic carving intent on being born. What I was making had begun to participate in its making.

Pitch black outside now. I'd lost track of where I was. When I was. Who I was. A guard whistled to himself as he walked past the window. I looked down at my watch. Nearly six. I swung the great shutters into place, barred them, and went out into the dim vaulted

passages, empty and echoing except for a diminutive old lady making her way toward me. She looked ghostly and I must have, too, with my long coat open and flowing behind. There was said to be a Lady Someone-or-Other who inhabited a magnificent upper suite of grace-and-favour rooms in the East Wing. The woman seemed to be in a world of her own. She must have thought the same of me. Two wraiths passed wordlessly.

A bright hot morning. River glinting through green summer leaves, heifers mooing from their luscious pasture in the river bend. Workshop windows wide open, letting in a sweet breath of water and grass. A world away from that foggy winter evening at Hampton Court. But I'm looking back at it from a shared vantage point, the middle phase of a carving. Those unexpected sprouts of self-determination stand out bravely, in my memory, against an autocratic regime of replication. If little shoots of autonomy can push out from the carving when you are slavishly copying a model, imagine the rich growth that's possible when you are working from your own pliant design. As I am today, carving the fruits and vegetables and leaves of that botanical chef's face. Carving on the fly, looking for the sudden opening, the flash of possibility in the half-done forms, the chance to veer into something more lucid and fluent.

At Hampton Court that opportunism was denied me, and my failed strategy, when the photograph was ambiguous, had been to ascend to Gibbons's mind and conjure up his intentions. To treat him as if he were a conceptual artist, whose ideas were the supreme guides to the execution of his work. And why not? Maybe he wasn't Jeff Koons, but he had strong and distinctive notions of design, and he employed a large workshop to execute them. What were his men doing if not following his instructions, conveyed through various

control devices? Gibbons would have transferred his design to the board and had it sawn out, to anchor the piece to the design. He would have hung his drawing on the workshop wall as a guide for all to see. And if he wanted to, he could have intervened continually and directly by drawing on his carvers' half-done work. His ideas would have been paramount. I thought I knew the man well enough to summon up the ghost at his design board and divine the choices he would have made. Plunge deeper into the blur of the photograph until I found the man.

But in front of me was that humped leaf rope, the bitter residue of my mistake, to remind me of the dangers of trying to plumb Gibbons's mind. I pondered this during my half-hour walks through Hampton Court Park every morning and evening. I mulled over the carving I had just done or was about to do. I'd marinated in Gibbons the man for years, but now I was immersed in something else, the physical creation of his carving. Gradually my way of thinking was transformed. I stopped believing that understanding Gibbons was necessary to understanding how to carve his work. The shadow of the man, which had hung about me for so long, began to drift away.

At Hampton Court I had gone in the wrong direction, up rather than down. Gibbons's mind and his designing pencil had been my inspiration, when it should have been Gibbons's chisel. Maybe I hadn't thought hard enough about what really happens when you make a thing, whether it's a carving or a poem, or a table, a book, a garden or a painting. You start out at the top of the chiasmus, all right. But soon enough the moil of the making fills your consciousness and informs your decisions. You plunge down that X, like a fallen angel, toward the crossing point with the thing you are making, the point of equal power.

Only it's not an X, it's more like an H. The middle part isn't a

momentary crossing but a sustained congruence of maker and made. A long sunlit convergence, with any luck, where the work is really done, where the carver and the carving look straight across at each other, and chisel and wood converse like old friends. It's a middle landscape that isn't inhabited by gods or slaves, or victims or terrible queens. It's the Arcadia of the workbench, where an affable demigod, a genius loci, sets up shop with a hamadryad, an amiable wood nymph. It's not clear who's boss. They ignore office rules. Flirt during work hours.

The clear light of afternoon shines down on these days. On cold gray evenings, on hot summer mornings. You look forward to these weeks and months with impatience before a project starts, and back at them with wistfulness when it's over. Isn't it the texture of everyday life that's recalled with the most poignant longing by those who are in exile, or ill, or on their deathbed? Often at Hampton Court I would remember the sweetness of ordinary times at my own workbench.

There's no waiting, then, for the muse to descend. You take up where you left off the night before. You come to the workbench every morning and ask yourself, "Where was I?" Inspiration is for amateurs, somebody once said. The creativity is incremental, not divorced from the making. You invent while you make. You work in the churn of the moment, and the forms seem to determine their own shape. You think with your hands. The carving thinks with your hands.

The conviction grew in me that this was the frame of mind of Gibbons's carvers. They weren't working for him as fabricators work for a conceptualist. No doubt they were attuned to Gibbons's ideas, and had long ago memorized his vocabulary and his turns of phrase. But they also knew to the bone the genre they were working in. They knew what could be done with limewood and sharp

tools and what couldn't, what worked visually and what didn't. I'll bet that Gibbons's working plans (as opposed to the beautiful presentation drawings he made for his patrons) were in a kind of shorthand, as mine are, a collection of rough circles and oblongs and lines without detail. And that after a certain point in the carving his men made their judgments less by scrutinizing that design than by sailing their own way through the stormy sea on their workbench.

They seem to have carved as if it were their own composition. Sincerity shines out from the work, sincerity that seems inseparable from skill. The daunting technical demands of the work appear only to have deepened their engagement. Its difficulty was their honor. So far as I've been able to discover, no woodcarver taken on as an apprentice by Gibbons ever left his employ to set up on his own. They were the best of their age, second only to Gibbons, and they were content to work anonymously for him.

They had steady pay and security and the prestige of working for a famous artist. Is it fanciful to think that what also kept them there was the sensation that they were doing their own work? They may have created from Gibbons's designs, but they created nonetheless. And to be original with the minimum of alteration, says Eliot, is sometimes more distinguished than to be original with the maximum of alteration.

Once I'd assumed that Gibbons held his carvers in the tightest of grips. So stylistically uniform is their work that they seemed almost like thought-controlled biorobots. Now I'm more inclined to think that Gibbons embraced a seventeenth-century version of Google-era management philosophy, purposely keeping his carvers on a loose rein. He knew that once they had roughed out the work according to his design, they would know how to read that inchoate landscape, and that he could trust their skill and instinct to find the way forward.

At Hampton Court I didn't have that kind of trust in myself, not yet anyway. Only at the final stages of modeling an object, when the choices had dwindled away, did I dare to carve as if the work were my own. But I'd learned to temper every glance at the photograph with a glance at the wood. And I'd stopped trying to impersonate Gibbons. The truth is, I was growing less interested in the man.

My pretty ideas were going down the drain. Mike Fishlock fixed me with his blue eyes. "I've spoken many an eloquent word on the subject of Gibbons's chisel marks, on your authority." He was smiling with what looked like wry goodwill. I said I'd spoken a few myself. He shook his head. "Think of all the people we've led astray."

For years I'd harped upon the vices of sandpaper and the virtues of a surface taken straight from the chisel. Then Luard removed the yellow wax from the carvings and revealed those disconcertingly smooth surfaces. It was time to embrace reality and contrive a way to re-create this smoothness in our replacement carving. The identity of Gibbons's abrasive seemed to have been lost in the mists of history. All we knew was that he didn't have the commonest tool in the modern arsenal of finishing: sandpaper, which wouldn't be invented for another hundred years. But sandpaper is ubiquitous now, and it seemed reasonable to see how close it could get us to a Gibbons-like surface.

I had carved to near completion one of the long leaves on the right-hand side of the shamrock rope. I was at the point where I'd begin smoothing it in my usual way, with painful small twisting and scraping-like movements of my gouges. Instead I picked up a piece of fine sandpaper I had cadged from the carpenters, wrapped it

around my finger, and commenced the sacrilege of rubbing it across the gouge-sheened surface of the leaf. I felt the grinding scrape under my fingers, heard the infernal rasping noise, saw the dust appear.

There were similar leaves on a surviving drop lying on a table behind me, so comparisons would be easy once I was done. But I hardly needed to look. The moment I took my hand away I could see an uncanny resemblance to a Gibbons leaf. The surfaces even felt the same: satiny smooth. I compared them under a magnifying glass. On both the little chisel facets were softened almost out of existence, the pores of the wood were clogged with wood dust, the chisel sheen was gone, and the leaf edges were strong and regular.

And there was something else. You might think that carving is primarily a matter of scooping out wood with a gouge, leaving concavities behind. That's the way the modeling starts, all right, and with beginners that's where it tends to end. But convexity rather than concavity is the basis of Gibbons's treatment of foliage and petals. A leaf is not a simple valley shape for Gibbons, it's a subtle geography of swelling flows. Even what would be a continuous arc of surface in nature, like the petal of a tulip, Gibbons turns into a riverine surface of undulating hillocks.

These bulges convey the impression that the plant material is paper-thin, easily ballooned out by the life surging through it. But they are awkward to model. At their base difficult angles occur. The gouge must deal with rapidly changing configurations of the grain in the same sweep, which often makes for tearing out. But sandpaper, which doesn't have to slice through but simply grinds away, is indifferent to complexities of grain and will quickly yield an unbroken continuous curve. A wave of the forefinger takes you from the boulder-strewn landscape of Salvator Rosa to the smooth blue mountains of Claude Lorrain.

Suddenly the use of abrasion seemed to be a key to the sleek

vigor of Gibbons's forms. So much for rugged chisel marks and horny-handed integrity. Gibbons wasn't nostalgic for a golden age of preindustrial craftsmanship. He wasn't a Victorian. He hadn't read Ruskin. He didn't need to leave rough surfaces to prove his authenticity, to prove he was not a machine. He was probably pragmatic enough not to scruple at any method that would produce the dynamic forms he wanted. It might trouble *me* that my carefully developed smoothing skills could be replaced by a simple rubbing motion any fool could perform. Gibbons probably was happy with the increased workshop productivity this allowed.

But there's a darker side to this expedient. One day Trevor announced that he and Richard Hartley habitually used sanding not just to finish their own work but as a part of the modeling process itself. As they carved they freely alternated between sandpaper and chisel. I pondered this as I looked down at my workbench. Well, why not try it? Next to the leaf I'd just sanded was a second one, barely roughed out. I began bringing it along using sandpaper as a supplement to gouges, switching from one to another and ignoring my worries that slicing through sand-impregnated wood might dull my blade edges. The work went quickly. You could fashion a rough shape, then use heavy-grade sandpaper to smooth down the ragged edges and unwanted projections. Down the road I went. The gate was wide, and broad was the way.

To perdition. The leaf was stillborn. I'd created a precursor to one of those zombie CNC machine carvings that soon would begin to appear on the market. There was no crispness to the forms, no subtlety to the modeling. The surfaces were hard, but at the same time they looked as if they were made of something overly soft. Like tofu. They'd lost their strength of purpose somewhere along the line. I recalled the unusual smoothness I saw in Hartley's carving, remembered that it struck me with mixed wonder (how did he

produce that with a chisel?) and unease (why is it so flat and feature-less?). Now I suspected that Hartley, despite his protestations to the contrary, had used sandpaper on his Hampton Court carving. And that it had produced just that deadness that Ruskin complained of.

Trevor and I talked and talked, and looked and looked. He agreed that Gibbons didn't use abrasion as a modeling technique, but as a last-step smoothing operation after the chisels had been set aside. His workshop seemed to have had the discipline to resist the temptation to overabrade the carving, to abrade it too soon.

If only we knew what abrasive Gibbons used, then we'd probably know how and when he used it. I racked my brains. Rasps, scrapers, a cloth charged with pumice or emery or rottenstone? Hadn't I once heard something about a charged bulrush or some such thing? Most of these alternatives could be dismissed outright, for one reason or another. And none of them would produce those regular little striations that could be seen in many places on Gibbons's silky surfaces: four or five parallel scratches just visible to the naked eye. Our only clue, still leading nowhere.

Gibbons had apprenticed in a limewood figure carving work-shop somewhere on the Continent. It seemed likely to me that he would have retained the finishing methods he'd learned there, just as he'd retained limewood and his meticulous sculptural approach. Surely assiduous art historians had researched the techniques of the great Northern Renaissance masters, Tilman Riemenschneider and the others? I canvassed the sculpture curators and conservators at the Victoria and Albert Museum. They could only suggest that Gibbons might have adapted abrasives used in marble polishing. Back to emery or pumice. Unlikely, I was sure.

One morning an old Cambridge friend appeared at the carving room door. She was with her latest admirer, who happened to be a maker and restorer of harpsichords and spinets. Like most

early instrument makers, he was immersed in the arcane lore of seventeenth- and eighteenth-century workshops. A brain ripe for the picking. I described our quandary to him, and he proceeded to reel off a list of early published treatises on wood finishing. He said that techniques of smoothing by fine abrasion had grown very sophisticated by the sixteenth and seventeenth centuries. Most if not all wood surfaces were treated in this way. Ruskin's nostalgia for a chisel finish was ahistorical.

Our conversation continued the next Saturday morning, after he had consulted his library. In the eighteenth century, he told me, one André Jacob Roubo asserted that the skin of the dogfish made a good abrasive, and the ears were the best part of all. By which he meant the rock salmon, which is a kind of shark, and its fins. Had we experimented with sharkskin? And incidentally, he said, we also should try Dutch rush, which was often mentioned in early texts. Dutch rush? It sounded like a drug experience. Or a disease. I'd have to look into it. In the meanwhile, Ted, the carpenter, told me he knew a fishmonger who came down from Grimsby every Tuesday, to sell rock salmon among other things, skinned at the dock. He could ask him to bring the skins next time.

Let's suppose you've devoted your life to studying Caravaggio. What would it be like, in some dusty attic one day, to stumble upon a previously unknown painting by the artist? If my own experience is anything to go by, it would feel like déjà vu. In the years after Hampton Court, people began sending me photographs of their "Grinling Gibbons" carvings, asking me to (as they put it) authenticate them. In every case I had to respond with unwelcome news. Scores of carvings, none of them even close. A few seemed to have been done by decent early followers of Gibbons. Most were

much later and saddeningly crude. Although it surprised me that such carving could be mistaken for Gibbons's, it didn't surprise me that no hidden treasures came to light. Gibbons has been famous since his death. Almost all his works are in the public realm, and have been known for centuries.

One day several years ago yet another manila envelope appeared in my mailbox. An owner had telephoned earlier with a tale about a large panel with a glamorous provenance. I warned her that the chances of it being a work by Gibbons were remote in the extreme, but I said I'd be happy to look at a picture. I opened the envelope, shook the photograph out onto my workbench, and glanced down. Oh yes, I remember this, I thought to myself. Preternaturally wise-looking cherub heads supporting a flower basket filled with tulips and crocuses. Swags of fruit and foliage, their shape emphasized by ribbons that were sometimes free and loose, sometimes pulled tight by gravity. Unmistakable. I've been here before. But wait—have I? With a sudden glory I realized that I'd never laid eyes on the piece. Its every gesture was familiar, but it was entirely new to me.

Curators and collectors like to tell of this visceral sense by which they recognize the hand of an artist. They know at once, and look for reasons later. They feel it in their bones. There's an instantaneous interior engagement with the piece. But this is only a specialized version of the altered consciousness many people experience when they respond intensely to a work of art. Subject and object telescope together. Inside and outside collapse into one another. Our thought rushes out to the edges of our flesh, is the way Yeats puts it.

A few months later I went to see the carving. Along the curves and over the fine rolling plains I wandered, down into the shadows and up onto the high slopes. My eyes seemed to be modeling the forms. As if I were creating them as I perceived them. Was this because I was a carver? That seemed beside the point. It was the

same sense of participation I'd felt that day in the church on Piccadilly, when the world disappeared for a few minutes as I swam down the torrent of the carving.

What is this consciousness, evoked by painting or sculpture, or poetry or music, or even a painterly landscape? It's the thinking of the body, says Yeats, smelling the salt air when he read of Odysseus, feeling a tingle in the soles of his feet when he saw the *Winged Victory*. But isn't the thinking of the body an almost perfect definition of *skill*? Isn't it what happens, not when you're experiencing art, but when you're creating it? What better phrase to describe the unconscious kinesthesia by which the chisel in your hands works the object?

So, then, the viewer's consciousness repeats the maker's. This is the ancient secret of art's power, the crux of the matter, the hidden valley where the roads come together. The work of art and the *work* of art transport you to the same charmed place. One phrase can encompass the making of art and the enjoyment of it, because the bedrock of both is the same baffling sensation of mind and body melting together, of outside as inside, of seeing as making.

It's the antithesis of the blank feeling you get looking at CNC machine work. And the manufactured art of conceptualists may have many pleasures, but how often is this one of them? It's hard to share in an artist's making when there's no artist making. But when that embroiled instinctive creating is embodied in the work, that spontaneity and embedded inspiration, then? You can know Hamlet as Shakespeare knew Hamlet. Become Mozart for a while. Play your air guitar to Jimi Hendrix, for that matter.

On the way to ask Ted for news of the Grimsby sharkskins I turned into the narrow and brooding Master Carpenter's Court. Who should be there, standing in a newly dug hole, but

Simon Thurley. He said he was searching for the foundation of a fifteenth-century oven. For once Thurley was stationary, and easily buttonholed. I'd been looking for the chance to propose an idea for resecuring the Gibbons carvings after their restoration. During the fire everything else in the King's Apartments had been removed in the few hours before the flames had burned through the ceiling above. But Gibbons's carvings were screwed to the wall, and so they were abandoned to their fate.

Thurley stared up at me from his hole. I forged ahead. When the carvings are put back up, why not hang them as if they were pictures? We could use either wire and eye screws or mirror plates (brass plates screwed to the back of the carving, with slots so they can be hung on a nail or screw). No more helpless victims in an emergency. No more danger of collateral damage from other activities in the room. You could just lift off the carvings and remove them to safety. Furthermore, regular cleaning and inspection would be a hundred times easier if the carvings could be laid on a workbench. They could be seen from the sides and back. You could move around the workbench and gain access from different angles, rather than having to stand on your tiptoes or get down on your knees. Especially on a wobbling scaffold.

Thurley looked as if he wished he were in another hole. We can't do everything, he said, and we have enough on our plate without introducing a whole new hanging system for the Gibbons carvings. It came to me that he had seen one consequence immediately, and this was leading him to mistrust my motives. If the carvings were hung rather than screwed to the wall, it would certainly make it easier to lend them to an exhibition. I won't pretend that this thought hadn't occurred to me. On the other hand, just because it is in one's interest doesn't disqualify an idea. And this one had come to me long ago, on that afternoon when I was collapsed in my chair

after hearing the news of the Hampton Court fire, my head filled with images of havoc. Luard had come up with the same notion independently, and Mike Fishlock had approved it in principle.

There was another consequence Thurley may have been half aware of, and none too pleased with, either. Hanging the carvings might signify a tectonic shift in their status, away from their being part of the fabric of the building and toward their being portable works of art, like paintings. It might begin their migration away from the historic building agencies and into the purview of the Royal Collection. The old ambiguity about Gibbons's work—is this ornament or sculpture?—would raise its head again, and with this the prospect of another turf war. Whatever was going through Thurley's mind was not making him receptive. He told me I couldn't expect him to entertain such proposals while he was standing in a ditch thinking about ovens.

Not a successful presentation. He was as viscerally against this idea as he was against the proposal to lighten the carvings. Ted had nothing to report from the fishmonger, either. Back to my refuge, the carving room, and Trevor's sympathetic ear. I was warming to my workshop companion, with his distinguished but unvaunted Royal Air Force record, his bicycling, his accordion lessons, his willingness to tackle anything. Once I spoke to another carver about a young prospect, and was told, "She's going to be a good carver. She's courageous." Trevor was courageous, undaunted by any project. He didn't like "mysticism," but he knew all about the trance of intense making. He was happy for us both to fall into hours of silence. And he was generous. He saw that I subsisted on digestive biscuits, so one day he gave me a round tin for them, painted to look like the paper package they came in. Once I grumbled about the draft from the inch-wide gap between the two parts of my huge sash window, and the next day he brought in a strip of foam rubber to fill it.

He was accustomed to working alone, and like me he probably didn't find it easy to adjust to a workshop atmosphere, with its blend of camaraderie and competition. The breakthrough for both of us came one day when, out of the corner of my eye, I saw Trevor take off his work glasses, step back from his bench, and sigh. "This is taking me much too long," he said. It was a quiet confession of hardship, a dropping of the mask of pride. I felt a surge of sympathy. "Welcome to the club," I replied. He was enmeshed in a bunch of forget-me-nots. I told him that I always found those never-ending and that I thought their name was appropriate. All those little blossoms endlessly clamoring to the carver, *Don't forget me! Don't forget me!*

We talked about the little round hole in the center of each, shorthand for the opening at the center of a real forget-me-not. I told Trevor that I supposed Gibbons could have used a little drill for these, but that wasn't the way I did them myself. "It's not the way I do them, either," Trevor said. "You just spin a little veiner between your hands, don't you?" Yes. In fact, I'd shined a light down one of Gibbons's little forget-me-not holes and saw at the bottom the kind of cutting around the circumference that is created when you twirl a half-circular gouge. "Well, look at this," said Trevor, and he handed me a tiny round plug of wood he'd found at the bottom of one of Gibbons's forget-me-not holes. We'd both produced these a hundred times before in our own work. Trevor and I and, triangulated between us, Gibbons. All conversing together, though there were speaking parts for only two.

Three, really. Luard wandered in and started talking about how he'd removed an upper layer of carving and found that some of these little flower-center holes had penetrated right into the layer beneath. So some final touches to the modeling must have been done after the carving's layers had been assembled together, at least temporarily. The three of us talked out the implications of this.

Our days were filled with such conversations. No grand speculations, just compared notes about matters of procedure. And Gibbons? He was standing around like the rest of us. The monkey had jumped off my back.

A fulcrum, dividing into a before and after. Before, you think one way; then something tips, and you think another way.

Heifers grazing farther down in the river pasture now, on this hot summer afternoon. Almost out of earshot of my workroom. They remind me of the cows in the Cambridge meadows, mooing in the distance while I was defending my essays in a don's oak-lined chamber. Deeper and deeper into botanical detail now, in these long middle reaches of my vegetable-faced chef. The carving has broken its tether to the drawing. It's moving ahead on its own path. I'm swimming in the pleasures that were denied me at Hampton Court. The free creativity of making something to its own script, the high trance where working and creating are one: the thinking of the body.

It was a phrase from student days, one of a throng of similar phrases that filled my head then. "How can we know the dancer from the dance?" "God is Man & exists in us & we in him." "You never enjoy the world aright, till the sea itself floweth in your veins." Yeats and Blake and Thomas Traherne, three among many poets and painters who report feelings of oceanic oneness. My authorities, who have been to my thoughts what Gibbons has been to my hands.

Plotinus, too, in this sunny workroom. The man who was ashamed to be in his body, who thought that art should turn its back on the physical world and climb to the realm of ideas. He's made his share of mischief over the years, luring me away from my senses in early days, and later feeding my impulse to ascend into Gibbons's mind rather than take my cues from the carving in front of me.

The river pasture.

Down with the chisel so I can stare out at the river. You think one way and then another. Once I was content to accept those poets' and mystics' high visions as what they were intended to be: a description of reality. When Plotinus talked about rising to a mode of perception in which seeing and being and creating are one, and when he asserted that this vision shares in the ongoing creation of the universe, I received it as what it is, his account of the literal truth of things.

Did I actually *believe* him? Not for a moment. Then why were those glowing words so attractive? Why have poets and painters and sculptors found Plotinus a kindred spirit? Not because of his metaphors and his beautiful imagery, as I once thought, but because artists swim in a sea where Plotinus's vision seems to hold sway. What is absurd as an account of reality is a luminous report from

the unreal world of art. There, making and seeing are entwined together. Mind and body and object dissolve into one another. You think in the marrowbone. You paint with your brain, as Bernini said of Poussin.

Artists seize upon Plotinus because they're inclined to regard their creative experience as a general account of reality. They want to turn it into philosophy, and the philosophy they want to turn it into seems to resemble Plotinus's. "We know everything because we have made everything," declares Yeats. Everything in the *universe*, is what Yeats is claiming. Everything in my *poem* (or novel or sculpture or music), is what he might more truthfully say. With a chisel or pen or brush in hand and your work before you, oceanic dreams, preposterous in real life, can come true. You can be one with what you see, with a seeing that melts into making. That's business as usual at the workbench. It passes almost without notice, until you think about it. You don't even have to be at a workbench. If you perceive a work of art intensely enough, its sea will flow in your veins, and you'll see as its maker saw.

Artists and mystics may want to turn this experience into philosophy, but these days I'd rather turn the philosophy back into an account of the experience. I'd rather turn Plotinus into a sage of making, a spokesman for what happens at workbench or desk or easel or piano. He and Yeats and the other visionaries can be relieved of their metaphysics and invited into the workshop, into the thick of things, where they become your comrades. Isn't that how you end up dealing with revered authorities anyway? You bend them to your own selfish purposes. You think and think about them, and finally you get the purchase on them that makes them useful to your life. You put them to work.

Time to clear the mind. Down the path past the little cemetery to the swimming place. Not a fisherman in sight, only a surprised

osprey, which launches itself and wheels over the river with its high chirping. Into the cold amber-clear waters, to swim across to the other side and, swimming back, let the current in the middle catch me and carry me downstream.

Puffy clouds, dark blue sky, water soft against the skin. Mansions of green on either bank, a dazzling white thunderhead billowing up. Indulging myself, swimming on and on, into an imaginary geography. The River Cam leaves the trim colleges behind, flows into the Thames alongside the gleaming palace, then turns north into wild country, narrows, gathers speed, and runs past a workroom paneled with rough barn planks.

The shortest days of the year. A dressy office party for the architects and others at the Banqueting House, which did not include carvers or conservators. But I was invited for Gaelic coffee with Ted and the other carpenters. We sat on stools and debated whether old tools were better than new because old steel grows harder over the years, as Ted said his father had claimed, or because, as I argued, the old steel is more flexible and takes a better edge. Late in the afternoon Mike Fishlock shouted "Happy Christmas!" through the carving room window as he left for the long holiday. Simon Thurley appeared at the door. "How are you getting on with your masterpiece?" He came in, looked at the uncompleted bottom third of the carving, and asked whether the rest of the drop was finished yet.

Flora performed in a school production of *A Christmas Carol* in a hall in Hampstead where Dickens once gave public readings. We went to holiday parties, which all seemed to include someone useful for my machinations. At one, the harpsichord restorer and I huddled together talking about Dutch rush. A little leafless plant

used to sharpen swords and prepare clarinet reeds, he told me, and he suggested that the Natural History Museum would be the place to go for more information.

Just before Christmas we drove out to a lunch in Suffolk, in a manor house with a towered entrance gate that wouldn't have been out of place at Hampton Court. It was built in Henry VIII's time by a defiantly Catholic family. There was an enormous table and a roasted goose. One of the guests was a Sotheby's auctioneer who said he could introduce me to the curator in Florence who was responsible for the Cosimo panel, which I'd hoped would be the centerpiece of the Gibbons exhibition.

The Sotheby's man asked how plans were coming along. I told him I was hoping to persuade the Prince of Wales to be patron of the exhibition. That might smooth the way at Hampton Court, which was proving to be problematic as a venue. I said that Charles was being approached by a couple I knew who were friendly with him, and by the director of the Royal Collection. At that point I didn't have an inkling that the response from St. James's might up-end my plans. But a few weeks later an unexpected message came back from Prince of Wales's office. Why have the exhibition at Hampton Court? It's out of the way. More people would come if it were held at a neutral venue in London.

Of course! Why not? I'd been thinking too narrowly. The time had come for something undreamt of, a comprehensive Grinling Gibbons exhibition. The first and last. One that wasn't tied to Hampton Court, but set out to illuminate the entire sweep of the carver's career. But Gibbons's work is nailed to the wall, isn't it? How could you ever get enough material? And after all, it's only decoration, isn't it? I could imagine the objections. But they couldn't deflate the moment, when a quixotic idea seemed, by expanding, to be turning into something less quixotic.

All that was in the future. For the moment it was enough to be having a Pickwickian Christmas lunch in the Suffolk countryside, staring out at a stone courtyard that wasn't Hampton Court, with a glimpse of green fields and hedgerows and copses through a great arched entrance. The carving restoration project was being covered widely in the media, so what everyone around the table wanted to hear about was Gibbons, Gibbons, and more Gibbons. I didn't tell them that the man himself was fading from the landscape of my work at Hampton Court, that in the wild interior of the carving I'd been handed on to a different guide.

❧ *The Fountain Garden, with the Banqueting House beyond.*

CHAPTER VIII

Meaning Isn't the Meaning

L uard uncovered another time capsule. He had pried off a layer from the drapery on the Second Presence Chamber overmantel, and there it was: a smooth surface of remarkably pale bare limewood that had been carved to completion, only to be concealed for the rest of time. Or so the carver who secured the forward layer on top of it must have thought. Another pristine world, much larger than the one he had shown me back in the autumn. Scattered on its silky surface were the same curious abrasion marks we'd seen before, little patterns of four or five striations barely visible to the naked eye.

They mocked our ignorance. It was time to bring the enigma of Gibbons's finishing method to a head, even if this meant admitting defeat and moving forward as best we could. I went to the anteroom, telephoned the main switchboard of the Natural History Museum, and began delving my way down into the botany department staff. Before long I'd struck a rich lode.

"Of course. Dutch rush. *Equisetum hyemale*. A living fossil, as they say. The genus goes back to the Carboniferous period. That was three

☙ *Left: Dutch rush.*

hundred million years ago, before the dinosaurs. It's a principal component of coal. You're right, it's known for its abrasive properties."

The voice belonged to one of the museum's fern experts, whose interest was quickened by the fact that she happened to be an amateur woodcarver. She told me that the species familiar to most people is the bushy *Equisetum arvense*, the common horsetail, which is also abrasive and was used in handfuls by turners to smooth their wood. By contrast, *Equisetum hyemale* grows in single hollow stalks and is less common in Britain. It was imported in large quantities from Holland; hence, Dutch rush. The plant had other names that reflected its functions: scouring grass, pewterwort, shave grass.

For centuries—probably millennia—it was used to sharpen blades and to scour everything from pewter objects to kitchen utensils and milk pails. And it smoothed wood objects of all sorts. The curator said that there were herbals from as early as the twelfth century that gave instructions for using *Equisetum hyemale* to finish the surfaces of furniture. It occurred to me that since this furniture often would have been made of oak or beech, it must be a robust abrasive. Yes, she said, Dutch rush, like all the *Equisetum* species, takes up silica from the sandy soil on which it grows and deposits it on its surface. It was an example of biomineralization, like animals turning calcium into shells and bones. But this was silica. The glass in glasspaper, the sand in sandpaper.

Later I learned that Dutch rush is superior to all the other *Equisetum* species—in fact to all other plants—in the quantity of silica it can absorb and deposit in its epidermis. As much as a quarter of its dry weight is made up of the mineral. Furthermore, Dutch rush arrays this deposited silica in a way that makes it particularly effective as an abrasive. There are small ridges on the plant's surface, and along the summits of these there are two parallel rows of silica nodules.

Hard cutting points, set in a forward position. Like the diamond studs in drill bits.

I wandered back into the workroom, lost in thought. Soon the phone rang. It was the curator again: a colleague had just told her he had a patch of Dutch rush growing at the bottom of his garden. Some plants, she promised, would soon be on their way to Hampton Court.

They arrived on my birthday a week later, along with a violent case of flu. The pages of my journal are filled with references to illness during these months. One nebulous virus after another, part of the fabric of life, as they were back in the old days in our cold Sussex cottage. That morning I'd tottered to the station at Hampstead and onto a North London Line train that crept along at half speed, as if it, too, were suffering from an ill-defined malady. It arrived in Richmond thirty seconds after the connection to Hampton Wick departed, so I spent forty-five minutes on the station platform that chilly morning trying to keep warm before the next train arrived.

Trevor was waiting with birthday presents. There were two rusty, lethal-looking nineteenth-century grapeshots retrieved from the Solent. Then, to go with them, he handed me a piece of oak from the bow of HMS *Victory*, Nelson's flagship at the Battle of Trafalgar. He'd been given it by a friend in Portsmouth who was working on the ship's restoration.

I tried to do some carving, but my hands were weak and shaky. Somewhere Dante writes of an artist who has the skill of his craft but whose hand trembles. Before long I asked Trevor if he would join me for an early lunch, liquid in my case. We walked to the King's Arms, the old inn at the Lion Gate entrance to the palace. I was hoping a pint of Adnams Mild would be the remedy for my symptoms.

We talked about the numinous quality of the *Victory* fragment. When she was built in the 1760s, said Trevor, five thousand oak trees were felled for her. Talk turned to the working properties of

oak, then to limewood and its qualities. This set Trevor to expounding his theory that the key to Gibbons's technique was his desire to exert the least possible effort in carving.

The Adnams was failing me. I was woozier than ever. We returned to the carving room. Sitting on my workbench was a box from the Natural History Museum, delivered in my absence. I opened it, looked inside, and burst out laughing. What was this, a phantasm of my illness?

We called them Indian cigarettes, my childhood friends and I, playing our frontier games in the forest. Thin, hollow, jointed green stalks two feet high, like miniature bamboo. You could break them apart at the joints, with a satisfying pop. At the tip of each segment was a gray papery footlet that looked for all the world like cigarette ash. This allowed the ten-year-old lordlings of the wilderness to engage in some theatrical smoking, after Hollywood models. And when you were finished you could stick the plant back together and pretend nothing had happened.

Even now the little stalks were familiar presences in the countryside around our house. There was a patch of them growing in the alluvial sandy area between the Bass Pond and the Swale Pond, and next to the dirt road on the dugway, and along the river down near the swimming place, and now that I thought about it, scattered in many other places as well. The summer before we left for Hampton Court I'd sat on the hillside with Flora and showed her the trick of popping the sections apart. Then we had a sophisticated smoke together, to her extreme merriment.

What could this apparition from childhood have to do with Grinling Gibbons? I pulled off a segment and rubbed it on a piece of wood. It left behind a green chlorophyll smudge. Evidently these

plants needed to be dried first. I spread them out on the windowsill. I was feeling light-headed, adrift from my surroundings. I decided that I'd better make my way home. Just as I turned to leave I noticed that a couple of the plant segments had died some time ago and so were already in a dry state. Well, why not try these? I flattened the hollow stalk, wrapped it around my finger, and rubbed it sideways on the wood. It seemed to move disconcertingly smoothly, but soon enough it was raising fine sawdust. I blew this off to reveal an almost burnished surface, with the edges of chisel cuts subtly tempered.

Then came the turning point, the solution to the mystery. I looked at the diminutive ridges and furrows that ran along the length of the stalks. Could it be? I changed the position of the plant on my finger and rubbed it back and forth lengthwise, along the axis of the little ridges. Just visible on the wood, left behind by those silica-studded ridges, was a pattern of four or five parallel striations. I took my piece of wood over to the Gibbons time capsule. My marks and his were cousins. Siblings. No, identical twins.

Trevor was looking over my shoulder and growing as excited as I was. We could do a little chiromancy on the plant and deduce Gibbons's practice from its characteristics. Already it seemed that the mildness of its sanding effect established the limits of its use. This kind of abrasion couldn't have been part of the substantive modeling process. It would be useful only after chisels had gone nearly as far as chisels can, and the surface just needed amalgamating and smoothing. Maybe Trevor was right, and Gibbons took all the shortcuts he could. But modeling by heavy abrasion wasn't one of them. Sharp blades were the armaments he used right to within sight of the end. Perhaps there wouldn't be time to get enough Dutch rush plant material to actually use at Hampton Court, but at least we could employ our fine glasspaper with more confidence that it was an approximation of Gibbons's method.

I made my way out of the palace in a dream, thinking about the countryside at home, imagining harvesting forays into the remote vleis and swales. In the coming weeks, after the plants had dried, I experimented with different methods of preparing them for use. If you soaked a segment in water to soften it, you could slit it lengthwise, unroll it, flatten it, and dry it in a paper towel with a weight on top. This turned it into a pad like a little piece of sandpaper.

But Dutch rush is a subtler tool than sandpaper, and more various in its effects. Sometimes I inserted a dowel into the hollow stalk, which turned it into a kind of sanding wand. If you rubbed this back and forth in the valley of a petal or leaf, it left behind especially deep striations that gave an accenting texture. Bernini once spoke about how texture is the surrogate for color, in a monochrome medium. I wasn't sure that Gibbons had this in his mind as he used Dutch rush, but I couldn't get it out of mine. Anyway, I always felt a thirst for shadows, in the blanched world of limewood, and Dutch rush could produce them on a subtle scale.

I had suspected that whatever device Gibbons used to smooth his carving was also used by the great South German limewood sculptors in the centuries before his birth. Later I learned that Michel Erhart and Veit Stoss and Tilman Riemenschneider knew all about Dutch rush. A museum curator in New York told me that a conservator once even found a piece of *Equisetum hyemale* stuck deep in a crevice on the back of an early sixteenth-century figure. It was Gibbons's connection with that old European tradition, forged in his apprenticeship on the Continent, that had put the plant in his hands.

A few days after the Dutch rush arrived, the palace security office telephoned to say that they had received a bag of smelly fish—"they don't half pong"—and please could I collect it forthwith. I asked if they would mind holding it for a couple of days. The voice spluttered in dismay. Much puzzlement and joking. Soon six little

sharkskins joined the Dutch rush drying on the Duke of Albemarle's windowsill.

A few days later they were stiff as cardboard and the flies had lost interest. I cut a piece off with scissors and tried rubbing it back and forth on the wood. It slid smoothly one way, but was rough and catching the other way, like a cat's tongue. A good abrasive, though it clogged quickly with dust. More trials, more comparisons. Gradually the candidacy of sharkskin faded, as it became clear that it didn't produce the characteristic qualities of Gibbons's surfaces. The surface it left behind wasn't silky, and the harsh little scratches it produced were in no particular pattern.

Dutch rush, on the other hand, became part of my carving life. Every few months now, in the snowless seasons, I make my way to one of my harvesting places. Last time it was a sandy bank overlooking a waterfall, where the shoots grow especially thick and plump. I cut a dozen or so, tie them in a bunch, and stand them in a corner of the windowsill to dry. When I look at those green stalks, wayward images sometimes float into my head. Hushed primordial forests, long coal trains, belching smokestacks, a boy pretending to be John Wayne, a carver in antique dress wrapping a little plant around his finger, a moment of dizzy astonishment at Hampton Court.

I'd learned some things about the process of making, the shifting tide you ride when you bring something into existence. But it didn't mean that the challenges at Hampton Court were at an end. Before me loomed the high Alps, the forward layer of carving in the central section. This was the showpiece of the drop, its crown jewels, good enough to set alongside the best work at the palace. Carving that had probably been touched by Gibbons's own chisel, or so I told myself.

Gibbons's practice was clear from the drops and overmantels that Luard had disassembled. Their depth was built up from one or two (or more, sometimes) added-on layers of work. Each layer was carved from its own board and then nailed in place on the work below. Making each was like starting afresh on a new composition. There was no carving in midflow to take instructions from. So with this prominent upper layer I'd have to start again as a pure copyist, with only a blank board before me and a dim photograph to go by.

It showed a fearful tangle of vegetation. Arching leaves, delicate exposed stems, blossoms of many sizes and descriptions: tulips, crocuses, forget-me-nots, daisies, and a few indeterminate flowers of Gibbons's fancy. In my own work I might be inclined to carve separately some of the large blossoms and the bunches of smaller flowers, then experiment with their placement before attaching them. But Gibbons seemed to care nothing for convenience and flexibility; from the evidence of the other drops, he turned this flowery territory, at least a large part of it, into a single composition and carved it from one board.

But *what* part? Somehow I'd have to determine the shape of this upper-layer composition and draw a line around its perimeter on one of my clear plastic sheets laid on the photograph, then transfer this to a board and saw it out. Unfortunately there seemed to be a dozen possible routes for that outline, a dozen possible ways to turn this burgeoning flowerscape into a single piece of carving. Come to think of it, who was to say there was only one layer here?

I was wandering in Dante's dark forest. The Virgil who guided me toward safety took the form of an unprepossessing lump of charred wood. A little piece of charcoal, found by Luard back in October. He couldn't place it in any of the surviving carvings and so by a process of elimination decided that it must have come from mine. It was so small and so burnt beyond recognition, with only a few caramelized

petals recognizable here and there, that I wondered how it had escaped from his morgue of hopelessly unidentifiable fragments.

Wherever it came from, the lump showed a composition that was three layers deep. It was mostly a bottom piece, but it had a slanting platform on which was nailed a separately carved mound, a few inches square, that looked like burnt plum pudding. Upon inspection it resolved itself into a flattish blossom. But it *too* had a platform, for a third layer of work, now empty except for a handmade square-cut nail still sticking out of it like the mast of a wrecked sloop.

So there were two superimposed layers that had to be defined. But where exactly did this fragment come from? In my carving it could only be this central section that was three layers deep. I laid the lump on the middle of the photograph. There was a rose to the center left of it that seemed vaguely like a rose in the photograph. But nothing else in the fragment correlated to anything else I could find there. Could the whole lump have been concealed by forward carving? Frustration, despondency. Better, maybe, that the piece had never been fished out of the rubble in the first place.

☛ *The magnificent lump.*

But I stared on. Something was there, right in front of me, that I wasn't seeing. The mind swings by a grass blade, says Pound. Outside the window, the chatter of passing tourists, even the hammering and sawing from the building site, grew muffled.

I turned the lump to the right, trying to make the unpromising rose fit better. On the far side were two blasted forget-me-nots with dark holes in their centers. I rotated the lump a little farther. Suddenly they lined up perfectly with two forget-me-not holes just visible in the photograph, far to the right. The lock turned, the pins dropped into place. I looked more closely still. In the photograph the tip of a daisy petal protruded out from under an acanthus leaf, and I could just discern another petal extending out from the other side of that covering leaf. And there in the lump it was, the burnt form of a daisy, with its center exactly between those two spokelike petals in the photograph.

Now a cascade of correspondences. That flat rose that I had thought was at the very back of the carving turned out to be a plumper blossom that was much more forward. The empty angled platform on the second layer surely supported the great bunch of forget-me-nots in the center left of the photograph, which I had not imagined were the boldly projecting elements they must have been. Adjacent was a little pale flat surface that was clearly a platform for the neat little tulip that appeared in the center of the photograph. Everything matters, every fragment you can shore against your ruins. Magnificent lump! Of all the small remnants that might have survived from the carving, none could have been more useful than this.

So, two superimposed layers, the forward one being the forget-me-not grouping. But there was still nothing here to help me map the perimeter of the big middle layer of carving. Then I remembered that mine wasn't the only right-hand overdoor drop in the King's Drawing Room. Another one had originally hung over the

doorway opposite. Its overall silhouette was closely similar to mine. Perhaps, I thought, the shape of its middle layer of carving also had analogies to mine. Conveniently Luard had already removed this layer for cleaning and resecuring.

I found it lying on his table. It had a complicated shape, like an island with bays and promontories. Gingerly I laid it on my photograph, in the middle of the central grouping. A little shifting, a little rotation, and once again came that sudden levitating sense of the puzzle piece fitting, the problem solved. The outline coincided with the outline of a group of elements in the photograph that might logically be carved from a single piece of wood. It was the second layer, self-evidently. In an instant I knew, with assurance for the first time, that the lost drop could be recarved accurately. I'd broken out of the forest into a high meadow, and the land lay lucid below me.

What I'd discovered not only made my own work immeasurably easier, but also revealed one of Gibbons's fundamental design principles. I'd known that he used a counterproof technique to set the outlines of his carvings. He would draw one drop of a pair, for example, in greasy chalk, fold the paper over so it transferred in reverse form, and then turn that smudge into the outline for the other drop. Now I realized that he also used the same procedure for the layers *within* his compositions.

At Hampton Court the result was everywhere to be seen. In the early years of his career Gibbons's carvings were often undifferentiated cascades of flowers and fruits and foliage. Here, by contrast, they were gathered into rhythmic groupings that mirrored one another left and right, like visual rhymes. The whole composition progressed along together, like the heroic couplets of the poet laureate of the day, John Dryden. What his contemporaries admired in Dryden—"the varying pause, the full resounding line, the long majestic march"— they probably admired in Gibbons's long cadenced drops.

The discoveries followed close upon one another. They seemed to be absorbed straight into my chisels and gouges, which now moved with new assurance. I felt enveloped in a nimbus. The world seemed transparent and lucid. Spring had come and the palace wore a trim of crocuses and primroses, flowers like those I was carving at just that moment. I took my lunch out to the garden so I could admire their bright freshness. With every glance they seemed made anew, and so did everything else. The moment turned golden. I was where I was meant to be, doing what I was meant to be doing. Clouds rolled over, rivers of waters flowed past, and I thought I would never know a time like this again.

As if I were a traveler who had clambered over a rugged divide and come down to a green sweet land. Surprises and vexations might be in store, but the path went steadily forward now, and sometimes even gave glimpses of a glimmering sea beyond, the end of the journey.

Days were growing longer, and I decided to take advantage of this by catching the first North London Line train out of the Hampstead station, the 6:35. Five extra hours of work a week. Even when you were half asleep it was pleasant to take the steep walk from our flat down Christchurch Hill to the station. On the left was the border of the Heath with its greening willows; on the right, like a benediction, a glimpse of Keats's house. At the other end of the journey Hampton Court Park had come to life, with gamboling lambs and a new swan's nest on an island in Hampton Wick Pond.

One day I arrived to find that Luard had removed a large nodding tulip from the cresting of an overmantel and found on its underside another placement notation. This time it was in written words. *Top Regt*, the curious script seemed to say. Was that Dutch

for "top right"? (Gibbons probably was happier in Dutch than English, and this blossom was placed on the right-hand side.) Was the handwriting Gibbons's? I persuaded Luard to jump ahead of his schedule and remove a corresponding large blossom on the left side. To the surprise of us all, it had the same inscription as the first, though now both seemed to say *Top Reye* or *Top Reje*. Was that some version of "rex," meaning for the *King's* Drawing Room? The handwriting was almost impenetrable to me. But it couldn't have meant "right" in any language, since both the left and right blossoms carried this word, whatever it was. Another little enigma, but at least this one would not impede progress.

Meanwhile I'd sawn out the forward layers and begun fashioning their mountainous landscape. To prepare myself, I studied the showiest passages I could find in the other drops and overmantels: forward work where Gibbons unleashed his gods of modeling and seemed to carve with passionate intensity. How dynamically, I thought, these flowers and leaves and fruits are translated into wood, how easily Gibbons tells each little story and moves to its punch line, how dramatically he embodies the sense of surging growth, how nonchalantly he dances on dangerously thin edges. He seemed to have some life force at his disposal.

It was tempting to pay this work the timeworn compliment of saying that it appeared to be modeled from clay or wax or some other pliable medium, rather than carved from a rigid one. I can handle marble as if it were dough, boasted Bernini. Do such comparisons simply mean that the carver makes the work look easy? Or do they imply that additive modeling has a higher status than carving? Shaping a soft material seems more godlike, more like creating something out of nothing. Jehovah didn't carve Adam, he modeled him with his hands. It's hard to imagine God picking up a chisel.

No, carving operates further down the ladder of making. It's a

subtractive art, a fallen enterprise in a fallen world. Its operations will always be external and mechanical. If you're as good as Gibbons, it might look as though you've shaped the wood with your hands. But I had chisels in mine, and it was laborious work wasting away around the high projecting forms of this forward layer, then modeling and undercutting them. My tools may have been moving confidently, but I couldn't have felt less like Jehovah.

Carvers are bringers of shadows, stainers of the white radiance of eternity, wreckers of a smooth plank. They live in a world permeated by error. Every carving starts the same way. You stare at a drawing on a board and think to yourself, I may not know exactly what should be there but at least I can see some things that shouldn't. So you start by rounding the corners of a sawn-out peach, thinking, Well, I can't go wrong with that anyway.

You know that most of the wood in front of you is superfluous. It's all potentiality, a hundred delusive paths forward. The songs it sings are siren songs, luring you to wrongdoing. All you can do is lash yourself to the mast of the image visualized in your mind, and cut away the false until something resembling that image begins to emerge and you hear a song that seems to beckon to safety. A long night leading to the dawn, or so you hope; a string of minuses ending in a plus.

Nothing godlike about this kind of making. And if what you've chosen to carve is something as earthbound as flowers and fruits and foliage, then you've positioned yourself in an even humbler universe. Botanical forms may offer beauty, and some simple folk associations (red roses for romantic love, and so on), but as a rule they don't deliver a moral or philosophical or political message.

Sometimes their limitations are exactly their appeal. Gibbons took up flowers to escape from the dangerous religious associations

of figure sculpture. And these days they may allow you to escape from an arena of sculpture that seems repetitive and cerebral. Flowers and fruits and leaves refuse to rise to concept. They balk at being harnessed to a notional project. Unless you're a relentless ironist like Koons and make flowers an easy shorthand for kitsch, it's hard to put them to conceptual service. I'd always been exhilarated at not having to worry about a message in the things I made. Not having to think up titles. If my carvings had meaning in that sense, then I, for one, didn't know what it was. They didn't seem to require explication.

If all you're conveying is the formal beauty of growing things, then doesn't that make you a kind of ice cream merchant? To my mind there's a tang to this ice cream, however, an acerbic undertaste beneath the sweet surface. Flowers have always been an emblem of transience, but at this moment in history that is true in a broader and more painful sense than ever before. When I contemplate beauty of this kind, carved or real, its poignant loveliness seems to harden into something like an accusation. I can never quite forget that this is the world we are grinding under our heel.

It has an edge to it, this beauty, sharp enough to cut. Nature, which gives us sustenance, physical and psychological, is being despoiled wherever you look. That's not exactly a news flash. But the nagging awareness of it colors our perceptions, and it can turn an innocent foliage carving into a reproach as well as a refuge. The plant-scapes made on a workbench are surrogates for nature as a whole, and so they can tap the great malaise of our time even without making a conceptual statement about it.

It's hard to entertain such thoughts just now, writing on this late summer day, with fruits and vegetables swelling and flowers coming into their third flush. Apples and cherries are bright in the orchard, and so abundant that they rain down before the harvest. In the evenings deer come here to befuddle themselves on the fermenting

windfalls. I can bring the orchard fruits into the workroom, along with zucchinis and potatoes, carrots and tomatoes from the vegetable garden, and by experimenting with their arrangement I can make models for my travesty carving of Bernini's bust of Scipio Borghese. The high-living cardinal I'm turning into a celebrity chef with a fruit and vegetable face.

It occurs to me that this carving is in danger of rising to concept. Thinking up a message for it would be easy enough. We are what we eat. We are what we cook. Or more grandly, we are cousins of everything that lives (after all, we share half our genes with a turnip). Not gods composed of spirit, but creatures of the same substance as things that grow from the earth.

But would that be the *meaning* of the carving? Or our angst at the embattled beauty of nature, for that matter? These things might be the pretext for its composition. They might give the carver something to think about during the carving, and a viewer or a critic something to talk or write about after it's finished. Even Gibbons's work can provoke critical interpretations of this sort. But they seem incidental, almost like a carapace keeping you from the heart of the matter. Meaning isn't the meaning. It wasn't, that day I first saw Gibbons's carving in the church on Piccadilly, when thought stopped, talk was stilled, and looking suddenly seemed like making. The carving was saying something that couldn't be said in any other way, and it wasn't saying it to the intellect.

Mike Fishlock seemed unhappy when I mentioned that the Gibbons exhibition now seemed more likely to take place in London than on his home ground, Hampton Court. I reminded him that the palace administrator had rejected my proposal, and told him that a member of the royal family, which technically owns

the Hampton Court carvings, suggested that it would be better to find a larger stage. The tide had turned, and now flowed in the direction of London.

But toward what institution? A friend knew the president of the Royal Academy of Arts and, more to the point, its famously temperamental exhibitions secretary. I thought of the RA's imposing Palladian facade and its courtyard on Piccadilly, in the heart of things, and I encouraged her to make a telephone call. She reported back that the exhibitions secretary was crusty, as always. He began by expressing doubts that I could ever get enough material to exhibit, and went on to raise other objections. But he did not say no, and he agreed to see me.

I telephoned him the next day. A gruff voice said that he knew nothing about Gibbons and had never heard of me. He demanded that I summarize the exhibition plan at once. His abrasiveness seemed practiced and less daunting for that reason. He rehearsed a long list of doubts. It was like riding a bucking horse, but I stayed in the saddle and tried to answer his points one by one while scattering little glimpses of the attractions of the project. Eventually the horse began to tire, and I detected a spark of curiosity beneath the bluff talk. By the end he'd confessed his interest openly and we agreed to meet in a few weeks. Marietta persuaded me to send him everything I'd ever written about Gibbons. Overkill, she advised.

During all this I forbore to mention that I had received permission to exhibit not a single object. It was like making a carving. You have to proceed as if the thing already exists. Besides, at the moment the Royal Academy seemed the only way forward. I'd recently met a painter who was acquainted with the new head of exhibitions at the Victoria and Albert Museum, and promised to arrange a meeting. But a few days later she reported that her friend had expressed doubts that Grinling Gibbons would work as the subject of an exhibition.

She couldn't imagine he'd draw much of a crowd. I decided not to press for an introduction.

Meanwhile, someone in the office at Hampton Court revealed to me that Fishlock's duties outside of Hampton Court were winding down, and that to fill his free time had just taken the job of surveyor to the Royal Academy. And the day before my meeting with the exhibitions secretary Mike appeared at the window of the conservation room to say that he'd just sat next to that very man at a dinner the night before. The topic of me and the exhibition had come up. What, I wondered, had been said? I didn't want to ask, but I could guess, because Fishlock proceeded to make it clear to me that he still thought the Gibbons show should be at Hampton Court. And he added, dishearteningly, that in his opinion once the restored carvings were up on the palace walls they should not be taken down again.

Next day I donned psychological armor and appeared at the Royal Academy. The exhibitions secretary turned out to be more like a sheep in wolf's clothing. He was abrupt and animated to be sure, but he seemed to have already decided that a Gibbons exhibition was a good idea. I want to rescue Gibbons from the *Country Life* crowd, he said. We talked about dates and strategy. He said he would need only to pass the proposal before the RA's exhibitions committee. But no need to worry about that. "Have they ever crossed me yet?" he asked his secretary complacently. I was given a tour of the handsome William Kent suite of rooms where the show would be held. Afterward I walked out on Piccadilly, crossed the street to St. James's Church, and stood in front of Gibbons's altarpiece again.

Later in the month I telephoned to see how the proposal was progressing through the Academy bureaucracy. There was a new tone to the gruff voice. "Just as I expected. The thought of a Gibbons

show didn't appeal to the committee." Too decorative, too familiar. Not enough there. An ancient painter had murmured that he knew Gibbons, he'd grown up with Gibbons, and he didn't need to know anything else about Gibbons. Furthermore, the Royal Academy's secretary had fully approved of the decision to turn down the exhibition. "I never know whether Gibbons is a sculptor or a furniture maker," he'd said. I felt the sweat trickle down my brow. The sheer unexpectedness of this news made normal conversation impossible. I thought the committee was in his pocket! Could it be overruled somehow? I was told that I might try approaching the Royal Academy's president, but there was no hurry since the next committee meeting wasn't until autumn. I put the phone down and stared despondently at the carvings in the anteroom.

But hope, extinguished one place, had just flared up in another. Two nights before we'd been at a dinner party given by a writer friend. Among her guests were a pair of rising stars in the London museum world, each already carrying about him an aura of glowing prospects. In future years they both would become directors of major museums. At the time one was keeper of medals and coins at the British Museum. I told him that there was a still life masterpiece in Florence that I wanted to be the flagship of a Gibbons show, and that this piece included among its detail a carved portrait medallion of Pietro da Cortona. With the name spelled "Cortonna." He told me that the British Museum probably had in its collection the medal that Gibbons had used as a model, that he thought it was French and he'd bet it was where Gibbons got his spelling. He said he'd search the medal out, and invited me to come see it and talk about my plans.

The other guest was working at the Victoria and Albert Museum. I can't imagine why, but I was moved to reflect on how the greatest art and design museum in the world would be an appropriate home for a Grinling Gibbons show. But I'd been discouraged, I

said, by the exhibition department's apparent lack of interest. I mentioned that the Royal Academy seemed to be taking up the project and that it was under review by the exhibitions committee as we spoke.

We talked on. It emerged that he had an interest in baroque interiors. He was writing a book about the building of Castle Howard, the grand Yorkshire house completed in the early eighteenth century, years when Gibbons was working in stone at Blenheim Palace. After a while he mentioned that the V&A had an exhibitions committee, too. And that, as it happened, he'd just become chairman of it. Then, after a pause, he said he thought that the V&A was the place for a Grinling Gibbons show.

At Hampton Court life settled into a kind of nonroutine. The carving moved forward methodically, inch by inch, in a carver's plod; first this, then that, then this, then that, again and again. But along the way something unexpected often was encountered, and each day seemed different from the one before.

The season had changed more abruptly than usual. Earlier in the year there had been ferocious gales, when you had to lean into horizontal rain to cross the park. Once a storm worsened and I saw the construction workers nearly blown off their feet as they made their way back and forth outside my window. The old building creaked and howled and the workers' shouts and songs echoed down from above like cries of the damned or blessed.

During those gloomy days Ellis told me that he'd felt a ghostly presence once when he was carving alone. He'd heard sounds of movement in the long-locked chamber next to the conservation room, and then he distinctly smelled chocolate. It was wafting in from the direction of Chocolate Court, the little stairwell area that

once had a kitchen where a servant named Mr. Nice made chocolate for William III every morning. Who's the mystic now? I asked Trevor. No such hallucinations for me, although one evening not long after I heard footsteps in that same sealed chamber. As I looked at the door to it, the knob turned slowly, and then turned back again. A security guard, surely. I should have called out, but for some reason I could only stare.

Then the weather tipped the opposite way, and April was the sunniest on record in London. One day I was absentmindedly working on the right side of the upper layer, narrowing down a crocus stem just where it lay on a large forget-me-not. It was an arching stem and I wasn't paying attention to what my eyes and gouge were telling me about the changing direction of the grain, which turned weaker as you progressed along the arch. I was undercutting with too much force, and without a compensatory slicing motion. There was a loud snap, the sickening sound that I'd heard often in our cottage in Sussex but less frequently in the years since.

Trevor was at my side in an instant, laughing merrily. "You could hear that all the way to North Dakota!" More laughter, almost giddy. I joined in, though mine was rueful. On the day when Trevor told me he was carving much too slowly, he was confessing to being a less than perfect carver. I'd just made a similar confession, but mine was nonverbal and much more eloquent.

And what about Trevor's hilarity? Was it sudden glory at the misfortune of others, as Thomas Hobbes famously defined laughter? Workshop competitiveness getting the better of workshop camaraderie? I thought it was more benign, a kind of solidarity with another's imperfections. When someone reveals frailties you recognize in yourself, you laugh in a kind of relief. I remembered feeling something like pleasure when Trevor spoke of his slow progress. Besides, Trevor was perfectly aware that every carver breaks things

occasionally, and that there's rarely any lasting harm. A dab of modern glue will make it stronger than ever. You'll laugh later so you might as well laugh now.

As a matter of fact I was getting used to breaking things. But breaking them intentionally. The photograph of my drop showed gaps where elements had broken off, probably years before. Since there was to be no speculative replacement carving, I had to figure out how to represent these breaks. First I thought that I would carve a stub and then score the face of it in some way to represent the texture of a break. To make a model I found a piece of wood, and with a twist of my chisel snapped off a chunk of it. Then it occurred to me that I could do the same thing in the carving itself. If I could snap the wood off in the right place, then I could leave a broken edge that was as authentic as could be. A perfect reproduction of a break, because it was one.

Since the grain of my piece went in the same north-south direction as Gibbons's, the weak shearing planes were along the same vertical lines where the breaks had actually occurred. The breaks were exhilarating to produce. And now, if unborn generations couldn't tell from its shape, I'd left behind physical evidence that the piece in front of them was damaged goods—in particular, that the oddly empty top right corner was missing large sprays of arching foliage. Perhaps in the distant future someone might think that the accident had occurred not to the original but to this replacement carving. But what would be the harm in that? Anyway, my hope was that as time went by the knowledge that this was not an original carving would be lost, and that it would fold quietly into Gibbons's ensemble. I was hoping to be forgotten.

One afternoon there was a brief power outage, then a longer one. Then the electricity failed altogether. I worked on in deepening shadows until late into the afternoon, with ever sorer eyes but

an ever growing pleasure in the accuracy of natural illumination. Years before I'd learned the trick of turning lights off occasionally so I could see surface texture better. Features that were flattened by overhead lamps, the little rises and hollows left behind by the gouge, would come forward in the slanting cold light from a window.

Now this light also seemed to bring the whole geography of the piece into sharper view. The bunch of berries at the bottom of the drop coalesced more lucidly, somehow, and so that I could see at once that two or three of the berries needed to be lowered. It made me wonder whether the absence of artificial light in ages past, for all its inconvenience—its shortening of the workday, its harsh demands on the eyes—didn't make for better results in the end.

Daylight turns a carving into a natural object. It becomes part of the world in a way that it never does under workbench lights. Suddenly it's pale and elegant and it speaks a new language of simple clarity. One of the best moments in the making of a carving comes when it is finished and hung outside on a wall in indirect sunlight to be photographed. The thing that was so long recumbent on the operating table, flooded with harsh illumination, now is upright and self-standing, at ease next to the grass and trees. The shadows gather force and fall in the right direction. The piece appears in a new light altogether.

Another day. Two art historians, one a neighbor from Hampstead, appeared at the carving room. They were specialists in a seventeenth-century Hungarian artist named Jacob Bogdani, at least one of whose unusual paintings of birds hung over a door at Hampton Court. We went to see it and then returned for pleasant conversation at my workbench. Idly, I showed them Gibbons's large tulips with *Top Regt* or *Top Reye,* or whatever it was, written on their backs. Its deciphering had defeated curators at several museums.

The Hampstead neighbor, who'd long swum in the seas of the

seventeenth century, looked at the writing and looked at it again. "There's no tail on that R. It's not an R, you know. It's a P. And that's not a G or a Y, it's an S, written in the old style, like an F. What it says is *Top Pese*." Top piece. She was right. Too simple! The inscriptions specified the position of these tulips in the part of the overmantel that is now, fancily, called the cresting. It was more evidence that Gibbons's big compositions were anatomized into different tasks for different carvers. Years later, when I got to know his hand, I could see that this wasn't Gibbons's writing. Perhaps it was his specialist in tulips, or maybe large showy flowers generally. Whoever he was, he could read and write as well as carve, and the workshop was busy enough to require written placement notations.

Flora's school year was coming to an end. So was our lease on the Hampstead flat. With every month our fears that I would not finish by the end of June had grown, and now they were coming to pass. Flora and Marietta would go home without me. I'd have to move to a friend's house in Clapham and work on alone.

I'd plucked my schedule out of the air, so it wasn't surprising that I couldn't keep to it. There had been that murderous two-month delay before I even picked up a chisel. My machinations for an exhibition had used up more time, and still worse were the interruptions that plagued workdays at Hampton Court. Delegation after delegation visited the carving room. Publicity about the project seemed to be feeding on itself. If one newspaper did an interview, the others had to follow suit. I tried to divert them to Trevor, but when the cameras and reporters appeared everyone was sucked into the vortex.

Often the days spun out of control. There was to be a topping-out ceremony to celebrate the placing of the highest beam above

the fire-damaged apartments. Workers and officials and minor royalty had been invited for tours and toasts and other festivities. The palace had organized a publicity campaign, with a lavish press packet detailing the construction project and its interestingly archaic timber frame techniques. As usual the carvers and conservators hadn't been invited to the ceremony. By now this felt more like a favor than a snub. The day before, Mike Fishlock told me that there wouldn't be enough time for the Duke of Whichever-It-Was to drop into the carving rooms after the ceremony. We could be happily immured with our work all day long.

After Mike left, Marietta and Flora arrived with a party of relatives and friends for a look at the carving room. As their visit went on I noticed that a crowd of television people and equipment was beginning to materialize in front of my window. Mike reappeared to say that filming for the topping-out ceremony was being done today. The television people, who had been peeking in, told him that they wanted to include shots of carving, so they would be arriving shortly. I shooed Marietta's group on their way, and in came a preening interviewer with his camera and sound people and their equipment.

I was filmed carving, or pretending to carve. The gunslinger's flip that lands the tool in the hand seemed to fascinate the cameraman. He made me repeat it, and thinking about it made me fumble slightly. I was asked the usual questions and I gave the usual answers, with what seemed like the usual gawkiness. The moment the camera came on, the interviewer was transformed into a head-bobbing sycophant. Camera off, narcissist on again. I'd noticed this phenomenon before. Finally the caravan packed up and moved off. Marietta's party reappeared, I gave them a tour of the palace, and soon enough another day had slipped away.

On the morning of the topping-out ceremony a crowd of besuited dignitaries sporting hard hats began to gather outside our

windows, along with virtually everybody who had anything to do with the fire restoration project. Luard and Ellis and I stared out from our workrooms, like schoolboys in detention. An hour of milling about, more curious peeking into the carving room, and then the royal cousin arrived with his entourage. The group followed him up to the roof, then down again to the Orangery, where speeches were given. At last there was an undistracting field of vision outside. I was beginning to concentrate on work again when the director of palace security, known universally as "King George," swung open the door breathless with enthusiasm. "You're about to have a visit from an HRH!" he announced, like a herald.

In came the young duke, who seemed distracted and ill at ease. He arched an eyebrow when I explained how conservative the restoration policy was. The idea of following the archive photograph so strictly as to leave an empty platform, when it could perfectly well be filled with carving, didn't appeal to him. He didn't like the creating of artificial damage, either. Jokes deepened his frown. Journalists and photographers pressed in. Time went by, until finally everyone moved on, and Trevor and I were left to try to recover our concentration. The day was warm and clear and I had my lunch sitting by a fountain, refreshed by its drifting mist.

At the end of the day I met Marietta and her mother at a South Bank preview of *The School for Scandal*. Halfway through, the performance ended with loud bangs, signifying that the stage elevator had broken down. While repairs were made we waited outside on the uppermost terrace, looking across the river at the City skyline in the orange dusk. I decided to telephone Flora, who was at home with a babysitter. She was in a state of wild excitement. "I just saw you carving on TV!"

Next morning every palace security guard I passed offered a kind comment. The film from our room was the only thing to have

made it onto the air, it seemed. So a glimpse of the act of carving, followed by some ineloquent words by an obscure carver, who wasn't invited to the ball, had displaced royal dukes and politicians. Cinderella triumphant, for fifteen minutes. Maybe the BBC editors had found something primal and irresistible in the sight of wood being carved, or maybe it was just the curiosity of the thing.

Luard and Ellis quarreled. The unsalvageable parts of Ellis's carving had been sawn away and Luard was consolidating the remaining charred elements by injecting them with resin. Ellis would be gluing his replacement carving onto the saw lines at the edges of these. The charred material would need to be deeply impregnated with resin that then cured into rocklike hardness, so that he would have a firm edge to glue his work onto.

When I walked in one morning, Luard pointed to a container full of glutinous liquid and remarked that the resin had not hardened overnight. He was afraid that the low temperature of his room had slowed the process. He'd had to keep the windows open so that the toxic fumes of the thinners he was using for cleaning wouldn't accumulate. What about an extractor fan? He hadn't been supplied with one. It was the heroic age of conservation.

Later Ellis brought over to my bench a piece of charred work that Luard had consolidated. He poked it with a tool to show that it was still soft, and then added that he didn't think the resin had penetrated very far below the surface, either. He confronted Luard, who bristled at this encroachment on his territory.

Ellis examined the resin and catalyst containers and found that they had an expiry date of months or years earlier. He grew irritated and said that he'd done some conservation in his time and that he could do the job better in his own heated workshop with his

own resin. Luard telephoned his superior and was told that the expiry date was there for legal reasons only and that these resins in fact had an indefinite shelf life. Nor did they require a minimum temperature to harden; it was only that when the temperature was lower hardening took longer. He told Ellis that the resin *he* would use would not be of a professional standard.

From there the rift widened, with experiments and counter-experiments, accusations and counteraccusations. Eventually Luard acquired an extractor fan that allowed him to keep the conservation room warmer, so that the resins would harden more quickly. Ellis, meanwhile, was given permission to take pieces of original carving down to his workshop in Hampshire so that he could glue on the replacement carving in an environment that was under his control. A cease-fire, with occasional sniping. In truth we were all under pressure, and even equable professionals like Ellis and Luard sometimes showed it. We were in the coil of the project, working as fast as we could, and we were in a fishbowl, as exposed as could be.

I had finished the alps and moved to the foothills just around them, on the lower board of the carving. It contained the most beautiful passage, where a flow of elevated thin stems, like a river dividing into strands in a floodplain, supported pairs of little tulip-like blossoms spraying to the right and left, and between them a pair of long leaves. Below the stems it was almost three inches down to a ground of flat forget-me-nots.

It was the kind of deep excavation that Gibbons was famous for, and I was painfully aware that I didn't own the array of robust, radically front-bent and back-bent chisels that he must have had at his disposal to carry it out. The task at hand required reaching between the delicate high stems and excavating down to a low substratum, and then, at the bottom of this constricted abyss, modeling flat blossoms and stems. In my own work I usually cut away that

lower ground altogether, from the back, to spare myself the kind of task I was facing now.

There was nothing for it but to make do with the bent chisels I had. I found only one tool in my armory that was curved acutely enough to attack at the right angle in those lower depths. I'd nearly left it behind, thinking it more exotic than I'd ever need. It was my deliverance. Pound's words came to mind again, this time the whole line. When the mind swings by a grass blade, he wrote, "an ant's forefoot shall save you." It looked like an ant's forefoot, this small crooked tool that was forced to carry out huge excavations. When I pick it up even now I remember how I once grasped it in desperation, and put it to brutal use far beyond its ordinary capacity.

I was pushing myself beyond comfortable limits, too, working implacably every hour I could. Time was growing short. On a perfect high summer morning I accompanied Marietta and Flora to Heathrow, after farewells from a group of neighbors right up to the moment of closing the taxi door, annoying the commuters trying to race down Christchurch Hill.

At the airport I watched the two disappear around a corner into the passenger hall. I waited a few moments, turned away, and an empty zone swallowed me up. As in a dream a bus appeared that conveyed me straight from Heathrow to the front gate of Hampton Court. The 111. Along the way the residents of Harlington and Heston and Hounslow and Hanworth could have seen a stricken solitary man staring out the window at the sunlit bustle of their little High Streets. Someone who'd already come from Hampstead and Heathrow. Trapped in the letter H, I thought idly. Could I have worked harder over the past eight months? Should Marietta and Flora have stayed on despite the expense, despite Marietta's lonely

mother and the neglected flower garden, and the hamlet's Fourth of July parade Flora had set her heart on?

Now every second thought was of finishing the work. I moved to our friend's house in Clapham, a faster train ride that took me straight to Hampton Court Station and the front entrance to the palace. From now on I'd be walking across the bridge rather than through the park. I put myself on a still earlier schedule, which got me to my workbench by seven thirty, sometimes earlier. The palace was on summer hours now, so I could stay later. Sometimes I managed to carve for twelve hours straight, with a short break for lunch. Afterward there was time for nothing but dinner and bed.

I reapplied to King George for permission to work on weekends. He denied it. Probably just as well. The weeks went on and I began to come unglued. There was a tiny cottage free on the Shawcross estate in the South Downs, a few hundred feet from the house where we once lived. I made a habit of going there on weekends to recover, traveling by train and the familiar green bus. I would walk the Downs during the days and sleep prodigiously on Saturday night. The place was deserted. I'd speak hardly a word between Friday and Monday.

Up and down the hills, resting where the grassy tracks met in Charleston Bottom, then on to the wilderness of Lullington Heath, where there were wild ponies, then climbing to the crest above the chalk figure, the Long Man. On one side the forested Weald stretched away to the gray-blue north, with villages among its trees and fields. On the other a great empty sweep to the white cliffs and the dark blue sea. I would plunge down an old hollow way to the Cuckmere winding in its valley, to a pub where I'd have cheese and bread, and a pint of Harveys beer. Sometimes I'd return along the edge of the dizzying cliffs by the sea, smelling the salt air and hearing the cries of the gulls.

Once I walked on to the top of Firle Beacon, the highest sum-
mit, and then down to a tiny rural station where I could catch a train
back toward the cottage. Waiting there were a handsome older man
who could have been a sensitive painter, and a young companion
who looked like Rupert Brooke. I seemed to have wandered into
1913. Another afternoon I came upon a tea garden above a village
near the Cuckmere. Flint walls overgrown with vines, flowers spill-
ing out of classical pots, quaint wood shelters where you could take
refuge from sun or rain. A young woman in a long print dress was
serving strawberries and cream. A few tables of people, murmuring
quietly. A pretty little girl who reminded me of Flora, playing with
her doll. Big dogs lying around. A benevolent vicar wearing a straw
hat. No one seemed to see me as I came in from the hills. I felt like
Matthew Arnold's scholar gypsy, lost to history, lost to myself, an
unmoored shadow living a posthumous life.

Two months went by. The letters and telephone calls from Mar-
ietta grew ever more grieved and discouraged. She had gathered a
supply of Dutch rush for me, and I'd been away so long that they
were almost dry. I surely should have finished by now. At the work-
bench I would climb a hill only to see another hill beyond. The
payments from my contract had come to an end. I was running out
of money.

And, for all that, I was learning to carve as never before. Some-
thing had cracked, and the current was gushing. No more fuss
about who Gibbons was or who I was, no agonizing over design
principles or construction methods or workshop organization. No
theorizing, no thought at all, just the raw action of carving. It hard-
ened me into ruthlessness. I'd reached the end of my rope and there
was no alternative except to keep on keeping on. I became obsessed
with making every motion purposeful.

It was the year's last gift. The extreme is the circumstance under

which you continue to learn, even after years of plying your trade. You push through your second and third and fourth wind, until the creature gives up the ghost and all that's left is the task. Not that what you're doing becomes easier, under pressure, just that it becomes second nature. *First* nature, even, like breathing and eating. Somebody asked Stravinsky whether he enjoyed composing. "Do you enjoy waking up in the morning?" he replied.

The carving itself had begun to tighten like a bow, a sign that the end was near. During the final undercutting, when the delicate lines and shadows emerge, a piece seems to grow tense with internal energy. As if a clock is being wound and the thing readied for the world.

News came that Simon Thurley, who was in his mid-twenties, had vaulted above his boss to become curator of Historic Royal Palaces. This put him in a position of almost unassailable power over the disposition of the carvings at Hampton Court. I went to see him in his elegant office. From his first words it was clear that he was determined to have all the carvings back on the walls by the time of the reopening of the Royal Apartments, and that he wasn't likely to allow any to be taken down again to be exhibited in London.

I told him that at the pace of work I'd seen over the past year it was unlikely that the carving restoration would be finished by the scheduled opening date, little more than a year away. Not to the completeness set out in the specifications I'd written for the project, anyway. I said I'd imagined there would be a continuing program of restoration even after the opening. Absolutely not, he said. What repairs were necessary to get the carvings back up on the walls and presentable would be finished by the opening date, and that would be the end of it.

What about hanging the carvings rather than screwing them in, so they could be removed to allow more work later, and easy maintenance in future years? We've already talked about that, said Thurley. He said he thought he'd made it clear that the carvings would be screwed back into place.

With rising desperation I told him that I'd gathered wide support for a Gibbons exhibition, and I'd hoped the Hampton Court carvings would play a central role in the show. The director of the Royal Collection had indicated that he was in favor of this, I said, and I had reason to believe that the royal family was also well disposed to the idea. Thurley bridled. "I wouldn't try that angle, David." If he didn't want the carvings to go, they wouldn't go, he told me. No matter, it seemed, what the Prince of Wales said.

The lieutenant held the field. There was a last brick wall to run headlong into. Thurley himself brought up the subject. The original carvings would remain the brown color that was revealed when the pigmented wax was removed. The recarved parts of the carvings would be colored to make them consistent with this. So would my drop, so that it didn't stick out like a sore thumb. It was my turn to bridle. I said that whatever flaws my carving might have, its paleness meant that it was far closer to Gibbons's intended visual effect than even the original work at this point. Not to lighten the other carvings would mean missing the opportunity to show these apartments as they really were in William III's time. Or perhaps at least this replacement could be left the proper color so that viewers would have a glimpse of how these rooms looked in 1700. And so on. But Thurley's attention was already drifting. The interview was over.

It had been in the cards for months, the prospect of Gibbons's carvings remaining trapped in their dreary brown habiliment and mine being daubed with brown paint to match. Even so, it sent an

arrow to the heart. I'd begun writing an article about the restoration project for one of the Sunday newspaper magazines. I decided to end it with a plea to lighten the carvings. There was nothing to lose and probably nothing to gain, either, but at least one objection would be on the record.

I was loath to break the news of Thurley's recalcitrance to the Victoria and Albert Museum, which was rapidly warming to the idea of a Gibbons exhibition. I'd spoken a number of times with my new acquaintance there, the chairman of the exhibitions committee. I said I wanted to show the carving from the vantage point of the workbench. The exhibition would mirror the process of discovery that had occurred at Hampton Court over the past year, delving into the techniques that once were lost and now were found. I wanted it to be an inside story of how the carvings were made, how Gibbons invented his style and changed it over the years.

At last I went to see the head of exhibitions, the woman who had expressed skepticism about the project. What was the best way to approach her? In the end I decided to speak from the heart. I told her I wasn't another art historian pitching an exhibition based on academic research. I was a dirty monk with a vision. She seemed amused at the language that I used. We talked on. She bought the idea. A few weeks later the exhibitions committee voted to accept the proposal for a Gibbons exhibition.

I had told the V&A that there was the chance that we could borrow the Cosimo panel, Gibbons's masterpiece, from Florence. And though we may have lost Hampton Court, there was the prospect of an even bigger prize in prospect: Gibbons's greatest work in England. I'd got wind that the National Trust was planning to conserve the carvings at Petworth House, magnificent surrounds from Gibbons's greatest period, as sculptural as could be and rich with symbolic connotations.

I'd just accompanied a National Trust official to lunch at Petworth with the Egremonts, whose family house it was, and whose ancestor, the Duke of Somerset, had commissioned the work from Gibbons. I suggested that the conservation at Petworth might make use of expertise gained at Hampton Court, and that perhaps, since the carvings would be off the wall anyway, it would be possible for them to be part of an exhibition in London. The Egremonts seemed receptive. And maybe, I thought to myself, these carvings could end up light again, and serve as a lesson to Hampton Court.

One day near the beginning of September I undercut in the top section of the carving, then worked on some surface detail, and then altered the small platform slightly so the overlay carving fit better. Then, astonishingly, I ran out of things to do. I looked up, and instead of another range of hills, there was the open sea in front of me, lapping my feet. I put the whole carving on the floor and walked around it, looking at it from all sides. Back onto the workbench for another stroke here and there, then down on the floor again. This time I could find nothing. The carving was silent. It had stopped issuing instructions. I lifted it onto a table at the side of the room. I sat down in a chair next to it and stared straight ahead, feeling hollow and too tired to move.

A weekend went by, and the last day came. I signed and dated the back of the carving and fastened it to a long board I'd covered with red fabric Marietta had given me. Trevor pushed it through the window to me as I stood in the bright sunlight on the other side of the railings. I carried it over to a wall and stood it up in a shaded niche. Daylight and wind on it for the first time. It didn't stir to life, as in Flora's story, but it looked at ease among the flowers and grass and trees. In its ethereal paleness it seemed like a Platonic form of

the growing life around it. A photographer came to take pictures. Tourists gathered. I stood next to the carving to give it scale while the camera snapped away. I felt like a fisherman on a dock next to his trophy. The visitors asked questions. Where had I hooked this huge marlin? Did it put up much of a fight?

Then a reporter from *The Times* arrived to ask questions and take more photographs. I was already late for the farewell lunch Mike Fishlock had arranged in the Banqueting House. Back into the carving room went the long board with its load. In Mike's office the wine was already flowing. I was presented with a portrait photograph. Me at the workbench, but altered by one of the architects so I was wearing robes and a periwig. Grinling Gibbons, to the amusement of all.

I walked Trevor to the security gate, then turned back to the carving room, where one by one I slipped my chisels back in the tool rolls. Slowly and without bloodshed this time. I tidied my side of the room, made it empty and anonymous again, and closed the shutters. I wished I'd carved a notch in the edge of one of them, to leave some mark behind. A final glance at my carving, leaning against the wall. You're on your own now. It looked frothy, as if the brown wave of carving in these rooms had reached shore here and broken into white tossing foam. Lights off, key turned noisily in the lock, then out through the vaulted arcade of Fountain Court. The fountain's splash seemed loud and echoing, as it always did in the evenings when the place was deserted. Six strikes of the great bell in Clock Court. The escapade ended as it had begun, with a man on foot carrying a bag of vicious tools.

I went out into the slanting light, thinking about all that had happened, trying to distill it to a single image, like a keepsake.

A few months before, one of the architects had appeared in the carving room to invite me to a close view of the acanthus scroll frieze that runs under the cornice in the King's Bedroom. It was a carving I'd praised to him as the best frieze in the land, and without parallel in Gibbons's work. He told me that electricians had just erected a scaffolding, and so for a while the carving could be seen at its own level. I'd put down my chisel and followed him up to the chamber, which was at the far end of the Royal Apartments and almost undamaged.

From the floor, twenty feet below, even in its darkened condition, it was a miracle of delicate flow. Songbirds and flowers and ribbons and berries were swept up in its eddies. Seen near at hand, from the shaky platform, the scrolls seemed overscale, following Gibbons's usual method of making a composition readable from a distance. I tried to work out the repeating patterns in the design. My eye was caught by a passage on the south wall, across the room. The scrolls converged from the left and right to meet in the center, above the room's two windows. There was no scaffold there, so I had an unimpeded view from my position above what would have been the head of the king's bed. Just where they met the acanthus plants took a slightly different shape.

They morphed into something more than acanthus scrolls. They looked like back-to-back letters. Back-to-back Gs, as a matter of fact. A concealed GG monogram! Gibbons's signature, hidden in plain sight, right before the king's eyes as he lay in his bed looking out his windows. Not so much a concealed signature, where the pleasure is in its discovery, as a crypto-signature, ambiguous enough to have deniability in case the king noticed it and took exception to his carver's self-promotion.

Another example of Gibbons's delight in playful deception. Maybe also, it occurred to me later, a little allegory about how a

carver is present in a carving. Perhaps it could serve as an emblem for my time at Hampton Court. I'd wanted to plunge into the carving and roust out the man who had reigned over me for so long. I was looking for his signature in the beautiful foliage, thinking the man was the key to the work.

A few days later I'd gone back to the King's Bedroom again and found the electricians still busy. They were willing to roll one of their scaffolds over to the window wall so I could have a better look at that part of the frieze. I helped them position it, then clambered up the unsteady ladders, held on to the swaying rail, and leaned over to look at the place where the scrolls converged.

And there, disconcertingly, the monogram *wasn't*. At close quarters the letters disappeared. I looked and looked again, but it was hard to see anything other than two intersecting acanthus plants. I climbed down the ladder, walked across the room, and turned around. The GG was as distinct as ever. Back up the scaffold, and again the monogram disappeared into the foliage. So much for the little parable of finding Gibbons by drawing close to the work.

As I walked out of the palace for the last time I was musing on that will-o'-the-wisp signature. It was a fitting emblem after all. I'd arrived at Hampton Court thinking that the secrets of Gibbons's carving were to be found in Gibbons. But the deeper I plunged into the work, the more Gibbons faded from it. In the end there was no ghost to lay. The golden key to the carving was the carving. I'd had the Orion story wrong. Gibbons wasn't the giant whose shoulder I was riding on. The giant was the act of carving, the profession itself: the making of a carving, the making of anything. Making itself. The Ancient of Days in all of us, the impulse to create. Where I was riding, Gibbons himself had ridden.

He had spurred Orion on, and they had found the dawn. Genius and training were reoriented by the upheavals of the day, and a

brilliant style was invented. For me there was no such dawn in prospect. But I'd traveled with Gibbons for a year and gathered bounty enough. I was ready to make my way on alone.

I stood for a moment with my heavy bag, looking back at the palace. Is this a good enough ending? I wondered. Does it confer meaning and order on the story, like the ending of a novel? The truth is, this isn't a novel, and it doesn't end with a man walking out of a palace into an autumn evening. The story goes on, into the years, and it holds another surprise.

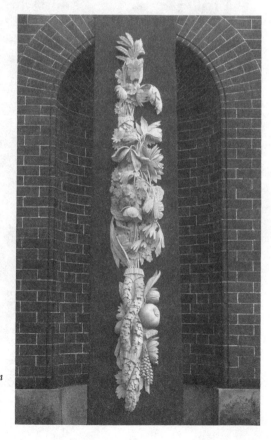

● *The completed carving, leaning against a niche in the Privy Garden wall.*

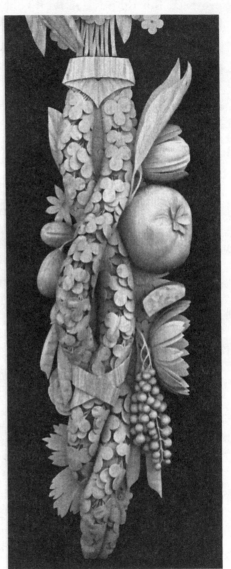

After

Bicycling today in the hinterland, along the ragged edge of the great forest. Deserted country: empty roads and full cemeteries, in the middle of nowhere. Reverting fields and fields that have reverted altogether, into tall woodlands with stone walls running pointlessly through them. The tide of humanity has retreated from these beleaguered margins, leaving behind its dead and the traces of their industry. At the end of the day a graveyard atop a little knob came into view, on the far side of a last field, caught in the evening light with the endless forest stretching beyond like eternity. You could imagine a disheartened farmer from another age standing there, contemplating a gravestone. Like the shepherds in a famous painting by Poussin, taken aback when they come across a tomb with the inscription ET IN ARCADIA EGO: mortality saying, I'm here, too.

It's early autumn, just the season when, two decades ago, I returned from my year at Hampton Court. I remember bicycling these same roads then to recover my frazzled equanimity, past the same wayside blue chicory and purple asters and yellow goldenrod. Now I've come to the end of a year spent reliving that earlier one,

Left: Forensic evidence: the charred remnant and its replacement.

reading my journals for the first time since I wrote them and trying to make something of it that doesn't bruise the truth. Between those covers the days often seemed new-minted. For a while they blotted out the future. I stepped in the same river twice.

Not something you can do three times, I thought today, as I cycled through those lost meadows. I'd barely closed the notebooks before the dew evaporated and the light of future events came over them. Now I can't think of those days without thinking of what happened afterward, how time picked out some things and made them part of the future, but turned its back on others, marooning them like a pasture wall in a forest.

A year after I left Hampton Court, the King's Apartments were reopened to the public. All the carvings were back in place. Screwed into the paneling, just as they had been before the fire. And their color? As comfortable as an old shoe. The brown everyone expected. The new replacement carving was toned to match with coats of acrylic paint. I brought to mind the pale figure I'd left propped against the wall in the carving room, pictured a brush being taken to it, and decided I wouldn't go out of my way to see it again.

Mike Fishlock retired, and in the next Queen's Honours List was made an LVO, or Lieutenant in the Royal Victorian Order, an award for those who've done special service to the monarchy. He wrote a book about the fire restoration project, and a few years later died of the intestinal cancer that had been diagnosed shortly before I met him. Trevor Ellis carved in his insouciantly unspecialized way until his seventieth birthday, when he downed his tools and did not take them up again. Too spiky a character, probably, to mellow into one of those serene old carvers I met in my youth. Richard Hartley went into the music business. David Luard became the leading conservator of seventeenth-century foliage carving, work-

ing in palaces and churches and country houses across the realm. Simon Thurley continued his meteoric rise. After Historic Royal Palaces he became director of the Museum of London. Then came an even bigger job: chief executive of English Heritage, the public body that oversees the great historic buildings across Britain.

Time ran on. My Hampton Court drop had gone from white to brown and my hair headed in the opposite direction. The trees I've planted are growing tall, the chisels I use grow shorter. We built our barn and moved in. Flora went off to a university in New York and then took a publishing job there. Marietta developed an intolerance for paint thinners and stopped restoring porcelain. For the first time I was alone in the workroom.

On the 350th anniversary of the carver's birth, eight years after I'd first proposed it, the Grinling Gibbons exhibition was held at the Victoria and Albert Museum. We managed to borrow the Cosimo panel from Florence, and carvings from many other places as well, along with a number of Gibbons's wonderful design drawings. One carving was mounted in a clear plastic box so you could walk around it and examine it from all sides. I wanted to give visitors a glimpse of the process of making a woodcarving, so I set up a workbench with my tools and a half-completed carving on it, along with some atmospheric wood chips.

And the Hampton Court carvings, which had spurred the whole idea in the first place? Thurley's successor at Historic Royal Palaces said he would be happy to lend a piece if there was a good reason for removing it from the wall. But what could that be, he mused, since the work had just been restored? I'd been lying in wait for this question. I told him that the previous regime had been determined to get the carvings back on the walls in time for the reopening, and so a number of missing elements whose replacement had been called for in the original specifications had been passed over.

For example? he asked. We walked along to the King's Drawing Room. I gave a quick sidelong glance at an odd brown incarnation above one of the doors, my carving in its new guise, and then I pointed to the top of one of the long overmantel drops above the fireplace. The forward layer of its crowning laurel wreath was missing, along with a whole spray of olive leaves. I offered to supply these gaps if they would lend the drop. The deal was done. I spent two weeks carving for Hampton Court again, in a chamber at the V&A off the exhibition hall. Luard colored the replacements and fitted them into place. At the show's opening, there on the wall was a carving that embodied design principles that Gibbons had spent a lifetime evolving.

M y path continued to cross Thurley's. When the exhibition opened, he interviewed me for a magazine and took the opportunity to question the ascription to Gibbons of the drawings that were on display. As an upshot of this a conference on these designs was organized by the V&A. At its conclusion forty assembled art historians were asked whether anyone present believed that these drawings were not from Gibbons's pen. Not a hand rose.

Not even Thurley's. But he held to this notion with a bulldog-like grip. Several years later he published an impressive study of the architectural history of Hampton Court, magisterial in its sweep and detail. Oddly, it included virtually no photographs of Gibbons's carvings and scant discussion of them. But it did illustrate a number of Gibbons's Hampton Court drawings—only to ascribe them principally to Christopher Wren's employee, the architect Nicholas Hawksmoor, who at that point was near the beginning of his distinguished career. Gibbons may have been capable of drawing carved ornament, Thurley argued, but it wasn't clear that he

could draw architectural detail. Hawksmoor, conversely, was not only skilled at drawing moldings and cornices and the like, but he was capable of drawing the carved work. Furthermore, wrote Thurley, if Gibbons *did* execute all these drawings, that would likely mean that he was responsible for the whole interior design of the King's Apartments, an idea Thurley found hard to swallow.

I turned the pages in amazement. This was about as wrong as it is possible to be. Gibbons was an exceptional draftsman and an adventurous designer. To deny him his role in the decoration of the King's Apartments is to misunderstand his kind of carving; to drag him down to the level of a subordinate craftsman. It's hard to imagine his work being designed by somebody else, even at the level of sketch. I thought of the hours you have to spend mapping out high-relief carving, visualizing its summits and valleys. Gibbons inscribed one of his still life panels *Gibbons Inventor et Sculpsit*, just to make clear who it was who designed the work as well as carved it.

Besides, in the drawing of carving in these designs you can recognize Gibbons's fluent hand from a mile away. There was only one sheet among these dozens where I could see another, less incisive pen at work (later I learned it was Hawksmoor's). As for the architectural details in these drawings, the moldings and cornices and the like? We know that Gibbons's workshop carved those elements at Hampton Court and elsewhere, and there is plenty of evidence that he designed them as well.

In a footnote Thurley remarked that all these matters would be sorted out when the drawing specialist Gordon Higgott cataloged the sheets in question, which are among Christopher Wren's papers at Sir John Soane's Museum. After Higgott started I was given a grant to spend two months at the Soane alongside him, studying these drawings from the vantage point of Gibbons's actual carving. I came away

more certain than ever that they were Gibbons's. Higgott worked on, meticulously analyzing each drawing, and when the catalog appeared it reaffirmed the opinion of the scholars who had assembled at the V&A: except for the one by Hawksmoor, all the designs in question were entirely Gibbons's, carving and architecture alike.

A dry-as-dust academic disputation, you'd be forgiven for thinking. In truth it seems far away now, like the buzzing of petulant bees around an orchard tree somewhere in the distance. So too with the other slights and missteps and frustrations at Hampton Court. Someday even this will be recalled with pleasure, remarks Aeneas, clinging to the wreckage after the Trojan fleet has gone down. For me the someday has arrived. All the painful moments at Hampton Court are wry stories now, told once in a while after dinner when the wine goes around again.

All the painful moments but one, that is. Time hasn't proved a liniment for my first and worst mistake, that too-prominent bulge in the leaf rope. Neither my conscience nor my vanity has let me forget that misstep. Or forget that after I left Hampton Court this section of the original carving was discovered, revealing to all just how badly I'd gone astray. I knew that the surviving burnt fragments of carving had been put in storage somewhere in the palace, and that this piece probably was among them. But it was like an old-fashioned Freudian trauma, buried in the subconscious, that you are loath to revisit.

Down in his vault this Caliban has been stirring ever more restively over the past year. How can I tell the whole story, even to myself, unless I drag that thing of darkness into the sunlight? As it happens, a new carving project has come up at Winchester Cathedral. It wouldn't be hard to schedule in an extra day . . .

Through unprepossessing Wimbledon. Then greener land-
scapes, playing fields and rich foliage. As the train approaches
Hampton Court Station I don't catch a glimpse of the palace.
Where's the great whale I'd sighted breaching above the Thames on
my first visit? Have the trees filled in? Then over the bridge, past
the bluff guards at the security office, down Tennis Court Lane to
meet an official who leads me to a little room off Chapel Court. On
the table in front of me are four large plastic containers and a card-
board box with tissue paper on top.

First, the cardboard box. I lift the tissue and find myself look-
ing at the visage of my old friend and helpmeet, the charred lump
from the middle part of the drop that saved me by revealing the
carving's three-layered structure. I pick it up and revolve it in my
hand, and in my mind, too. The charcoal blackens my fingers, just
as it did before. A surge of memory lifts me and bears me along for
a few moments, until I make myself swim back to the present.
Only a few other small pieces in this container, some of them
dimly familiar.

Then the first plastic box: charred oak moldings and other ar-
chitectural enrichments. Second box: burnt oak foliage carving
fragments from the Cartoon Gallery.

Third box. I lift the packing tissue and there is my quarry, un-
mistakably. A long, badly burnt piece of carving with crossing ropes
of shamrock leaves. But wait, something is missing. Where is the
forward layer, the superimposed rope segment that will establish
my guilt? The platform it was glued to is empty and uncharred.
Probably the firefighters' high-pressure spray, putting out the
flames, tore the piece away and sent it flying into oblivion.

Whatever happened, the key exhibit for the prosecution was
never there. You could put the surviving fragment on the stand

but it would not convict me of error. I stare out the window at the secluded little courtyard. You'd think that after years of self-mortification I'd be relieved by what I've found. But I don't seem to be. Vanity may be less appalled, but not conscience. If nobody can prove you wrong, that doesn't make you right.

There must be *something* to be learned from the charred form lying here on the table. An idea comes to me. If you measure how long that empty platform is, and assume that the original rope segment projected as far forward as the leaf ropes in the other three drops do, then you can deduce how steeply it must have bulged out.

I find a ruler on a desk and measure the platform. Eighteen centimeters, just about seven inches. That must be the length of the original rope section that was glued to it. But I'd made mine *nine* inches long! And all this time I've been tormented by the certainty that I'd made it too short! Even if the platform had somehow shrunk an inch, in the carving's ordeal of fire and water, the original rope section still would be shorter than the one I carved. Therefore, if it reached the height of the other three drops, it must have bulged up even *more* acutely than mine did. I step back and look again, and rehearse my reasoning. Caliban, dragged into the sunlight, was beginning to melt away.

Could this be proof that I was not only not wrong, but actually right? By these calculations my piece can't have diverged very far from the shape of the original. What, no mistake after all? The evidence that I thought had convicted me instead has drawn the thorn!

Why don't I feel elated, then? Try though I may, I still can't seem to exonerate myself.

Maybe if I see all four drops together? So I take photographs and make more measurements, then repack everything, pull the door shut, make sure it is locked, and go out into the noise and

crowds of the palace. Down the gloomy passage past the chapel, into Fountain Court, past Mr. Nice's Chocolate Court, then up the back staircase to the Royal Apartments and through to the King's Drawing Room.

There it is, my besmirched brown thing, now (correct in this at least) the *right*-hand drop over the west door, looking more than ever as if it had been carved by someone else. There's that protruberant bulge. I compare it to its companion on the left, and then to the other two drops over the door behind me. Some of the ropes are narrower than others, and they all bulge out a little differently. Mine is conceivably within the range of variability established by the others. Whoever would notice any difference?

Then why do I feel weighed down by what I see?

Because it is not beautiful, not fluent, not pleasing. No matter what the measurements say. I've been on a fool's mission. Did I imagine that Gibbons would have felt compelled to make this part of the carving bulge out just as far as the others, if that made it clumsily protuberant? No, he would have let the carving do what it wanted to do. He would have roughed out the rope on the lower level first, then surged it up into the forward layer and down again in a continuous graceful line. And he wouldn't have given a fig if it didn't project as far as the others. He'd take his instruction from the workbench, not from a formula. The lesson that was ingrained in me all those years ago, in this very place.

If the original fragment I've just seen had been complete, then I'm sure one glance at it would have confirmed that I can't absolve myself with a ruler now. The surprising shortness of the original platform, the straw I'd been grasping at, didn't mean that Gibbons's rope must have been as graceless as mine, only that it wouldn't have protruded as far.

I can tear away the last tissue of evasion now, and see into the

heart of my error. The arc of the day pleases me: You made a mistake. But you didn't make a mistake. But you did make a mistake. A worse one than you thought. However, one that confirms everything you learned here at Hampton Court all those years ago, about what guides your hands when you make a thing well.

I decide to walk down the enfilade passage that connects the King's Apartments, pausing in each room to scrutinize the familiar overmantels and overdoors. The dim brown forms make my spirits sag. After a while I climb down the back staircase again. I can't resist a detour into the carving room. It's unrecognizable, done up as one of the Earl of Albemarle's elegant apartments. I go to my old window and stand for a moment, wishing again that I'd cut a little notch in one of the shutter edges so that the room would carry some evidence of its year as a workshop. I'm tempted to reach out and feel the shutter's heavy swing again, but a guard is watching and I know he'll tell me it shouldn't be touched.

A day later. I'm walking down a lane in Winchester with David Luard. It runs along the old city wall, toward the water meadows. We've just come from a teetering scaffold in the cathedral, where a mutilated Gibbons-era composition needs conservation and (if I can figure out what originally occupied the huge gaps) some replacement carving. Every five or ten years the impulse rises up in me, the longing to find myself in some venerable building, with its smell of stone and old wood and dust, and sunlight slanting in from high windows, looking at carvings from long-dead hands. It's like malaria. You can be in remission for years, wrapped up in your own work, when suddenly you'll suffer a relapse and find yourself backsliding toward the old masters.

David and I are talking about Hampton Court. I tell him that

I've just walked through the King's Apartments and come away dispirited. There are tapestries in the rooms now and the windows have had to be veiled with opaque curtains to prevent light damage. So the apartments have been cast into a perpetual gloom. It makes the carvings darker than ever, hardly distinguishable from the brown oak paneling except as a kind of scabby texture. You can't even *see* that beautiful frieze in the King's Bedroom.

We're passing the house where Jane Austen died. Lovely autumn light over all. I go on complaining. Gibbons, whom I'd hoped the Hampton Court project would awaken, is slumbering again, and in a deeper slumber than ever. Entombed in gloomy chambers, covered with dust again, dressed in mourning colors as if in sorrow for his own demise. He's caught in a nightmare life-in-death, despite all our work.

"Well, it was a lost opportunity," says David. "Going the whole way was just too much for them."

"The project was a failure. That's the way I'd put it," I say. "As far as the presentation of Gibbons goes, anyway." I mention that you can see the beautiful seventeenth-century King's Privy Garden, the vast parterre that Thurley re-created below, only by looking through a narrow slit in the curtains. "It's like wearing a burka. No wonder the apartments were deserted when I was there."

We walk on. I don't mention another unhappy reflection, that my dream of the Hampton Court project spawning a new school of woodcarving has come to nothing. The other carvers did not go on to do new work with the old skills they had honed. I'm still mostly on my own, wishing I had more colleagues and competitors.

David has to get back to London. After we part I make my way down to the serene meadows where Izaak Walton fished and Keats wrote his ode "To Autumn." Being on that scaffold in the cathedral has made my thoughts brim with Hampton Court. Those great

windows in the King's Apartments face south. The light should flood in. You should see creamy monochrome carvings washed in light, like garlands of flowers gathered in heaven. That's the spectacle Gibbons invented. That's what King William saw.

It's not the only place where Gibbons's carvings have fallen on hard times. Petworth House has followed Hampton Court down a dreary brown path. The proprietor, the National Trust, ignored the overwhelming evidence that the carvings were lime-washed and left them an ever deepening brown. Worse, it was decided not to take the carvings off the wall for conservation, rejecting David Luard's advice. So they molder on, approaching a state where even dusting them is perilous. As if this were not enough, in order to return the room to its state during a brief few years in the nineteenth century, the National Trust has reinstalled a jungle of inferior nineteenth-century carving. It fills every nook and cranny, jostling so close that it almost touches Gibbons's work. The walls pullulate with detail. It's a Victorian's vision of a carved room.

There is one bright spark to relieve the gloom. Luard has produced an example of how Gibbons's carvings should look and how they can be made to look that way again. He has conserved the altar carving at St. James's Piccadilly. After the cleaning and repairing, he applied microcrystalline wax and then a coat of white gouache. (The treatment is reversible, in case a taste for the dark age returns.) The varnished ugly duckling has molted and grown new white feathers. It floats before the reredos, light and airy. It is easily readable again, with contrasting shadows defining its pale flowing forms.

In the main channel of the river, across a meadow, I can see a swan paddling, elegant and unearthly, like a portent. *It's not over yet.* The idea seizes me.

B ack from Winchester and Hampton Court, and freed from keyboard and computer screen now that writing is over and my notebooks are hibernating in their drawer again. At my workbench at last, carving from morning until late at night, and almost drunk with the pleasure of physical labor. As on the long-delayed morning I first began working at Hampton Court, when I was so overwhelmed by delight that I had to put the chisel down and compose myself. The old hypnotic motions: one arm pushing against the other, both propelled by the *contrapposto* twist of the body. Working ambidextrously, passing the gouge from one hand to the other so that the forms and the grain can be approached from either side. The brain no longer turning inward, but flowing out into the shapes on the workbench. Going to bed at night physically tired rather than mentally exhausted. Well done is better than well said, according to Benjamin Franklin. (Which is so well said that it undermines his case.) It makes you *feel* better, anyway.

Late this afternoon under cold gray skies I kayaked up past the island, through the inside passage rapids. Hard paddling, river running high and ragged, a newly fallen tree funneling the current into a kind of flume, making the current stronger still. When I emerged into the smooth water above the island, the sun suddenly dropped below the clouds, into a narrow slot of clear air just above the horizon. Paradise opened. Raking light turned the trees to hammered gold, extravagantly gilding the autumn reds and oranges. Fire upon fire, a color without a name.

Against the black sky to the east, a bigger conflagration: the hill above our house had caught alight. I wheeled and sped back around the bend, racing against the sunset, hoping for a better view of the alpenglow on already brilliant leaves. The escarpment hove into view and there was Marietta, too, walking unself-consciously along

the top of the high bank, gilded like the trees and the grass in a momentary eternity of beauty. In Elysium, all unknowing. Sometimes moments in the past are so vivid that they seem to be happening in the present. Sometimes moments in the present have such haunting splendor that they seem to be happening in the past. As if you see them with your memory. As if they were their own elegy. The sun fell below the horizon, and I drifted along on the darkening current.

Next morning. Drinking tea in the workroom and starting to think about the next project, the poor broken carving I've just seen at Winchester Cathedral. The authorities there have found a watercolor from the nineteenth century that shows the carving in its original setting on the altar canopy, undamaged. But the picture is of the whole wall, and the area in question is tiny and ambiguously painted. I guess I could try to deduce from that dim little blur what the form of the replacement carvings might be. But I feel a hand on my shoulder and a voice whispering, *Look at the carving that remains, let that be your guide.* Work from the bottom up, not the top down. A lesson I learned at Hampton Court: trust things, when you have them, not images. Fortunately the upper edge of the missing shield survives, so I ought to be able to extrapolate from that some ideas about what was below. And though one drop is gone, the other is there, so I can make up a reverse counterproof design out of that. I wonder what Luard has found out about the structure of the piece. We'll have to have a conversation about this.

Just like old times. Have I ever left Hampton Court? Some places are located in time as well as space, and you can't get back to them no matter where you take yourself. That farmhouse overlooking the Fens outside of Cambridge is forever gone. It has re-

verted, fallen back into the past. But Hampton Court seems to flow along in the current of time. I left it but it hasn't left me.

Who's in charge there now, I wonder? My spirits have begun to recover from the depressing sights in those gloomy apartments. *It's not over yet.* There must be a director of conservation. I could arrange to meet him or her at St. James's Church and let that pale carving speak for itself. No, go to lunch first and then make St. James's the coup de grâce. Perhaps one could offer to start by lightening the carving in one room, as a test case, to test official and public reaction. The wonderful frieze in the King's Bedroom, say. You'd be able to see that mysterious concealed GG again. Maybe I should write another article.

They'd have to remove the tapestries from these rooms, of course. Lightening and rehanging the King's Apartments' carvings would be a nice project for Luard. No work in it for me. Unless, that is, I decided to correct my mistake. It wouldn't be impossible to remove the bulging rope section and recarve it correctly. Salvation at last! And yet. That bulge is my notch on the shutter, the signature that shows it's not Gibbons's carving but somebody else's. It's part of the story of the palace, archaeological evidence of how another carver, years later, when the tradition was long dead, had to rediscover the mystery, as the skill of a trade used to be called. Leave it, then, to make the carving richer? I'll ask Marietta's advice.

Other thoughts rise up. I can't get that newly discovered Gibbons panel out of my mind. Maybe I can persuade the owner to introduce it to the world by exhibiting it alongside Gibbons's Hampton Court drawings. They are both from the same triumphant years and they are in the same ambitious grand style. The drawings are not plans for carvings but imaginative gestures toward carvings. If they were exhibited with the panel they would once and for all reveal to the world how Gibbons operated as a designer.

Still sitting in my chair, sipping tea. A new idea for a carving has come to me. I've been looking at old still life paintings of letter racks, as they're called: boards with straps across them where letters and papers and suchlike things are tucked. You used to see them in hotels and clubs. I've never heard of one being turned into a carving, but why not? Most still life compositions show items on a table or desk, and that horizontal configuration isn't as dramatic for a carving as something on a wall. But a letter rack is a still life on a wall, a still life conveniently tipped up to a vertical plane. I'd want to update the content, pour new wine into the old bottle, by including things like an iPhone, or an iPod with coiling earbud wires, or a digital camera.

As if it were an object in a corner of my workroom. Chipped chisels slipped under the straps, waiting for repair. A pencil, Dutch rush shoots, a peony blossom for beauty. A written contract with the patron who's commissioned this carving, the paper folded but flopping out. Some hundred-dollar bills. Money and art. Seashells, a watch, keys. How would you construct this piece exactly? How much separate carving would you need to do? And who could I get to commission it? There's that friend of a friend I met in New York the other day, a collector, I think . . .

Enough of that. Columns of rain march in from the north, blurring the hill as they move across it. Curtains of snow, soon enough. Coat already thick on the coyote that trotted past the other day. Down on the river the mergansers are turning noisy.

To the workbench now. On with the lights. Chisels and gouges gleam. Chef Borghese stares up in a disheveled state. Let's see, where was I?

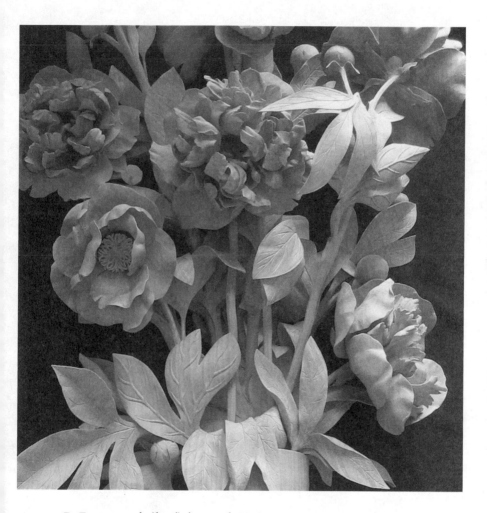

D. E., overmantle (detail), limewood, 2007.

Profound thanks to Marietta von Bernuth and Flora Esterly, to Robin Straus and Joe Kanon, and to Kathryn Court and Tara Singh.